Film Actresses
Volume 3
Joan Crawford
Documentary study

Part 1

ISBN-13 : 978-1514116265
ISBN-10 : 151411626X

Copyright©2012-2014 Iacob Adrian
All Rights Reserved.

Notice

This documentary study use historic, archived documents.

Because of this, some pages may look blurry or low quality.

Still are included in this book because they have

high value from critical, documentary, historical,

informative and journalistic point of view .

Dtp and graphic design

Iacob Adrian

**Copyright©2012-2014 Iacob Adrian
All Rights Reserved.**

Author statement

The actors and actresses are the the bricks .

The cast and crew are the plaster .

They stand on the foundation created by producers and writers and directors .

All these people creates the great palace of the art of film .

Iacob Adrian - 2013

This little Book conveys the greetings of

..

to

..

Intimate, late portraits of favorite stars as photographed by Hollywood's master camera artists

HAPPY NEW YEAR

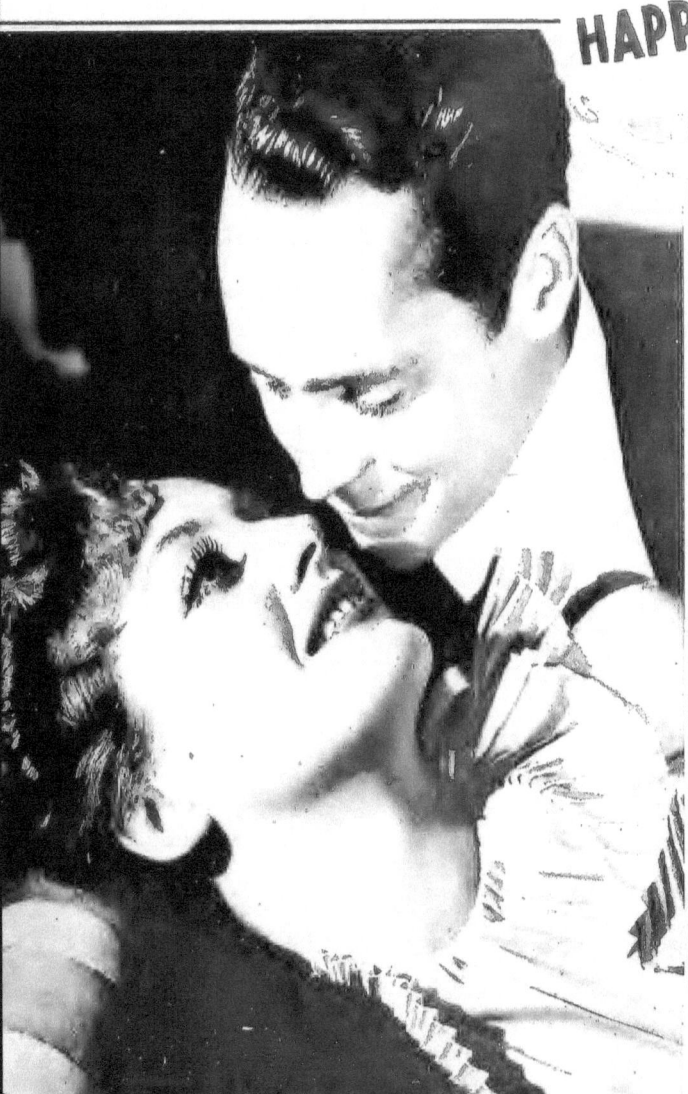

Thelma White
—*Ernest A. Bachrach*

Thelma is aptly cast in *Blonde Poison*, for this alluring comédienne certainly deals a lethal potion to the blues. She is also to be seen with Wheeler and Woolsey in *Hips, Hips, Hooray*

Joan Crawford and Franchot Tone
—*Hurrell*

Romance, as personified by Joan and Franchot in pictures, will find its culmination in real life for this attractive couple when Joan's divorce from Douglas Fairbanks Jr. becomes final, according to those professing to be in the know. Joan and Franchot appear together in *Dancing Lady*

WITH THE NEWS SLEUTH Timely news, inter

The Passing of Peg

DEATH OF Mrs. Margaret Talmadge, mother of Norma, Constance and Natalie, has left a void in the celluloid world's inner circle that cannot be filled. Peg, as she was known to her long list of intimates, was the mother confessor of Hollywood.

Mrs. Talmadge passed on rich in worldly possessions she had garnered through her own efforts.

While her will, signed in 1931, fixed the value of her estate at "more than $10,000," it is believed her fortune totalled above the $1,000,000 mark. A few years ago, she was rated as worth around $3,000,000, but, like so many others, she suffered tremendous losses through shrinkage in values of securities and real estate holdings.

Peg left all of her property to Connie, her favorite child. The reason for that was that she and Connie built their fortunes together. They were partners in all ventures.

And Now It Comes Out

JOAN CRAWFORD and Franchot Tone will lose no time in dashing to the altar after Joan's divorce from Doug Fairbanks Jr. becomes final early next spring. While neither Joan nor Franchot is talking about their romance, it is known they have completed plans for their future together.

Intimates of Joan have told me it was Franchot's insistence upon firmly establishing himself in the cinema heavens before taking a wife that led Joan to file her suit against Doug in California rather than taking the more speedy route through the Nevada or Mexican courts.

Had she followed the latter course, it is more than probable the popular couple would be wed by now.

Connie Does Her Bit

CONSTANCE BENNETT'S love for the Marquis Henri de la Falaise may not be as heated as it was at the moment of their marriage two years ago, but she's not going to stand idly by while the movie-makers poke fun at him.

Just before Hank's departure for Paris to have his passport renewed and to check up on his French realty holdings, Connie appeared in the office of Louis B. Mayer, Metro's head, with a plea that the fake marquis character in *Bombshell* be changed to that of a duke instead.

"Hank is the only bona fide marquis in Hollywood," explained Connie,

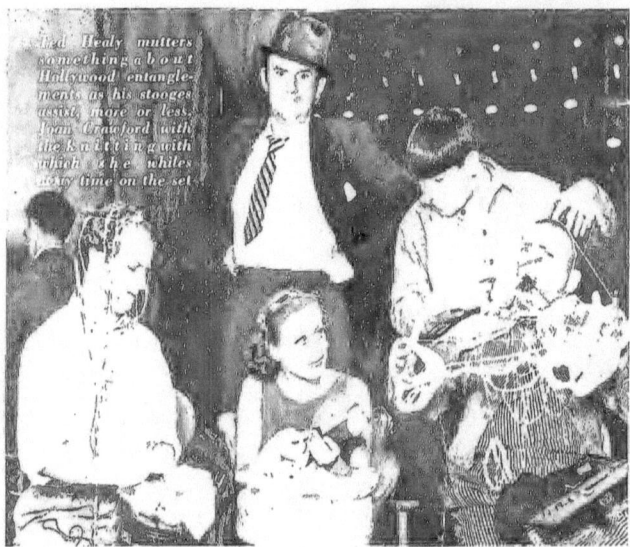

Ted Healy mutters something about Hollywood entanglements as his stooges assist, more or less. Joan Crawford with the knitting with which she whiles away time on the set

HOT from HOLLYWOOD

Marriages

GINGER ROGERS and Lew Ayres have settled all of the details except the date . . . Estelle Taylor and Director Roland Brown are liable to step off any day now . . . Eleanor Boardman, recently freed from King Vidor, will wed Director Harry D'Arrast next Spring . . . Louise Brooks is the bride of Deering Davis, Chicago sportsman . . . Fifi Dorsay will ankle it with Maurice Hill, Chicago manufacturer . . . Lenore Bushman, daughter of Francis X., is honeymooning in Europe with Dr. Webster Marxer . . . Joel McCrea and Frances Dee were married at Rye, N. Y. . . . Bruce Cabot and Adrienne Ames were married at Carlsbad, New Mexico . . . Polly Moran and Martin Malone, prominent Los Angeles attorney, surprised friends by assuming double harness at Las Vegas, Nevada . . . Johnny Weissmuller and Lupe Velez now admit they are wed.

Divorces

THE JAMES CROFTONS (Mona Rico) will air their domestic troubles in Reno . . . Prince Serge M'divani denied he socked his operatic wife in the eye when he took the witness stand in Mary McCormic's suit for a decree . . . Doris Kenyon is kept busy denying there's been a rift in her marriage to Arthur Hopkins . . . it's business that keeps the bridegroom in New York, she insists . . . Agnes Franey of *Follies* fame is suing wealthy Logan Metcalf, one-time husband of Madge Bellamy . . . Zita Johann cut the ties that bound her to Playwright John Haussman in the Mexican tribunals . . . Jerry Miley and Elsa Peterson severed matrimonial relations via the same route . . . Marion Sayers won a divorce from Jimmy Murray by charging that he drank to excess . . . Agent Ben Hershfield testified Rita La Roy was peevish at times, and asked the judge to free him from his marriage contract.

Births

IT'S A SON in the home of the Melvyn Douglases (Helen Gahagan) . . . the Karen Morley-Charlie Vidor offspring has been named Michael Karoly . . . Johnny Mack Brown's new heir has been christened John Lachlan Brown . . . the Robert Kenastons (Billie Dove) are preparing for the arrival of the stork in April.

Deaths

THE GREAT UMPIRE called strike three on Mike Donlin, famous baseball player of an earlier period and long a screen actor, at the age of fifty-three . . . Joseph Fazenda, father of Louise and leader in Los Angeles' French colony, succumbed at seventy-one . . .

The Editor's Mailbag

A Good Trick

How Does Mae West manage to walk after she adds six inches to her height through her slippers? Surely it wouldn't add to her delectably feminine self to be other than graceful—but how does she ever manage?

HELEN FIGI,
South Wayne, Wisc.

More Jack

Will someone please tell me why Jack Oakie is never the "headliner" when a picture is advertised? He is never mentioned as the star, but as far as I am concerned he has stolen every picture he has ever played in. He typifies wholesome, good-natured youth —the kind that can take it and grin. Let's have more of him!

MOLLY JORAN,
10509 Clifton Blvd., Cleveland, Ohio.

She's Angry

When I Read The interview with Jean Acker by Gladys McVeigh, such a feeling of violent irritation arose in me I was just "mad." How could Jean Acker see such strong physical and facial resemblance between Raft and Valentino? How can she see Valentino in Raft? Valentino with his velvety softness and mysterious glamor—fascinating and artistic.

Valentino was different. He was a soaring eagle—he was great—he was clever, daring, yes shocking, too. He had magnificent talent. He reflected tropics of passion in his love-making.

To me there is something amusing about Raft's love-making. I can't see him as a lover—as a menacing gangster —a gunman type—well, I might appreciate his talents there.

DORIS TAYLOR,
1328 Cabrillo St., San Francisco, Calif.

Wants Them Plump

I have heard that Clara Bow's successful comeback depends upon whether she can reduce sufficiently or not. Why, in the name of heaven, must she? So many actresses have to possess that very slim Harlow or Crawford figure. Personally I would enjoy seeing a plump, healthy looking actress on the screen such as Clara or Mae West.

MISS G. BAY,
1102A So. 35th St., Milwaukee, Wisc.

Watch for Mae's Story Next Month

I Could Never Say which of two stars I think is the greatest depression chaser—Mae West or Joan Crawford, for to me they are both marvelous. I think Mae West's article in HOLLYWOOD Magazine, "Must a Woman Be Immoral to be Glamorous?", the best ever. She certainly is not afraid to express her thoughts and if folks would be honest in what they believe, they would admit every word is the truth.

Joan Crawford is one of the most wonderful characters in the movies, to weather the storm of physical, mental and spiritual hardships with the courage she did. The expression on her face should be an inspiration for us to have more faith in life and people.

MRS. G. A. BIERSACH,
4803½ Virginia St., Dallas, Texas.

Not a Puritan

When more pictures like *Lady for a Day* are produced, the theatres will hang out more S. R. O. signs. After all is said and done, there's nothing so refreshing, nothing that will make one forget one's cares and worries, like a good, clean picture, well-directed and acted, with a laugh and a tear.

I'm not a puritan, but I have been disgusted with the tawdry, cheap sex stuff the producers have given us in the name of Entertainment. Hip-shaking heroines and mouth twitching heroes may appeal to some, but not me.

MRS. A. BANZ,
1227 Clay St., San Francisco, Calif.

Thanks

You Invited Us To tell you what we'd like to see in HOLLYWOOD. First: keep up the fictionizations, they are great. Second: give us more pictures and news about Hollywood. Third: how about letting us know in the preceding issue what date the next issue will come out?

ADRIAN FARINAS, JR.,
204 W. Romana St., Pensacola, Fla.

Every-day Truths

May I take issue with Mabel Stultz's letter in which she pleads that "for our kids' sake" the movies desist from "playing up" such repugnant expressions as "I am going to have a baby," etc.?

Where such an expression is repugnant I fail to see. Anyone with a clean mind cannot possibly see anything repulsive about our natural entrance into this world, and certainly children will be all the better off for knowing the plain vital facts of life.

I am a mother of three children and I am grateful to the movies for helping me teach them the natural every-day truths.

MRS. M. FELDMAN,
209 Peters St., S. W., Atlanta, Ga.

Weary of Temperament

After Reading Claudette Colbert's explanation of "Why I've Gone Temperamental" in HOLLYWOOD Magazine, I concluded the "Hollywood Technique" must be responsible for such publicity stunts as Katharine Hepburn's patched trousers, Marlene Dietrich's overly-broadcasted pants and the countless other idiosyncrasies one is forever reading about movie stars.

I know it is necessary to keep screen personalities before the public but sometimes I do grow weary of hearing so much about their unique behavior or dress and wish I might think of them as intelligent, polite people who confine their acting to the screen and otherwise lead a sane, normal life.

MRS. C. D. PALMER,
2513 Northway Ave., Fort Wayne, Ind.

Hollywood NEWS in Pictures

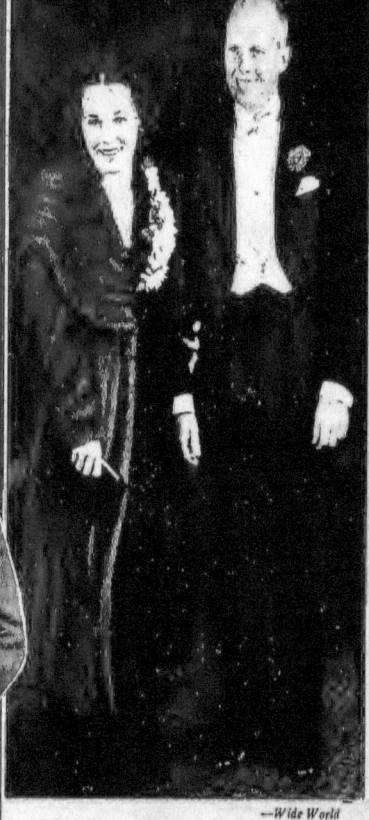

ENGAGED — Maureen O'Sullivan and Johnny Farrow, screen writer, have announced their engagement. —*Wide World*

IN HANDS OF LAW — take Baby LeRoy's used as aid in event

FAVORITE RETURNS—Roland Young and Lilian Gish in an exclusive Great Adventure which is to be her first screen appearance after a

BEAUTY WINNERS—Gwen Munro and Brian Norman, Australia, are among the winners of an international beauty contest who will appear in Search for Beauty

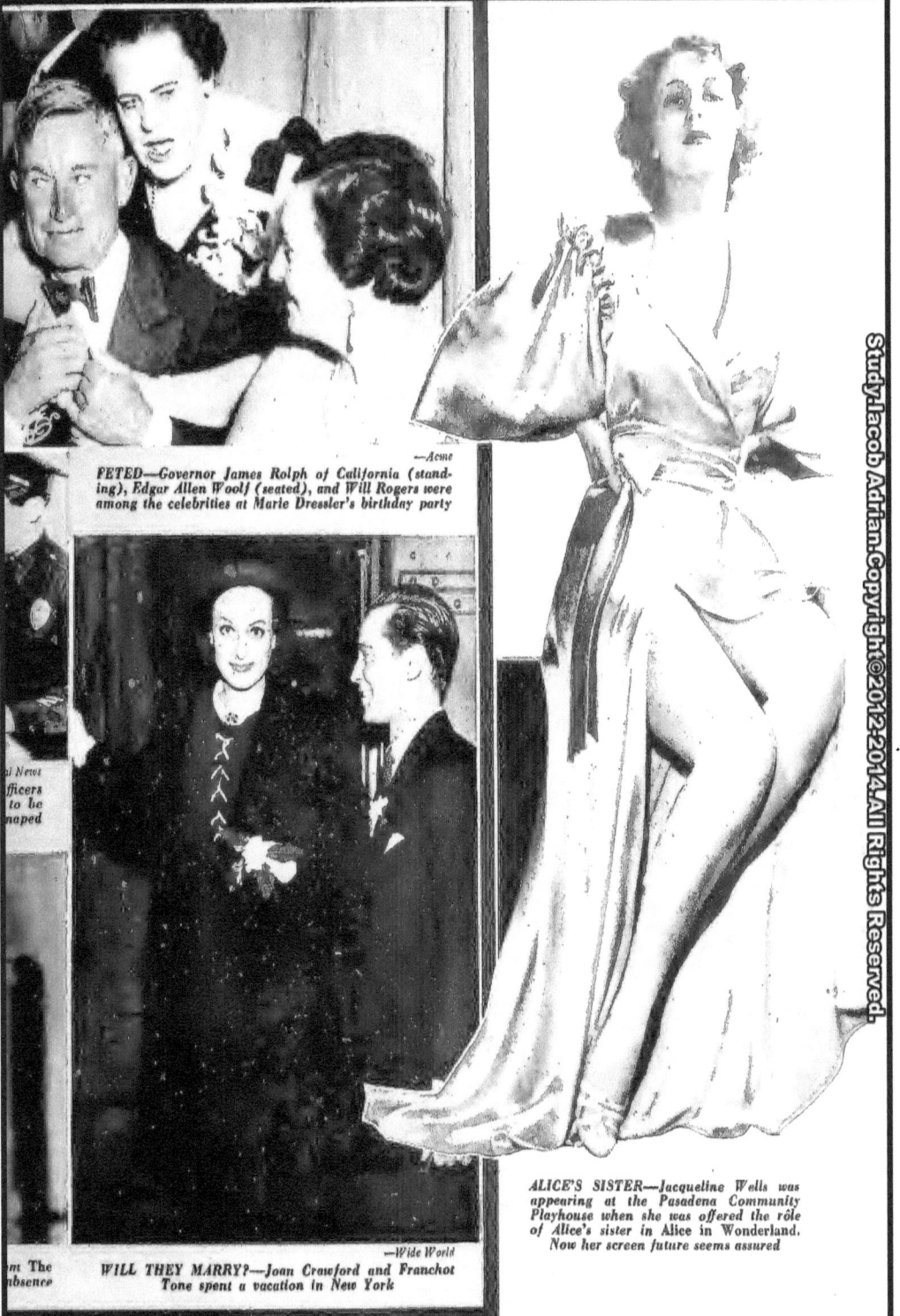

FETED—Governor James Rolph of California (standing), Edgar Allen Woolf (seated), and Will Rogers were among the celebrities at Marie Dressler's birthday party

WILL THEY MARRY?—Joan Crawford and Franchot Tone spent a vacation in New York

ALICE'S SISTER—Jacqueline Wells was appearing at the Pasadena Community Playhouse when she was offered the rôle of Alice's sister in Alice in Wonderland. Now her screen future seems assured

FEBRUARY, 1934

JOAN'S OWN BEAUTY TRICKS

by MAX FACTOR

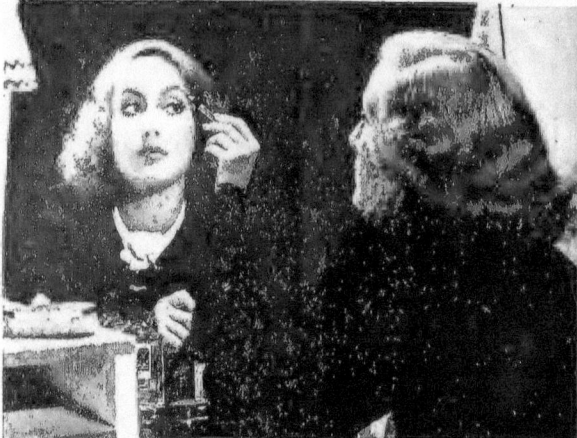

—*Clarence Sinclair Bull*

Joan Crawford now pencils her eyebrows in their natural arch. That arch and the backward sweep of her hair off her forehead lend a serenity in impressive contrast to the intensity of her eyes and drama of her mouth

A famous makeup expert reveals the beauty secrets that helped Joan Crawford win fame

JOAN CRAWFORD has travelled a long way up the path to beauty. She didn't arrive suddenly at the goal where she is today. Not by any means! I've watched Joan struggle and work and strive for it with all that splendid energy of hers. To me, it is one of the most inspiring "success" stories ever to come out of Hollywood, because it shows just what a girl *can* do when she sets her mind to it.

You may not be favored with a charming nose like Joan's. You may not have her eyes. But you've got *something*. Everyone is born with a certain accented feature and it's by making the most of it that you become attractive and distinctive.

Do you think, for instance, that Joan admired her really wide shoulders? She did not! She used to wear her sleeves set extra high to make her shoulders seem narrower and many a time I used to tease her about the thickness with which she applied her foundation cream. "But Mr. Factor," she'd protest, "I've got to hide those freckles!"

Today she has learned that by emphasizing the width of her shoulders, her body assumes more graceful proportions.

● Joan has come a long way since those days in 1925 when Hollywood first knew her. They say the secret of progress is change. And how the lovely Crawford has changed!

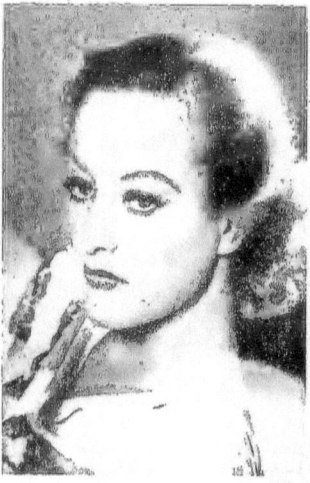

You can transform yourself, by following the hints given here, as Joan Crawford transformed herself into one of the most glamorous beauties of the screen

She has been a blonde, golden red-head and brunette. From a chubby, round-eyed ingenue she has turned into a slender, dazzling beauty. The chubbiness was due to what is termed "baby fat" so don't worry, you girls of eighteen or twenty, because you're overly plump. Don't eat quite so many sweets and pastries and leave the real thinning-out process to nature. The rest Joan accomplished by experiment and patience. Where she had laid too much stress on every feature before—too much rouge, lipstick applied too heavily, eyebrows too sharply defined—she learned the technique of *artistic emphasis*. That is, playing up one or two features. Dramatizing them.

That is the most important step in make-up. And incidentally, it is the real secret of Joan's unique fascination.

Her eyes were once merely a pretty blue. Today she has made them the focal point in her face. Wonderfully large. Mysterious. They fairly speak, those eyes of Joan's.

First of all, the whites are remarkably clear. That comes from just one thing—good health. Enough sleep. *And no hard rubbing.* People have a habit of rubbing their eyes when they're sleepy at night and when they first wake in the morning. It's one of the worst things you can do. Joan also makes a point of keeping her eyes clean—of washing them twice a day in a mild boric acid solution. There's nothing like a thorough cleansing to give them sparkle. And nothing like correctly shaded eye-shadow to give them depth! Joan uses gray, a new soft tone that is undetectable. She deepens it on the eye-lid and blends it off towards the outer edge. She uses eye-lash make-up to give the eyes that very open look. You see, when she raises them they seem to widen the eyes even more that way.

But don't do this if you have really round eyes. The thing to do in that case is to extend the upper and lower lids at the outer corner of the eye with an eyebrow pencil so that the eye appears more almond-shaped.

● Here's another trick the stars have of making their eyes seem larger. They hold their heads down and look up at you to accent the whites of the eyes. There's some-

Enjoys Travelogues

A WORD OF PRAISE for the entertaining and instructive travel-talks that are appearing more and more frequently in current picture programs. Every one of them so far has proven thoroughly enjoyable and I hope that the time is near when we can anticipate a travelogue as a regular part of each program just as we have learned to expect a newsreel.
LOLA ARGO,
R. R. 1, Dixie Highway, Shively, Ky.

Spunky Clara

WHY don't we see more of Clara Bow? She is one of the greatest actresses on the screen if she could just get a good break once. Grand in *Hoopla*, she's my favorite actress and will continue to be. She has a lot of spunk—just what it takes to come back.
NELLIE WHITE,
White Sulphur Springs, W. Va.

No More Mush!

PRODUCERS AND screen writers seem to think we kids enjoy mushy love songs and pictures. We want film entertainment featuring kids between fourteen and seventeen. Hollywood has lots of this talent. Let's see more of it.
BETTY ALLEN,
1549 Farwell Ave., Chicago, Ill.

Versatile Lewis Stone

LEWIS STONE has the finish of George Arliss, the poise of Clive Brook and the character ability of Charles Laughton. He is being kept in the background entirely too much. It's high time that somebody recognized that Lewis Stone is a star.
MRS. ELLEN M. GAULT,
367 E. Black St., Rock Hill, S. C.

Reason Enough

CAVALCADE, Tug-Boat Annie, This Living Age, She Done Him Wrong, Lady For a Day, The Bowery and Little Women are just a few good reasons why America spends its evenings at the movies. Old stars like Marie Dressler and Wallace Beery and new ones like Mae West and Katharine Hepburn are reasons enough for us to expect great things from our movies this year.
MARY JORDAN,
800 N. Mansfield Ave., Hollywood, Calif.

Magnetic Joan

TOO bad we haven't more actresses like Joan Crawford! Her vibrant energy seems to transfer itself to you as you watch her on the screen. She makes you feel alive and is a good example of what hard work and determination will get you.
MAXINE H. HOAG,
92 Elba St., Rochester, N. Y.

Wants Return of Seventh Heaven

THANKS TO HOLLYWOOD Magazine for giving us fans more space to voice our opinions. I hope producers will see this letter and bring back *Seventh Heaven* (which I missed) as a talkie with Janet Gaynor and Charles Farrell.
JACK GAYDOS,
1525 Winnemac Ave., Chicago, Ill.

Nope—Just An Old Custom

IS IT against the law to print a book, newspaper or magazine without two or three "rare portraits of Garbo?" If not, please give another face a chance.
LLOYD AUSTIN,
3908A Clayton Ave., St. Louis, Mo.

Typical American Girl

FRANCES DEE strikes me as the typical American girl. Clean-cut, lovely, frank—and what an actress! In such productions as *The Silver Cord* and *Little Women* she has shown outstanding talent and a deep and thorough understanding of her rôles. I predict that she will reach starring heights in 1934.
ROSE ELEANOR LEFCO,
916 N. Hawthorne Road,
Winston-Salem, N. C.

No Nudes Is Good News

LET me protest strongly against the idea propounded by Jay Brien Chapman in his article "Undraped Movies." Aren't they sufficiently undraped the way they are now? Further, I think most of my favorite stars would lose their charm and personality if they were exposed in the nude.
Such a daring venture would draw crowds to the theatre for a time, then their curiosity would abate and they would clamor for the stylish wardrobes these stars now exhibit. All things considered, our stars are prettier in their charm-suggesting fashions than they would be "in the raw."
OLIVIER LEFEBVRE,
3859 Claude St., Montreal, Canada.

Peggy deserves a break

More Power to Peggy

PEGGY SHANNON'S marvelous work in *Society Girl* deserves a reward. The rôles she has had in her latest pictures have not been worthy of her but they have shown that she has that certain something which all great stars have. May she attain to those heights for which she has so valiantly struggled and which she is so capable of reaching!
($5.00 Letter)
FLOYD WHITE,
209 Pacific Ave., Toronto, Ont., Canada.

Joan's Beauty Tricks

thing strongly appealing about that look. A side glance from half-closed eyes can be extremely alluring. But there's more to that wide-open, straight-forward look of Joan's than to all the siren glances in the world.

Of late she's been delicately penciling her eyebrows in their natural arch. No more angles. That arch and the backward sweep of her hair off her forehead lend her a certain serenity that is in impressive contrast to the intensity of her eyes and the drama of her mouth.

It is that which has given Joan Crawford new glamour.

"My career," Joan said to me once, "has taught me that *correct make-up* is one of the most important factors in a woman's life story. I've learned that by a periodic altering of the method of make-up you can change your whole appearance. The chief thing to remember is to use reliable cosmetics and *those that are natural to you.*

"For instance, I hated being a blonde. Do you know, Mr. Factor, I wouldn't look in the mirror when my hair was light! I did it simply for the cameraman's sake but I never felt quite myself. It's funny to see a stranger looking back at you from the glass. When my hair was red it made me feel rather dashing and different. But oh, I'm so glad to have my original chestnut brown hair back again! Actresses sometimes have to change the shade of their hair for a rôle but I'd advise anyone else not to do it!"

JOAN HAS LIKEWISE discovered how essential a clear, smooth skin is for beauty. And to have that kind of skin one must keep it clean and supple! Joan does this with two special creams—I'll give you the names if you write for them. Her particular little trick is to remove the cleansing cream with cotton dampened in hot water in place of the ordinary tissues.

Joan doesn't depend on creams alone to keep her beautiful skin. She has found out that one must have active blood circulation. To achieve this end she doesn't exercise, but she does believe in dancing.

"You don't have to be a real dancer to get the good out of it. You don't have to take lessons. But to any woman who feels she's getting listless and heavy and in a rut I'd say, dance! Roll up the rugs in your room, turn on the radio and do any steps the music suggests.

"Let me tell you something. The other night I went home from the studio terribly tired and, as is usually the case when vitality is low, I was depressed. Instead of lying down, I put on a record on the victrola and started dancing all by myself. Instantly, the outer world ceased to exist. If you let yourself go, you relax perfectly—and doctors say that's the first aid to physical perfection. I know that in a half hour I was a new person.

"I honestly think the habit of daily dancing plus a grand new make-up could change a girl's whole life! Try getting by yourself in an airy room and swinging your arms and kicking to your heart's content. Then go to your mirror. Begin making a fascinating new face for yourself with colors that work into your very own coloring—and see what happens!"

APRIL, 1934

out with Russell Gleason ... the Don Alvarado-Marilyn Miller romance is colder than an Arctic night ... and it's a famous tennis player who now draws the dancer's smiles ... Rochelle Hudson gets three-page telegrams from Barry Trivers ... Director W. S. Van Dyke used to play the field, but now he has eyes only for Muriel Evans ... Mitzi Green is growing up ... at least, she dines and dances with Junior Durkin sans chaperon ... Sally O'Neil airwayed it to New York to see Tommy Guinan ... and don't be too surprised if you hear of their marriage ... Lois January and Freddie Harris are carrying on ... Russ Columbo continues to keep Sally Blane supplied with orchids ... and there's no let-up in the Spencer Tracy-Loretta Young affair ... Lillian Bond seems to have a strangle hold on Sidney Smith, who used to belong to Lily Damita ... the Jack LaRue-Ida Lupino fire has been extinguished, and Margaret Lucille again decorates Jack's arm at social functions ... Muriel Kirkland and Leeward Meeker are gazing at each other across night club tables ... Gloria Shea has an impetuous swain who serenades her at 5 A. M., much to the discomfiture of neighbors trying to grab a bit of slumber ... Irene Lee and Frank Davis are that way ... Diana Wynyard and Gordon Westcott weren't glowing in a romantic way, but there's a certain brunette who seems to interest Gordon ... just in case Diana cares ...

In *Catherine the Great*, young Fairbanks completely spanned the gap between leading man and stellar roles.

A Smile Her Reply

JOAN CRAWFORD floats her sweetest smile when queried as to the date of her marriage to Franchot Tone, who again will play opposite her in *Pretty Sadie McKee*. Unlike her ex-mate, Crawford just isn't admitting anything.

But those of us who know the real Joan doubt that she will permit Doug to reach the altar first. In fact, there are some who are wagering Joan and Franchot will visit Yuma or some other Arizona or Nevada town the minute that Los Angeles judge scribbles his name on her final decree.

Won By an Orchid

WHAT WAS FOR months and months the hottest romance in this man's town has now cooled to the tepid state, with every indication that Cupid will cart it off to the ice box. Lola Lane and Al Hall originally set January as the month for their nuptials, then the date was moved back to February, and now—well, Lola and Al agree that there's nothing definite.

The other day I saw Lew Ayres' ex-wife lunching with Sally Eilers and Mrs. Al Rogell, with Lola proudly exhibiting a whole hothouse of orchids.

And they weren't sent by Al Hall, either!

Molly is Puzzled

IT WAS only a few years ago that Molly O'Day, sister of Sally O'Neil, dropped from the cinematic horizon because of excess weight after doing a magnificent portrayal opposite Richard Barthelmess in *The Patent Leather Kid*. In other words, Molly was fat—FAT—and just couldn't seem to reduce. Casting office doors slammed in her face just as she stood on the brink of stardom.

A hundred male eyes glanced up from luncheon tables in the Brown Derby the other day when a lovely, slim girl breezed into the eatery. Suddenly, the air was alive with news that Molly O'Day was back, thirty pounds thinner. And while the weight was disappearing, Molly gained two inches in height. It's all a mystery to Molly!

Kay Steps Out

THE GOSSIPS are trying hard to frame a romance between Kay Francis and Maurice Chevalier, basing their whisperings on the fact that they have been seen together frequently since Kay returned from the Eastern trip that resulted in the collapse of her marriage to Kenneth MacKenna.

Maurice, however, is not without a rival for Kay's companionship. None other than Count Alfredo Carpegna provides the fly in the Frenchman's ointment.

In her action for divorce, filed in Los Angeles, Kay charged MacKenna with having criticized her clothes.

Sally's Heart Throb

SALLY RAND, the little girl who started life with an ambition to be a missionary among the heathens and who ended up by electrifying the world with her fan dance, has been engaged to Charles Mayon, a vaudeville actor, for four years.

Sally's secret might have remained locked in her heart until their wedding, planned for the coming Fall, had not "Chizzy" as she calls her fiancé, fallen victim to a serious stomach ailment. When Mayon was sent to a Hollywood hospital, Sally went along, and for five weeks occupied an adjoining room that she might be near him.

When he was stricken, Mayon was serving as assistant to LeRoy Prinz, Paramount's dance director.

It's the New Deal!

MAYBE THE CHANGED political and economic set-up of the nation is responsible, or perhaps it's just because the gals have wearied of that constant round of cocktail parties and dinner dances, but whatever the cause, there's a heavy rush of débutantes into talkie extra ranks these days.

Winnie Flint, daughter of Amos P. Flint, wealthy president of the Corn Products Corporation, is the newest recruit, having deserted her seat among Chicago's élite for a berth as a Paramount chorus girl.

Oh, to be a cowboy if the cowgirls are like Iris Shunn as she appears in Stand Up and Cheer

HARRY SHOOTING

by Harry Carr

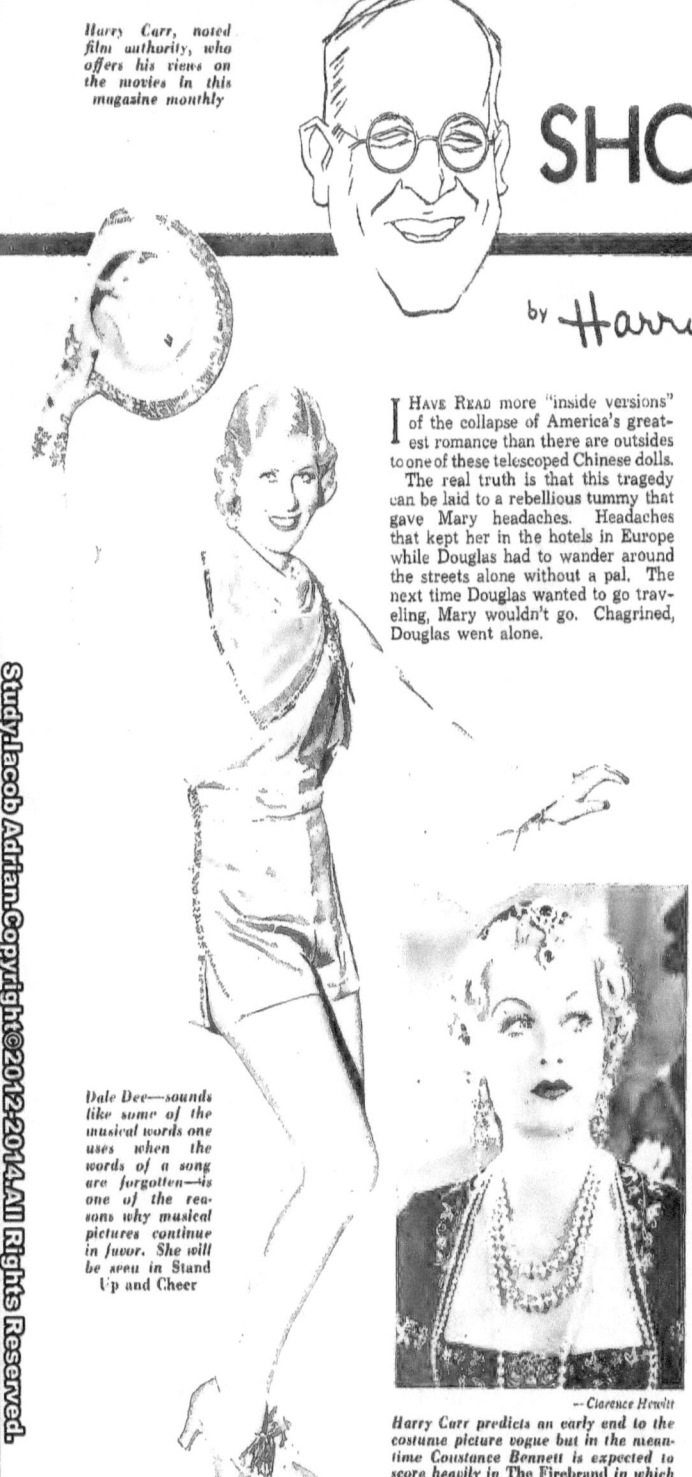

Harry Carr, noted film authority, who offers his views on the movies in this magazine monthly

Dale Dee—sounds like some of the musical words one uses when the words of a song are forgotten—is one of the reasons why musical pictures continue in favor. She will be seen in Stand Up and Cheer

—*Clarence Hewitt*

Harry Carr predicts an early end to the costume picture vogue but in the meantime Constance Bennett is expected to score heavily in The Firebrand in which she is appearing with Fredric March for Twentieth Century

I HAVE READ more "inside versions" of the collapse of America's greatest romance than there are outsides to one of these telescoped Chinese dolls.

The real truth is that this tragedy can be laid to a rebellious tummy that gave Mary headaches. Headaches that kept her in the hotels in Europe while Douglas had to wander around the streets alone without a pal. The next time Douglas wanted to go traveling, Mary wouldn't go. Chagrined, Douglas went alone.

Mary, equally chagrined that he would go without her, began going to parties in Hollywood for the first time in her life. Safety first, she picked out as an escort, young Buddy Rogers—too young, she thought, to make gossip; but that showed how much Mary knew about gossip. From then on ... Oh! Oh!

When Doug Comes Home

DOUGLAS is coming home again. He has no intention of living in Europe—despite all reports.

His friends out here have a plan that they hope he will follow; and I hope so too as it might save him. They want him to throw open his ranch in the San Dieguito Valley—half way to San Diego—for a big, three-day old-fashioned California barbecue; invite in all the neighbors and have some of his old roughneck pals like Jack Dempsey and Bull Montana as co-hosts. And see to it that not a single lord, duke, emperor or king is invited.

Douglas' friends have a funny defense against this snob stuff that has brought him so much grief. They say he seldom invited them; they just walked in; moved up a chair and began to eat.

Stop Press Bulletin

THE MOST exciting information I have received for some time is that Joan Crawford's mad moment—Franchot Tone—has eye brows that curl two ways at once. At the moment, I can't think of anything that can be done about it.

The truth is however—in spite of silly stories—Tone is a Cornell graduate and quite a boy. He says, among other things, that he is tired of continually being labeled a "gentleman."

John Barrymore

NEXT to myself, John Barrymore has the most violent case of Mexican fever I know of. We have become such a bore to our friends that John has invited me to go down on his yacht to Guaymas on the West Coast where we can sink ourselves in hot chili and Mexican music. Acting has become for John

When you read this amazing interview Joan Crawford may be Franchot Tone's bride, but her views on marriage will not have changed!—The Editors

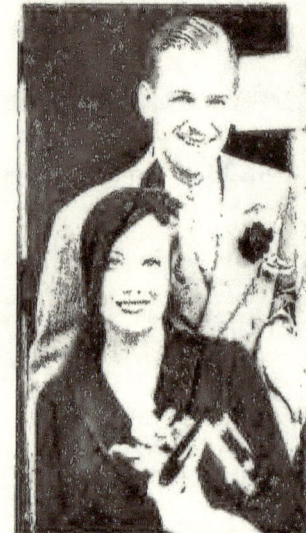

With her divorce in April Joan Crawford lost more than her right to be Mrs. Douglas Fairbanks, Jr. It was the end of a dream for her. Joan is finished with girlhood fancies that included "Dodos" and mystic baby talk and a great deal of sweet nothingness

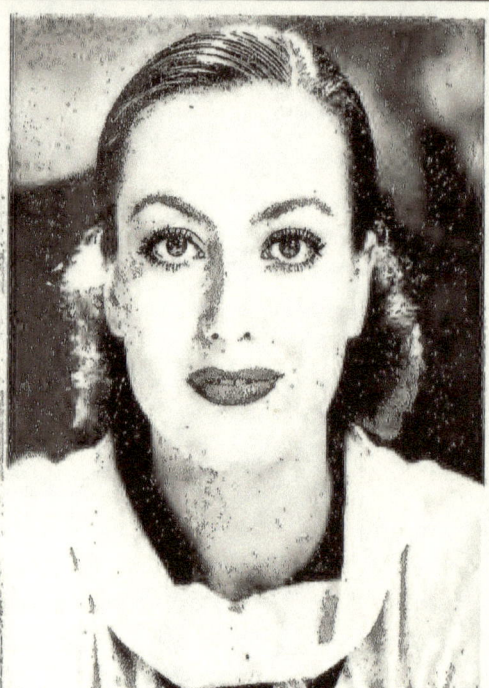

"I DON'T WANT TO

"**M**ARRY? I NEVER want to marry again! *Never, never* . . ." Joan Crawford saying that! The words were a bombshell smashing the serenity of that spring afternoon. Shadows of the girl Joan! That eager-eyed young thing who made romantic history in Hollywood. Who once prepared the very house we were sitting in then as a sort of shrine, a honeymoon home.

For years I've known Joan for the warm-hearted brilliant woman that she is, almost tyrannically honest with herself. I have seen her in many moods. But the picture that will live on with me is of Joan as she sat there, tense, palely beautiful, and told me: "I don't believe in marriage —for myself. Some people are suited to it. Others are not. I'm one of the 'others.' . . .

"I tell you, Michael, two people can go into it with all the ideals in the world—and in a year, no matter what they do, it's just commonplace. A noose in which they're both caught." Her eyes went dark. "Maybe it's because they are so conscious of that word *marriage*. It's a handicap because it implies subjection. You see, freedom is so essential to love. You can't bind it or force it in any certain direction. That is what a couple try to do as a rule. . . . Oh, I'm not a good person to talk about marriage!"

And this, while the world waited for the wedding bells to ring out for her and Franchot Tone! Had Joan done another right-about-face? And then suddenly I understood. With her divorce in April she lost more than her right to be Mrs. Douglas Fairbanks, Jr. It was the end of a dream for her. Joan is definitely finished with girlhood fancies that included "Dodos" and mystic baby talk and a great deal of sweet nothingness. She is ready for a rich, mature romance. But the Joan of today will never let it sink into a cut-and-dried marriage in the ordinary, restricted sense.

● Mrs. Fairbanks, Jr., was fiercely possessive. She wanted every waking thought of Doug's, because he had *her's*. She waited on him, mothered him, insisted that he eat the right foods, lavished her love on him. Mrs. Tone—if she ever does assume that title—will make none of these mistakes. She will be frankly a sweetheart, lastly a wife.

Joan Fairbanks worked at marriage.

Joan Tone would work to forget it. She would do everything in her power to keep the marital knot loose enough to prevent it from spoiling the dream.

"I'll tell you something else I don't believe in, Michael," she went on intently. "*I don't believe in the shop-worn, everyday emotion that passes for love.* It lets you down so. It fades before you realize it—and there's nothing left but emptiness. Sometimes bitterness.

"The kind of love I *do* believe in—well, I wonder if I dare hope to find it! I know it must exist—somewhere —or the poets would not have glorified it. Sometimes you catch a glimpse of it in beautiful music or in a sunset.

"It's strange. There seem to be two things warring inside of me all the time. One wanting that kind of love. The other doubting that I'll ever get it. But I just go on dreamin'. I have a good time."

She tried to speak lightly but it was apparent this was by no means a light matter to Joan. Love has betrayed her

Joan Crawford bares her soul in her most revealing, most fascinating interview!

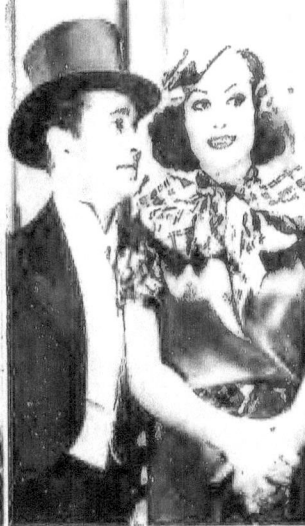

If Franchot Tone and Joan Crawford marry, she will make none of the mistakes of the past. Joan Fairbanks worked at marriage. Joan Tone would work to forget it. If she becomes Mrs. Tone she will be frankly a sweetheart — lastly a wife

MARRY"

Joan Crawford

by MICHAEL PETERS

too often. She has lost confidence in it. *She is afraid.* Afraid of letting herself go and feeling too intensely about it again.

● "Hollywood can ruin any romance," she says, dismissing all those ardent young hopes with a single gesture. No regrets for her. *Never go back.* That's her theory.

"What's the use? It doesn't do any good to retrace your steps—yet women are always doing that. They can't seem to go on from where they leave off. And pretty soon they begin to pity themselves so much they feel like martyrs! Let me tell you something I've found out—the easiest way to spoil your whole life is by being sorry for yourself. *Self-pity.* Heavens, how I hate it! I've seen too much of it. The more I study it, the more I loathe it—worse than ten thousand cobras!"

No, Joan will never waste sympathy on Joan nor write any epitaphs for lost love! She has become too wise—and too wary.

"You know, I can understand why a man would strike a woman who mopes." She reached for a cigarette and tapped it thoughtfully. "Let her go out and walk it off. There's enough unhappiness and gloom in the world as it is. You know what I do when I flare up? I go to my room and work it out by myself. If it was a temperamental gesture on my part, I apologize. If it wasn't—well, I don't believe in suppressing the temper when it's justly aroused!" Her laugh rang out, enthusiastic, young.

She never ceases to surprise me, this Joan. She has such a direct, masculine way of looking at things. Her interests are so apart from those of most women. Perhaps that is why she has not one intimate friend among them. Small talk, bridge luncheons and teas—and feminine pettiness. She has about as much use for them as a camel in her yard. You won't find any ribboned frills or fancy jewelry or lacey frou-frous in Joan's life. She has never had time for them. A girl who fights her way up from being a kitchen slavey to a first lady of the screen has to drive clean and hard. She stands stripped of superficialities.

● And yet—she's the most completely devastating feminine person I know. Deeply, vibrantly feminine. As, for instance—

"Right now there's nothing I'd like quite so much as a baby. I would rather have one than a husband! Provided, of course, I could find one with a good background and parentage. My sister-in-law recently gave birth to a little daughter. I would adopt it right away if she and my brother would let me! The baby is already named Joan Crawford. It's so adorable and tiny."

Here would be an Unknown Love for Joan. Something she has never experienced before. It would be a love into which she could pour her fervent, eager, young heart without fear of having it hurt. And she is at an age when she needs to do just that. Joan is twenty-five. Without doubt she is facing a crisis. Emotional rather than professional. And she is wondering, this woman-Joan, what lies beyond. "Work," she told me, "is just as important as

"I Don't Want to Marry"

love. Up until the time I started *Sadie McKee* I hadn't worked for four months and I was nearly crazy! You can give everything you have to work without fear of any rebounds." That quirk to Joan's lips; that knowing twinkle in her eye!

"You know what I did all that time after I came back from New York? I shut myself up in the house for weeks and read, read, read. Sometimes I went for long walks with the dogs. With 'Poopshun,' that's Franchot's dachshund —and 'Baby'—that's mine. Yes, and I had singing lessons every day too. For two hours. I'd come down in the morning feeling pretty dull and ten minutes after I had begun to sing I could have licked the world! My range? Three octaves. Very low C to high C. I used to think singing lessons would raise my speaking voice—and I can't stand hysterical, high-pitched voices. But—well, I've learned to use my chest tones!

"Professor Morando says Franchot is a second Pinza. I got him to sing too and he has a magnificent basso." There was swift pride in her voice.

We listened to her *Merry Widow* records, to her soft crooning numbers. They had a rich, warm ring that augurs well for the Crawford concerts of the future.

"But I'm Tired of hearing about my 'burning ambition'," she shrugged. "Good grief, Michael, we all must have some or we would not get anywhere. The writers seem to be afraid it might consume me. It won't! All I want to do is work. I'd like to get more comedy into my portrayals." Here was something new for Joan! Then I remembered: Comedy is the one respite when things get a little too much on the serious side. Drama is all right as long as life and love are aglow.

"The biggest thrill I've had in years," she was saying, "was that night of the preview of *Dancing Lady*. You know that scene where Clark Gable spanked me and I said 'Thank you?' The first time we did it I said that unconsciously and the director asked me to leave it in. At the preview *they laughed!* That's the first time an audience has ever laughed at me that way. I can't tell you what it did to me. I wanted to get up and cheer. I whispered to Franchot over and over again, 'They laughed!'"

Franchot . . . Franchot!

Will she find with him what she is seeking? I don't think she herself knows the answer. She is still too skeptical. Still a little too hurt.

Outside, the small theatre she is building in which she and Tone will co-star, was nearing completion. Overhead, carpenters pounded a sharp obbligato to our talk. Changing Joan's "honeymoon house" again. The house of the young star who "just goes on dreamin'."

McLaglen a Colonel

Victor McLaglen, who has been a soldier since he was fourteen, is the new colonel in command of the California Light Horse, crack cavalry outfit. Vic's brother, Cyril, is a lieutenant in the regiment.

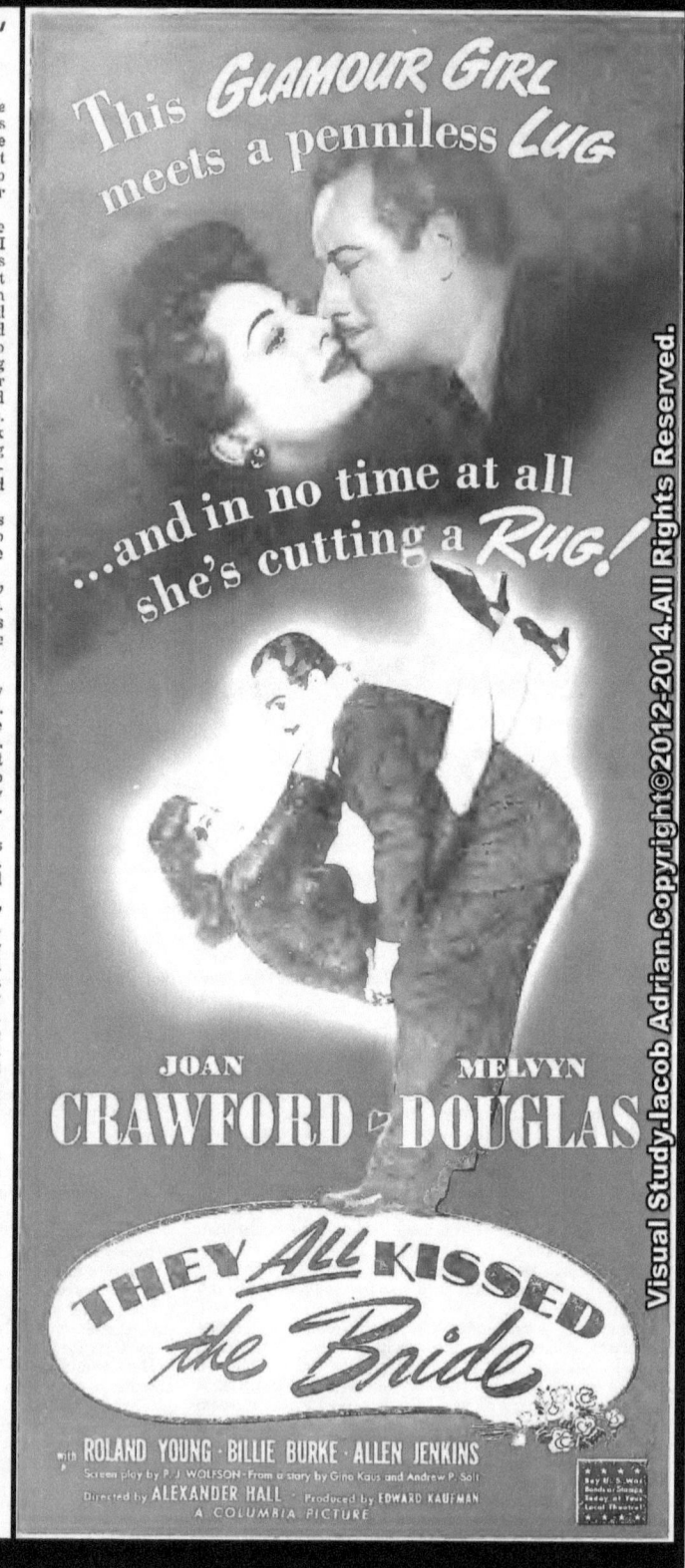

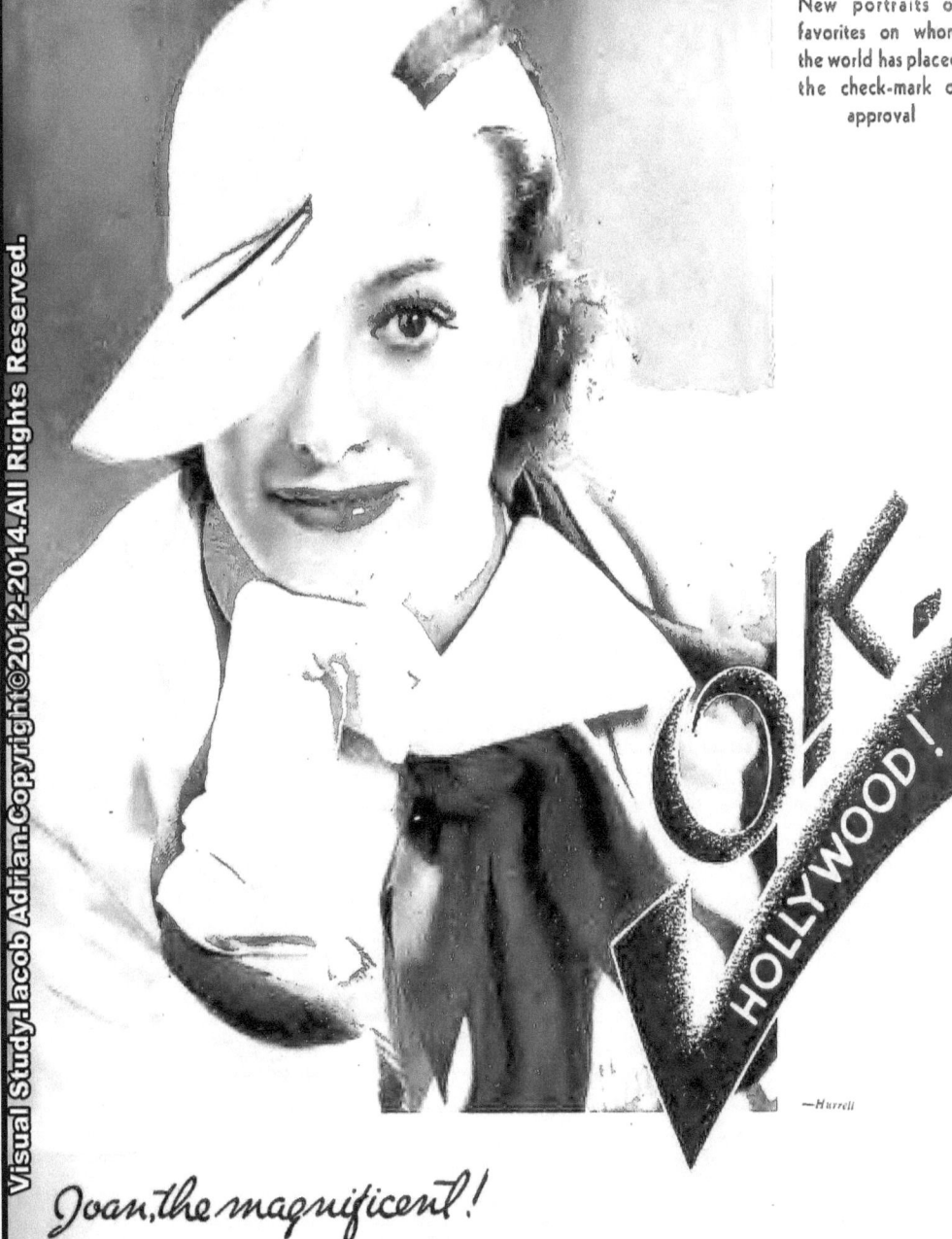

New portraits of favorites on whom the world has placed the check-mark of approval

—Hurrell

Joan, the magnificent!

● From dancing girl to sedate lady of the drama, the legions of fans have staunchly supported gay, sophisticated Joan Crawford. Perhaps the career of no star in Hollywood has been more colorful, more interesting than that of this fascinating, glamorous girl. Following completion of *Sadie McKee*, another great triumph for her, she started work on *Sacred and Profane Love*

AN OPEN LETTER TO JOAN CRAWFORD

J. Eugene Chrisman speaks to Joan on behalf of her fans! Watch for her reply next month

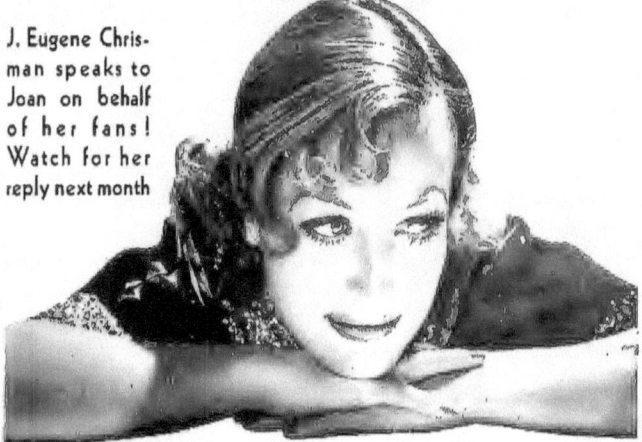

An Open Letter To Joan Crawford

Dear Joan,

THE GOSSIPS are at it again. They just won't let you alone, will they Joan? I remember when they were calling you a hey-hey girl whose only ambition was to make whoopee and win dancing cups. They said that you couldn't go far on the screen because you were too flighty and too intent on having fun. But you fooled them. I also remember what they said when you married Douglas. You were a social climber then, an obscure girl who had tossed your loop around the neck of the Crown Prince of Picturedom to advance your own social position and your career. Then again, when you divorced Douglas, the harpies of the press pounced upon you again. They have always pounced upon you Joan and now they are descending again.

They are printing stories that you have gone *arty*. They are saying that you are no longer the old down-to-earth Joan and that you want to be another Dusé. They are saying that you have gone high-brow and that Franchot Tone, Frances Lederer and others are a bad influence in your life. They are laughing at your ambitions for the stage and tossing brickbats through the windows of your Little Theatre. They are saying that you are foolishly jealous of Franchot, that you deeply resented his love scenes with Jean Harlow and with Madeleine Carroll. They have criticized the manner in which you have been using your lip stick and all in all Joan, they have been picking you pretty well to pieces.

All of which wouldn't matter, Joan dear, except that your fans are beginning to wonder if these things are true. Letters by the hundreds are coming to my desk. They ask me to tell them the truth. They can't believe these things but they want to know. I'm writing this to ask you if you won't tell them.

● You and I have been friends for a long, long time, Joan. I knew you when you were Lucille LeSeur. I've watched your progress through the years, admired you and respected you more than any other woman I have known. Once you did me a favor about which only you and I and one or two others know for you were never one to make your good deeds public. A great critic recently said, after praising your work in *Sadie McKee*, that you could become the foremost lady of the screen. I agree with him Joan and that's another reason why I'm writing this letter. I don't want you to fail to do it.

But Joan I must scold you a little bit. Recently while talking to a publicity man on the set, you went into a tantrum about these things which the gossips are printing about you. You said that because you study music they charge that you are forsaking the common things. Because you read good books they scream that you are taking on culture and because you built a Little Theatre that you are going in for long-haired theatricalism. You resented their criticisms of your make-up and the way you outline your lips, saying that it is your face

Please turn to page fifty

and your lips and that you will do what you please with them.

But Joan, is it your face and are they your lips? Can you afford to wear make-up which the fans do not like and outline your lips in a manner which they resent? No, Joan, you can't. You are the Joan Crawford you are today because you incited the love and admiration of millions of men and women, boys and girls. As long as you intend to appear on the screen and as long as you wish to hold their affections, you must be the Joan Crawford *they* want. Don't you see, Joan dear, what I mean? You no longer belong to yourself but to the millions of fans who love you.

There are many great personalities on the screen, Joan, but few great actors and actresses. You are both. There is not a man, woman or child in America who does not admire you for the things you have accomplished in the development of your personality and your career.

I DO NOT BLAME you for carping at the gossips but remember that your fans do not know you as I know you. They only know what they read in their newspapers and their magazines. Please, Joan, give them your side of the story in your own frank way. They'll believe you, no matter what you say.

Go on, Joan, with your books, your music and your languages. Build your Little Theatre and develop your undoubted talent for the stage. Invite only your close friends, if you want to; that is your business and no one else's. Study and learn and become great; your own career is an inspiration to every girl who wants to rise above the common herd. Only, Joan dear, take your fans into your confidence. Tell them what you are trying to do. Sit down with them and let them know the Joan Crawford I know and they'll stick with you until Doomsday. I'm not asking you to defend yourself, because you need no defense. I am asking you to give your fans, firsthand, the *truth*.

The other day on the studio lot, you passed in your open Ford as I came out of one of the stages. At the wheel was Franchot Tone. With that smile of yours which I can never forget, you turned and waved cheerily at me, "Hello, Gene!"

I had not seen you for months but you were the same Joan. That is the Joan I want you to show to your fans. They are beginning to think of you, because of this gossip, as having drawn yourself away from them. They are beginning to picture you cold and aloof when, as a matter of fact, all of the art, all the culture, all the Little Theatres in the world could never make you anything but warm, impulsive, vivid and generous.

I am not asking you to write to your detractors, Joan, I am asking you to write to your fans. Let your critics stew in their own unsavory broth. Speak to them, Joan, these millions who love and admire you and who want the truth as only you can tell it.

Always,

J. Eugene Chrisman

An Open Letter To Joan Crawford

and your lips and that you will do what you please with them.

But Joan, is it your face and are they *your* lips? Can you afford to wear make-up which the fans do not like and out-line your lips in a manner which they resent? No, Joan, you can't. You are the Joan Crawford you are today because you incited the love and admiration of millions of men and women, boys and girls. As long as you intend to appear on the screen and as long as you wish to hold their affections, you must be the Joan Crawford *they* want. Don't you see, Joan dear, what I mean? You no longer belong to yourself but to the millions of fans who love you.

There are many great personalities on the screen, Joan, but few great actors and actresses. You are both. There is not a man, woman or child in America who does not admire you for the things you have accomplished in the development of your personality and your career.

I DO NOT BLAME you for carping at the gossips but remember that your fans do not know you as I know you. They only know what they read in their newspapers and their magazines. Please, Joan, give them your side of the story in your own frank way. They'll believe you, no matter what you say.

Go on, Joan, with your books, your music and your languages. Build your Little Theatre and develop your undoubted talent for the stage. Invite only your close friends, if you want to; that is your business and no one else's. Study and learn and become great; your own career is an inspiration to every girl who wants to rise above the common herd. Only, Joan dear, take your fans into your confidence. Tell them what you are trying to do. Sit down with them and let them know the Joan Crawford I know and they'll stick with you until Doomsday. I'm not asking you to defend yourself, because you need no defense. I am asking you to give your fans, first-hand, the *truth*.

The other day on the studio lot, you passed in your open Ford as I came out of one of the stages. At the wheel was Franchot Tone. With that smile of yours which I can never forget, you turned and waved cheerily at me, "Hello, Gene!"

I had not seen you for months but you were the same Joan. That is the Joan I want you to show to your fans. They are beginning to think of you, because of this gossip, as having drawn yourself away from them. They are beginning to picture you cold and aloof when, as a matter of fact, all of the art, all the culture, all the Little Theatres in the world could never make you anything but warm, impulsive, vivid and generous.

I am not asking you to write to your detractors, Joan, I am asking you to write to your fans. Let your critics stew in their own unsavory broth. Speak to them, Joan, these millions who love and admire you and who want the truth as only you can tell it.

Always,

J. Eugene Chrisman

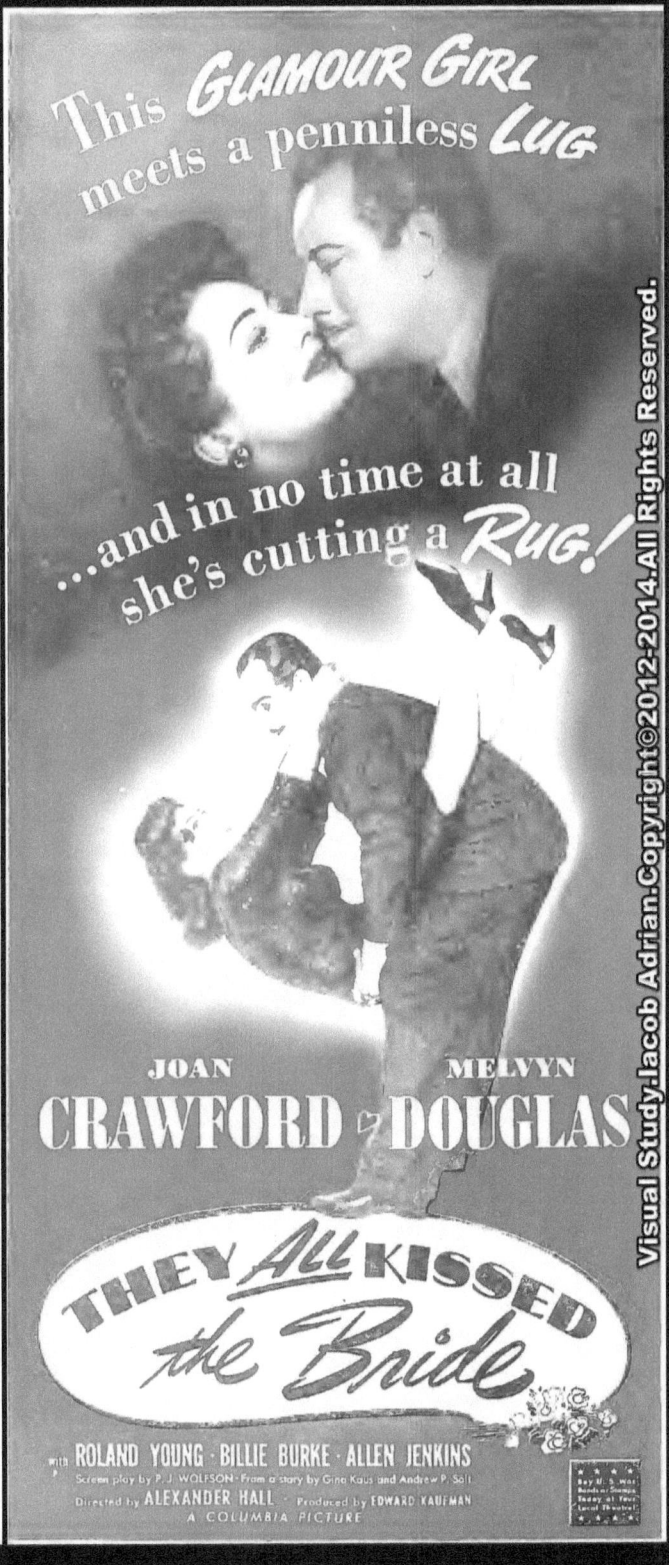

Clark Gable AND Joan Crawford

✦ ✦ ✦ because Clark and Joan thrilled movie fans everywhere with their first co-starring vehicle, *Dancing Lady*; because they're teamed again in another superb picture, *Chained*; and because each represents the ideal of millions of worshippers

AN OPEN LETTER TO LYLE TALBOT

from
J. EUGENE CHRISMAN

Tell us who you're winking at, Lyle Talbot. That is a wink, isn't it?
—Fraker

Perhaps Wynne Gibson will be the girl you choose. Is she the one at whom you're winking?
—MacLean

Dear Lyle:

Hitler and his Charlie Chaplin mustache, the New Deal and other events may hold the world's front pages but the question which is driving the ladies of the nation crazy is:

"Does Lyle Talbot intend to get married and if so, who, when and where?"

It's a serious question to the millions of girls who admire you on the screen, Lyle. They write me by the hundreds wanting to know. You started it all, you know, when you gave out that interview, saying that you wanted to find a bride and now it's up to you to make good or in the dog house you go as far as feminine America is concerned.

It isn't that the girls just want you to get married and out of circulation. It's because they know you are going to be hard to please when it comes to selecting a wife and they want to know who the fortunate girl is going to be. As a matter of fact, I imagine that the tears of the girls who will wish that they might have been Mrs. Lyle Talbot will reach the proportions of ole man river in flood.

I think you are a smart boy, Lyle. Hollywood marriage is no joke. It isn't something to be entered lightly or hurriedly into. You and I have seen too many of them go on the rocks with a dull, sickening thud, almost before the bride's permanent wave had set. Take your time, Lyle, but don't keep us waiting too long. Give us some action.

An Open Letter To Lyle Talbot

repertoire troupes, there were other women, other girls; and since you came to Hollywood, what a swath you have cut. There is hardly an unattached girl in town that you have not squired at some time or other. Once you were quoted as saying that when you did marry, you would marry an actress, a girl of your own profession. Most of those with whom you have associated have been actresses but evidently you are cautious. You want your marriage to LAST and you have seen too much of marriages within the picture profession to take a chance.

I can understand why you want a wife and home, somebody to take the hair out of your comb and find your other bedroom slipper for you. Like myself, you never knew what a real home was, as a kid. We were both tossed from pillar to post and it made us appreciate home life. But you want a real home or you will remain a bachelor. It has its compensations, I'll admit, especially in Hollywood. Most of the marriages one observes here would not inspire a man to risk his freedom.

But you have been going around with some swell girls, Lyle, one of whom should make you a good wife. Let's take a look at some of them and see.

THERE, FOR INSTANCE, is Sally Blane. I don't know Sally but I do know her beautiful sister, Loretta Young, and if I were picking a wife in Hollywood, I wouldn't look much farther than Loretta. Sally must be very much like her, young, beautiful, sweet and talented. I believe that Sally is your favorite just now and I'd give her serious consideration for the job of being Mrs. Lyle Talbot.

Then there is Gail Patrick, another fine girl but of a different type. I don't believe she would be as much of a home girl as would Sally. I believe that Gail's career means much to her. She is tall, statuesque and dark and she has beautiful eyes. But I believe that Gail is ambitious and I think that she would insist upon following her chosen profession. Her ambition is to return to her native state and become governor or governess or whatever it is you call it and I don't think your temperament would care a lot for that.

But what about lovely Jean Muir? You used to see a lot of Jean, didn't you? From Jean's quiet, somewhat wistful face you'd think her an inconspicuous little person, afraid to speak her own mind.

But she isn't. She never hesitates to say what she thinks, to prop boy or executive. Perhaps you'd admire that quality in Mrs. Lyle Talbot, I don't know.

Then there is beautiful and attractive Claire Trevor. A petite blonde with brown eyes that melt a masculine heart. I love to hear her laugh and her voice is one that wouldn't get on a man's nerves when he has his slippers on and his pipe going. She likes to dance and go to the fights, the tennis matches and the hockey games and at the same time, I imagine she could throw together a mean batch of biscuit if she wanted to. You might pause for a moment and review Claire's charms, Lyle, before making your decision.

Of course Alice Faye should be taken into consideration. That combination of German-Irish produces fine wives. She's a friendly little body and could keep up with your kidding and not get peeved; and a kidder like you has to take that into consideration. She came out of the chorus, but remember how many nice wives have. She doesn't like Hollywood very well but perhaps you could make her see it differently. She is just the right size, too, five feet two inches tall, and you'd make a striking couple.

DON'T FORGET WYNNE. Wynne Gibson, I mean. There's a swell gal for you. I spent the afternoon at her beach house, ten miles above Malibu, the other day. Wynne likes solitude and she certainly gets it up there. You never see her at the Hollywood night spots and parties but she has plenty of friends. Wynne is a girl who knows all the answers but she has a heart as big as a bucket and a fellow could be around a girl like her a lot without having a long face. I think she might go out among people more if she had a nice husband, but she wouldn't bore you with it. If you want a real home girl, Wynne is the answer to a home-maker's prayer.

If you can't oblige us with a flying trip to Yuma one of these days soon, please send us a post card. Or better, yet, write and tell us what YOU think about it all. We'll be looking for your reply next month.

Sincerely,

J. Eugene Chrisman

NO ANSWER FROM JOAN

● Busy making "Chained", her new picture with Clark Gable, Joan Crawford put off until "tomorrow" writing her answer to J. Eugene Chrisman's interesting open letter to her, which was published in HOLLYWOOD last month. But "tomorrow" just never came, as is so often the case, and it was with the deepest regret that we were forced to go to press without Joan's letter.—The Editors.

OCTOBER, 1934

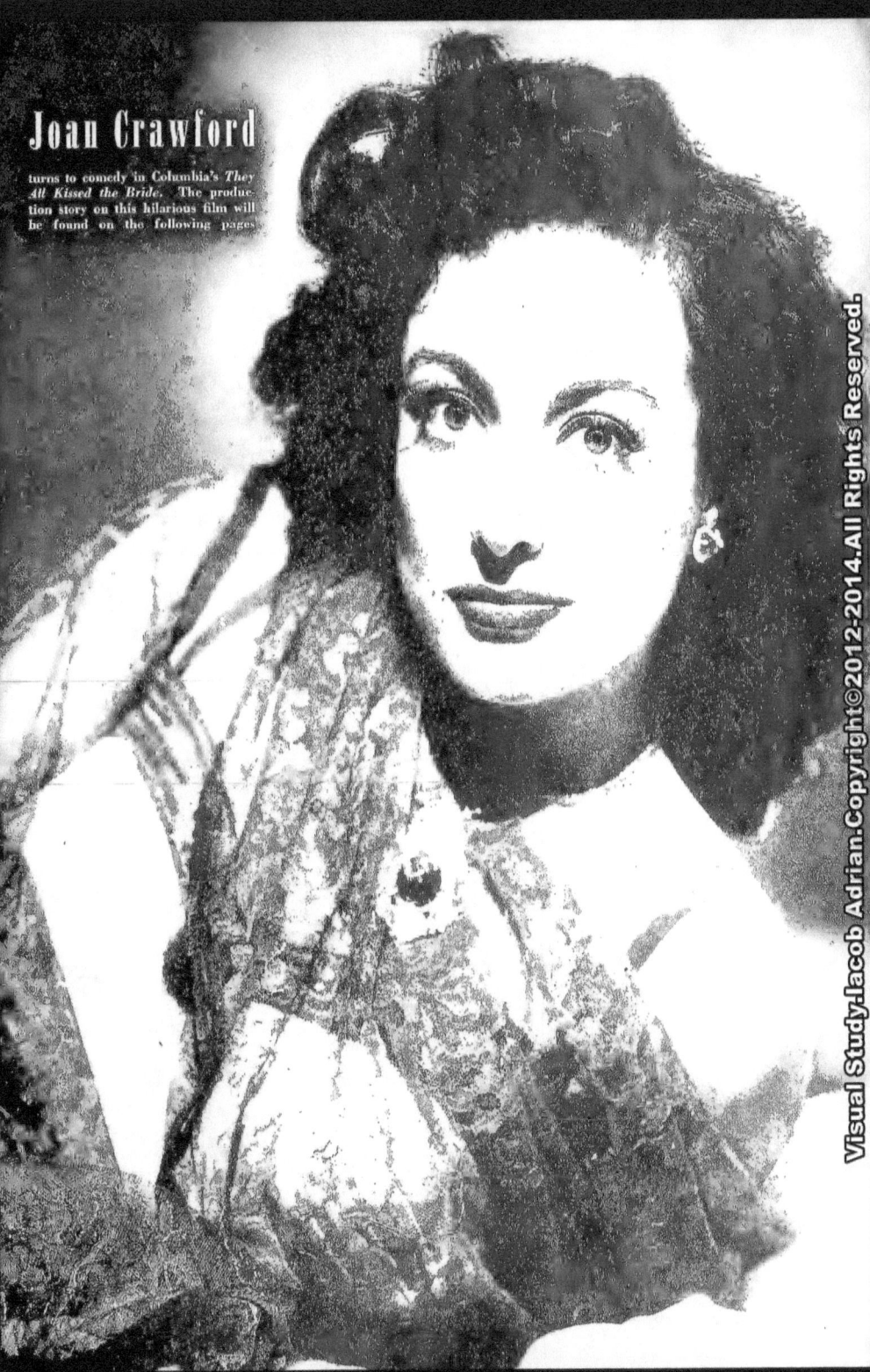

Joan Crawford

turns to comedy in Columbia's *They All Kissed the Bride*. The production story on this hilarious film will be found on the following pages

Santa Checks up on

SANTA CLAUS is nobody's fool. You can bet that against the hankies you think you're going to get for Christmas, because that wise old gent has something up his whiskers besides pine needles and last years' candle drippings. During 1934 he kept a special set of books on the good and bad points of Hollywood stars, so that he can decide just what to leave by the artificial fireplace on Christmas Eve.

But he didn't count on HOLLYWOOD Magazine swiping that ledger out of his igloo, to scoop the stars on what they can expect from Santa this year.

Here you are, you trembling movie actors and actorines! Cast your eyes over Santa's book, and see what he thinks of your doings. And remember, it isn't too late if you see that the bad points outweigh the good ones. So here is the ledger, containing the lowdown by that wily St. Nick who sees all, knows all, and tells everything!

GOOD POINTS	BAD POINTS	GIFTS
BING CROSBY. Now there is a fine lad; hope he continues to be a good boy, and gives us more like *She Loves Me Not*. Add two more good points—the twins. (Give Mrs. Crosby some credit there.)	Got put in the doghouse during the making of *We're Not Dressing* for keeping Director Taurog out all night. He and Carole Lombard tied a rope to the still man's camera and hoisted it to the roof. Makes Paramount worry by putting on weight.	*Triplets!*
CAROLE LOMBARD. Proved she could *act* in *Twentieth Century*. Came back to start *Repeal* like a good trouper, though still suffering from the shock of Russ Colombo's death.	Still cusses when excited. But improving. Gets mad at stupid producers who want her to make stupid pictures, and makes one now and then in spite of herself. Put your foot down, Carole!	*A Real Vacation*
MARLENE DIETRICH. When her studio make-up woman gave a little house-warming, Marlene came to the party and brought a gift. Keeps democratic; always lunches at Paramount cafe with common horde.	Caused great anguish and disappointment on return from Europe with trunks and trunks of gorgeous clothes—and then refused to appear in them, though all Hollywood waited in expectation. The meanie!	*Another Director*
JOAN CRAWFORD. Kept her head and won respect by not rushing into another marriage. Has stuck by her career. Left off that extra splash of lipstick this year. Always gives us good pictures.	Suspicion that she has gone a bit coo-coo on cars. That big white limousine, and now that all white, satin upholstered roadster. Joan! How could you? And that horn can be heard fully three miles!	*A Plain Ford*

Good Boys and Girls

Scoop! Here's a preview of Santa Claus' ledger, where he keeps the records of Hollywood stars, and decides whether or not they deserve a Christmas present

by JOHN WINBURN

GOOD POINTS	BAD POINTS	GIFTS
JEAN HARLOW. Well, you really finished that book, Jean! I like you to stick to things that way. Add good point; not letting personal problems sour her. Made her mother happy with beautiful room in new home. Lifted Bill Powell out of the dumps.	O, hum, with 115 pounds distributed like that, what are Jean's bad points? Hasn't sent the editor a copy of "Today is Tonight," her first book. Maybe he'll find one in his stocking!	A Letter from Every Fan!
CLARK GABLE. For giving us *It Happened One Night*. Being always thoughtful of others. When a friend had no place to keep her dog, he gave it a home on his ranch.	Balks at picture assignments with women stars. Drives studio frantic by disappearing between pictures, when he is wanted for story conferences.	More Dogs to Take Care of
W. C. FIELDS. For the biggest laughs of the year. For feeding that little blind duck on the pond back of his house every morning.	That fight with Baby LeRoy. GIFT: New Rattle	
SHIRLEY TEMPLE. Refuses to be spoiled by compliments. Is Mrs. Santa Claus' favorite actress. Can now spell her name and count. Invited all Hollywood (almost) to her birthday party.	Shirley, you mustn't ask for so much gum—I heard you! After all, Mama isn't *made* of gum! But I guess you've been a very good girl. GIFT: Carton of Gum Please turn to page fifty-six	

It's hard to catch Santa! Shirley Temple planned to wait up for the jolly saint but she just couldn't keep awake

JANUARY, 1935

What's New

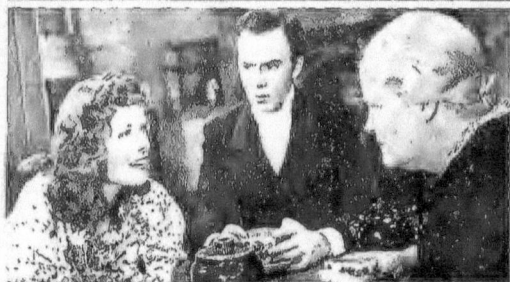

Katharine Hepburn—John Beal—Mary Gordon

The Little Minister

• • • • The classic drama of Sir James Barrie comes to the screen as one of the truly great pictures of the year. Katharine Hepburn is overwhelming with the fire and passion of her perfomance and John Beal in the title role turns in a masterly characterization.

John Beal, a young minister in charge of his first parish, finds his life disturbed when he meets Katharine Hepburn (Babbie) disguised as a gypsy. The conflict between her passionate love and his puritanical scruples makes up the theme of this powerful play.

Lumsden Hare and Alan Hale are excellent and Andy Clyde and Donald Crisp turn in fine performances.—RADIO.

The Mighty Barnum

• • • • Magnificent in conception and excellently screened, this film reveals the genesis of the circus.

The story opens with a flash of a modern circus, then cuts back to 1835 when it shows Wallace Beery as P. T. Barnum dreaming of owning a freak show. His wife Janet Beecher is revolted at the idea. Beery buys a negress supposed to be 106 years old and one time nurse of George Washington, and his career begins. Adolphe Menjou is assistant and guard against alcoholism.

You see Tom Thumb, The Cardiff Giant and all the freaks which made the name of Barnum famous. A great picture with not a dull moment in it.—TWENTIETH CENTURY.

Adolphe Menjou—Wallace Beery

Bing Crosby

W. C. Fields—Baby LeRoy—Kathleen Howard

Guy Kibbee—Aline MacMahon

Here Is My Heart—

• • • • Although he is J. Paul Jones in this play, it is really our old friend Bing Crosby who, after making millions as a radio crooner sets out to fulfill all his ambitions and does so in a thoroughly enjoyable way. This is Bing's finest screen performance to date and the story is packed with laughs. Roland Young, Alison Skipworth and Reginald Owen contribute to the fun as the half-wit family of the fascinating Princess (Kitty Carlisle).—PARAMOUNT.

It's A Gift

• • • This picture is just a series of gags. But what gags! There isn't much to the story, something about a henpecked husband who achieves his desire for a California orange grove through the death of his uncle, but it starts off with a bang and speeds right along through one continuous series of laughs. Fields carries the whole show but the romantic interest is furnished by two newcomers, Julian Madison and Jean Rouverol.—PARAMOUNT.

Babbitt

• • • An excellent screen translation of Sinclair Lewis' epic of the small town business man, although much of the vitriol and satire has been taken out. Babbitt (Guy Kibbee) is the big real estate man of Zenith who through stupidity becomes involved in a shady deal. His wife (Aline McMahon) rescues him and he basks again in the light of his self importance. Kibbee is at his best and Aline MacMahon, Glen Boles and Minna Gombell are excellent.—WARNERS.

Advance information on newest pictures seen at Hollywood previews by our staff of film critics

on the Screen

Forsaking All Others—

●●●● This is the first time W. S. Van Dyke has ever directed Joan Crawford and what a personality his direction makes of her! Clark Gable also responds to the magic of Van Dyke's direction with one of his finest films.

Joan Crawford is the girl and Clark Gable the boy who have known each other from childhood. Joan thinks she loves another boy (Robert Montgomery) but he leaves her flat and marries another girl. She then finds that it has really been Clark whom she loved. Charles Butterworth is great and Frances Drake and Billie Burke excellent. This film has everything, fine performance, grand comedy and dialogue.—METRO.

Robert Montgomery, Joan Crawford, Clark Gable

Babes in Toyland

●●●● This is a movie feast for the children and for grown-ups as well for it is fantasy of the highest order presented in a superb manner.

All Mother Goose's favorites are brought to life to the lilt of Victor Herbert's March of the Wooden Soldiers. Laurel and Hardy have some very funny scenes and a real star is the character (a marionette) who looks like a twin brother to Mickey Mouse.

Other players who score are Charlotte Henry, Felix Knight, Henry Kleinbach, Florence Roberts and Virginia Karns.

Don't fail to take the kiddies to see it and while there sneak a look yourself.—HAL ROACH.

Stan Laurel—Oliver Hardy

Shirley Temple

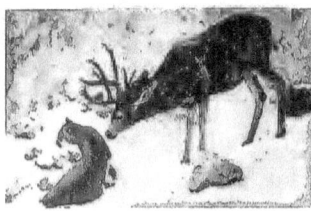
Gato—Malibu

Francis Lederer—Ginger Rogers

Bright Eyes

●●● Little Shirley Temple scores again and this picture is mostly Shirley. The story starts when Jimmy Dunn adopts the orphaned Shirley. Judith Allen, the estranged sweetheart of Jimmy is slowly won back through the sweetness of the child. Jane Withers, another tiny player is the heavy of the play and she makes life miserable for Shirley. It all ends satisfactorily however with a re-union between Judith and Jimmy.—FOX.

Sequoia

●●● The story of a strange friendship between a mountain lion and a deer, a story of love and devotion rarely equalled even among humans. It may not sound like much but when you follow the lives of Malibu, the deer and Gato, the mountain lion through the glories of the California outdoors you will get your money's worth. Jean Parker is effective and Russell Hardie is good but the cast is really secondary to the grand animal pictures.—METRO.

Romance in Manhattan

●●● A grand romantic tale of Francis Lederer, a poor immigrant who dreams of being a millionaire. When he is about to starve, Ginger Rogers helps him and finds him a job as a taxi driver. Two nosey old ladies report Ginger unfit to bring up her young brother and there is lots of trouble. Finally Ginger and Lederer marry and friends arrange to get him his citizenship papers. Lederer is grand and Ginger is splendid in her first real dramatic role.—RADIO.

RATING CODE: ●●●● Excellent ●●● Good ●● Fair ● Mediocre Additional Reviews on page 73

Joan Crawford is determined to be honest in what she says and what she does, no matter what the personal cost may be. She is the answer to the question: "Can a star be on the square in Hollywood?"

Joan Crawford Can't Lie

by JACK JAMISON

SUPPOSE THAT YOU were a star like Joan Crawford. Suppose you were faced with her problems every day. Suppose that newspapers and magazines found news in everything you did or ever had done. Suppose you had a career to protect and develop and that you had money and success. Could you conduct yourself properly on all occasions? Could you win and hold the reputation of being a square-shooter? In fact, do you think that a star like Joan can be honest in Hollywood?

The person best able to answer that question is Joan Crawford herself, who has the reputation of being just about the squarest shooter Hollywood has ever seen. Maybe you've never heard much about that side of Joan but all her life she has been honest to a fault. She takes no credit for it.

"It's something I can't help," she says. "It's just natural for me."

When she was seven years old she used to swipe candy off the dining room table. "Did you take that candy?" her mother would ask, and Joan knowing that she was going to get a spanking would tell the truth.

"I never could lie," she explains. "I knew a lie was always going to be found out. But, even if that hadn't been true, I would never be able to look a person in the face after I'd lied to him, and I don't like the idea of

Reflective beauty! Joan Crawford, resting between scenes on a "stand up" board, to save wrinkling the wedding gown she wore in Forsaking All Others

not being able to look a person in the face."

When she was fifteen Joan was working her way through Stephens College, at Columbia, Missouri, by waiting on table. (All through high school she cleaned a fourteen-room house every day, cooked for a family of nine, and did the washing, bathing, dressing, mush-boiling, milk-heating and colic-soothing for thirty babies at a nursing home!) At college the other girls were cruel to her, because she was so poor, and her unhappiness strengthened her resolve to go on the stage. So one morning she put on her one and only dress, folded her school uniform into her old suitcase, and simply trudged down to the railroad station with her savings. There, just before her train came in, she was discovered by the kindly old dean of the college.

"Running away!" he exclaimed, and shook his grey head sadly. "This isn't like you, child. This is the first time I have ever known you to do a dishonest thing!"

That nearly broke Joan's heart. "I—I have to go," was all that she could say.

"You know what this means," said the dean. "You'll lose all your school credits."

He urged her to come back to school, but she refused. And, eventually, although she was crying so that she could hardly talk, she made the gentle old man see it her way.

In the first place, she was running away because she loved him too much to go into his office and tell him goodbye.

"In the second place," Joan says, "I knew I was not cut out for school, and that I was cut out for the stage. Running away, I was being more honest than I would have been if I stayed."

The Dean must have been impressed by that honesty of

… hers, for he saw to it that she got her school credits after all. What is more, when he is in California on his vacations nowadays he always calls on Joan at the studio. They love each other more than they ever did, and he is proudest of her of all his ex-students.

And there are many friends from Joan's show-girl days, when she was a dancer on the stage, who recall that impelling honesty of hers!

All of which leads us to Hollywood.

It was an honest youngster, charged with the enthusiasm of her glorious youth, who came to Hollywood and took the name of Joan Crawford. Now Joan is a star. In between lie years of struggle and striving. Is it possible for a girl, fighting her way up to stardom, always to be honest? Is it possible, *after* she has attained success, for her to remain honest?

"Yes it is" say Joan Crawford's friends "just look at Joan."

• A star's relations with the world are threefold—public, social, and business. In other words, the Press, the Parties, and the Studios. There are a hundred examples of Joan's tremendous personal honesty as applied to each one, but there isn't room for all so we'll pick one of each.

First of all, the press. That means newspapers and magazines. They are the principal way a star has of reaching out and getting in touch with the public on a large scale. Therefore, most stars deem it necessary to be extra nice to writers, and take care not to offend them. A writer can if so inclined, do a lot of damage to a star, not only by making "dirty cracks" but by simply *forgetting* to write anything at all.

Not so long ago a woman writer printed an article which asked, "What has become of the old Joan Crawford? The dynamic, effervescent Dancing Daughter who used to win cups in Charleston contest is gone. In her place we have but a pale copy of her old self. Joan, today, is no more than an imitator of Garbo!"

Now that wasn't very nice and it wasn't good publicity. Most stars would have tried to hush the story up, or else jotted down the name of that particular writer and made it a point to be especially charming to her in the future. Either of these methods, to Joan's way of thinking, was hypocritical.

She invited the writer to visit her on the set, and promptly asked, "Can you prove that I'm imitating Garbo?" The woman couldn't.

"All right," said Joan, "then the reason you said that was just because you weren't thinking, wasn't it? You had some space to fill, and you wrote the first thing that came into your head. It's people like you, saying things carelessly, who start an actor on the downgrade. Now, the next time, dear, please think a little more carefully about

Please turn to page sixty-eight

Joan Crawford Can't Lie

what you're saying when you sit down to write about somebody."

Joan took the risk of making an enemy, for life, of that writer! But she told her what she honestly thought.

IN HER PROFESSIONAL contacts she is every bit as honest. Here's something that happened while she was making one of her recent pictures—we won't tell you which, because we don't want to hurt anybody's feelings, but it is one that is still playing. Working late, one night, with everybody tired, one of Joan's fellow actors tried to liven things up by doing a bit of clowning in the middle of a take. The crew laughed, but there was an unforeseen result. The director went into a rage, blamed Joan for spoiling the take, and stalked off the set.

Now, this was a situation that called for diplomacy! The director had really insulted Joan; made her lose face with the crew. He put her in a position where there were only three things she could do: She could stalk off the set herself, tying up production and costing the studio a lot of money in overhead. (For which not she, but the director, would get the blame). She could throw the blame where it really belonged, on the practical-joking actor; or she could hypocritically accept the blame, softsoap the director, and let him walk all over her. She was too honest to do any of them. She knew exactly why the director had walked off, and she made no bones about saying so.

"He's just trying to be temperamental," she said to the boys on the crew. "I'll bet you fifty bucks he's back on the set inside of three minutes." He was back inside of two.

"Will you please step into my dressing room for a minute?" Joan politely asked. He stepped in.

"Now cuss me out" Joan said "get it all off your chest."

He did with no uncensored words.

"All right, now let me say my say" and Joan said it!

Of course, there are things a lady can't say, but within her limits Joan did very well. She started in by telling him that he was rude, and ill-mannered, a rotten sport and disloyal to the studio, and she ended up with some personal truths that stung.

Again she took the chance of making a powerful enemy and one right in her own studio who could do her a lot of harm. But Joan insists on perserving her personal honesty.

Finally there is the social side of Hollywood. Perhaps more Hollywood business is transacted at parties than anywhere else. Social enemies can be the most dangerous of all. That is the reason you see actresses who loathe and detest one another being oh, so sweet to each other at teas and cocktail parties. Joan refuses to do it. She's simply too honest. She can't stomach it.

There is a young woman in Hollywood whom Joan doesn't care for because, as Joan says, "She's married and I don't like the way she ignores the fact."

One day not so long ago they met at a big party—seventy-five people or so. The other girl walked past Joan three or four times and Joan didn't speak. Most stars would have spoken, if only to keep from stirring up trouble—but not Joan.

Finally the girl came directly over to her.

"What's the matter?" she demanded, although she of course knew perfectly well what the matter was.

"Don't you like me" the girl asked.

"No" said Joan, point-blank.

"Why" said the girl.

"Because I don't agree with certain things you do" said Joan mincing no words, "I don't think I should gush over you and tell you how lovely you look and all that, when I don't."

"Thanks" said the other girl. "It's swell of you to be honest about it, and to tell the truth I don't agree with some of the things I have been doing either."

"Then why do them?" asked Joan.

"Well, they seemed to be the things to do at the time" the girl replied. "I want to have fun—I want to have a good time."

"There are ways to have a good time without hurting other people" said Joan ending the conversation.

And that is Joan's philosophy. She believes from the bottom of her heart that honesty is the one thing that can never hurt. That is—it can never hurt anyone but oneself—and Joan is prepared to take that risk for herself.

Next time you read about something that Joan Crawford has done or said, put yourself in her place and see what you might have done in the same situation. I'll wager you'll find yourself saying "There aren't many like Joan Crawford."

Two of the frankest, stories we have ever

I've Been My Own Worst Enemy

by

Joan Crawford

EDITOR'S NOTE: Today Joan Crawford stands on the threshold of a new life... new happiness. What a difference there is in contrast to the frightened girl who stepped down off the train in Hollywood nine years ago! What a difference from the lonely, impulsive girl so desperately seeking a tiny corner to grow in! What vitality it has taken to overcome many obstacles and yet emerge the girl who is now capable of facing life with a smile.

The first of the year, Joan signed a new contract with her studio. It gives her the privileges accorded our greatest stars. The salary is reputed one of the highest ever paid. The finest writers and technicians are assigned to her productions. Her directors are the same ones in whose scenes she once worked extra. Joan has never been more popular, her pictures more in demand. Life has never been quite so full. When most actresses with her background might be living in the past, Joan exists in the exciting future. This story by Joan herself, tells why:

● I HAVE BEEN my own worst enemy. Now as I look back on a great many things, I realize how much I could have spared myself. If only I had known then what I have since learned! It has taken me all this time to find out why I used to be so unhappy. I have had to make mistakes and learn many bitter lessons, before reaching the state of mind that has brought me the comfort and happiness of today. It has been tough at times, but the lessons I have learned have been worth it. I alone am responsible for whatever unhappiness I may have suffered. I hate looking back, even for a moment. But to tell you this story, I have to.

I was always expecting too much from other people. No one has a right to do this. When people disappointed me, I would blame them bitterly. In reality, I was creating an ideal that did not exist. It was not the person who failed me. It was the ideal, actually a product of my own imagination. But I would not admit to myself that I was wrong.

I used to be unhappy because I did not have the kind of friends I liked. Now as I look back I doubt very much if I could have held on to them. I was miserable if I stayed home an evening or missed a party. I thought they couldn't get along without me. I thought that all the people I met at these places were necessary to my life's happiness. Actually, way down deep inside, I was not positive about this. But I did not have the courage to be honest with myself.

As time went on, I began to find out that the people I depended on most were never there when I needed them. Parties, night clubs, dances, all seemed to become more shallow as time went on. Then the light began to dawn. Finally I reached the point where I could not stand another evening of it. I shut myself up in my house and refused to see a soul. My phone rang continuously but I never took the receiver off the hook.

I was searching desperately for some way out. How, I did not know. For days I just sat and thought things out for myself. I wanted so badly to become sufficient unto myself and never have to depend on a living soul for my peace of mind. Then the complete realization came to me.

Human beings come into this world alone. They go out alone. Others touch our lives but we have no right to include them in our own scheme of things. Eventually there comes a time when we must be by ourselves again. When the day came that I wanted to be with people again, I found myself a different person. Being by myself was a strange experience but a wonderful one. At last I had grown to know myself. Because my own understanding had deepened, it was easier for me to seek out the friends I had always wanted.

I feel that happiness does lie ahead for me, for these given reasons and many others. Of course, I do not mean that my life miraculously shall become devoid of any problems. Nor do I mean that there won't be the usual heartaches, disappointments and spells of depression that come to all sensitive people. No person in this world escapes. I never expect to, nor would I want to.

Today I believe I am more serious than I have ever been, yet I take myself less seriously. Instead of getting all upset over some unavoidable thing that goes wrong, I try to devote that same energy to creating something twice as good in the place of it. When I read things about myself that are unkind or unfair, I now laugh them off. They were only important before because I gave them importance. If friends happen to go back on me, I no longer point an accusing finger in their direction. They probably

I've Been My Own Worst Enemy

would not have disappointed me if I had not let them down in some way.

I try to meet all my problems with this same philosophy. I feel that the period spent in getting acquainted with myself has given me a calmness and peace of mind. I hope I have definitely passed beyond that danger point of confusing my values. Both as an actress and as a woman, I have tried to emerge from an emotional cataclysm into a new world of thinking—and being.

For years, I have wanted a home to share with my friends. Mentally I have pictured it. I dreamed of planting beautiful flower gardens. I saw myself in possession of a wonderful library with book-shelves reaching to the ceiling. I hoped for a baby grand piano where I could study my singing, a swimming pool and eventually my own little theatre.

It really is a dream come true. On Saturday nights, I invite a few close friends to share my happiness with me. On these occasions, sometimes there are such friends as Helen Hayes, Jean Dixon, Lynn Riggs, Jean Muir, Dorothy Parker, Alan Campbell, Franchot Tone, Mr. and Mrs. John Beal. All of them are people of fine intelligence and rare sensitivity. We have such good times together. We usually run a movie, and afterwards sit around and eat hot buttered pop corn.

Now maybe you can understand why I hate to go out. I have had my taste of that, and now I have my whole world right here. I have everything I have always wanted, with dear friends to help me enjoy it. My radio brings me music. My bookstore keeps me supplied with reading. My happiness is complete. I hope I have completely worked away from the superficial things in life that once concerned me, and made me so unhappy.

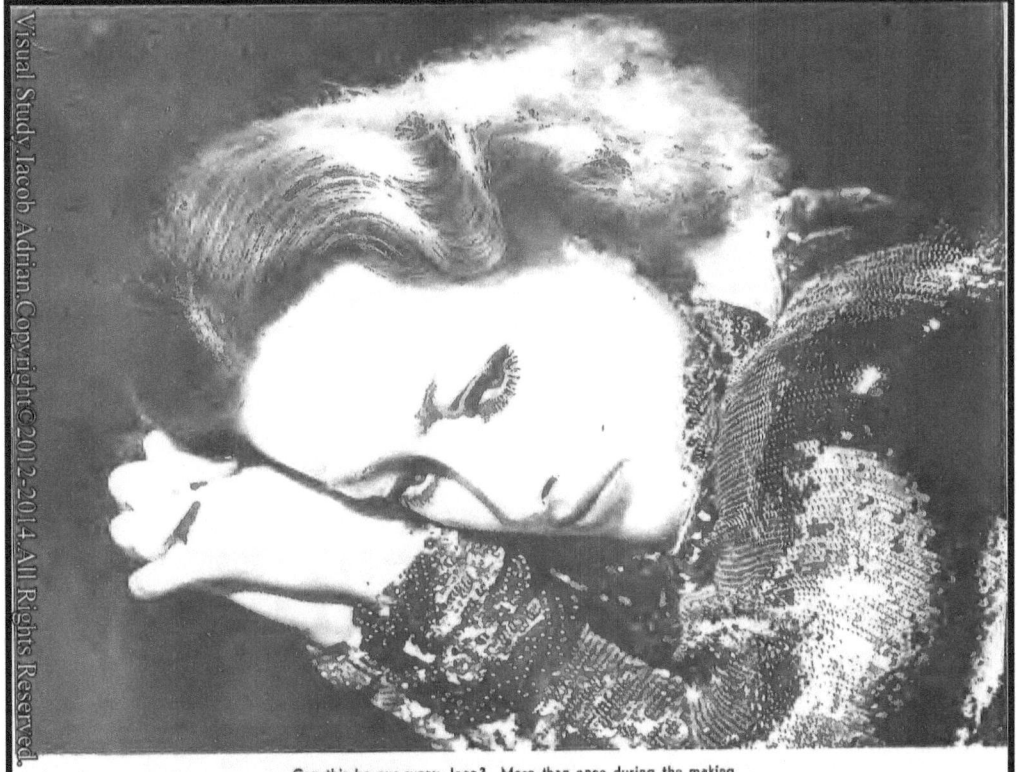

Can this be our sunny Joan? More than once during the making of *Mannequin* she turned this hostile glance at Spencer Tracy

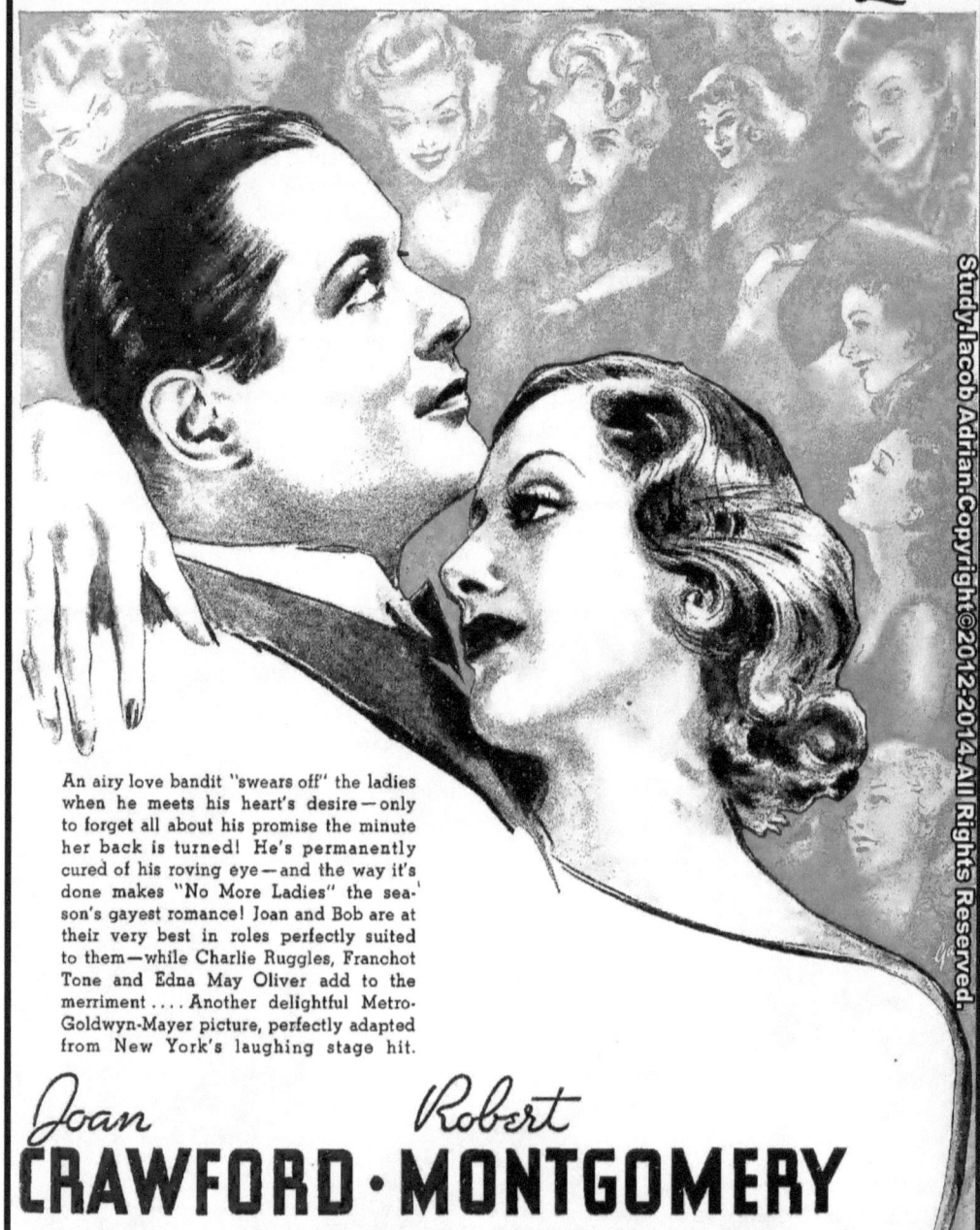

The Command Story

Joan Crawford and Gail Patrick as they appeared in "No More Ladies"

What is JOAN CRAWFORD Really Like?

Kindly, friendly, and human, Joan has helped many people whom she scarcely knew. Why? This story gives an answer to our readers, who demanded one

by JERRY ASHER

JOAN CRAWFORD has been in Hollywood for almost ten years. In that time she has shown a growth that is amazing in its proportions. There are more new things happening to her every moment that she lives, than the season's newest ingénue. Joan herself has created an exciting, interesting world to live in.

Many people have written stories on the "real Joan Crawford." No doubt they represented the real Joan at the time the stories were written. But Joan changes—imperceptibly, perhaps, yet constantly. Recently, letters have been pouring in from her fans, demanding to know even more about her. When they see her on the screen, they are conscious of her continuous improvement. When they hear the rich tones of her voice, and feel the warmth of her personality, they are curious to know what the Joan of today is really like. They wonder what things are happening to her, in just what way her life is touched to produce such evident effects.

My friendship with Joan started six years ago, when she befriended me at the M-G-M studio. I was new at the job and it was Joan's kindly interest that enabled me to hold on. Since that time I have never known a day when Joan wasn't trying to help someone. How she helped Gail Patrick is a story that should be told.

Not so long ago I began my friendship with Gail Patrick, the lovely Alabama beauty, now under contract to the Paramount studios. Our mutual admiration for Joan Crawford was an immediate bond. Gail's one ambition was to be able to wear clothes like Joan, to pose as Joan did in her still pictures and above everything else, to acquire Joan's great kindly warmth on the screen. Gail confided that she bought all the movie magazines, just to see Joan's pictures. Sometimes in the privacy of her own room, she even attempted to pose like Joan, before her own mirror.

● HAVING DINNER at Joan's house one night, I told her this story. Joan was quite touched. Having herself gone through a period of readjustment, she knew what it meant to need poise and confidence on the screen. Several days later came a call from Joan. She was having a portrait and fashion sitting with George Hurrell. Would Gail Patrick care to come out and spend the afternoon?

Gail was just getting in her car to drive to San Francisco, when I called her. Instead she headed for the M-G-M studios in Culver City. Joan didn't wait for an introduction. She walked up to Gail, greeted her in that rich tone of hers and extended a hearty handclasp. All afternoon Gail watched Joan at work and took mental notes. When she asked Joan questions about makeup, Joan made a list of suggestions that contained some of Joan's own personal make-up hints.

Recently Joan Crawford started work on *No More Ladies*. There was a good part in the picture for a girl who must look

What Is Joan Crawford Really Like?

beautiful enough and intelligent enough to take Bob Montgomery away from Joan. Dozens of tests were studied. Suddenly Gail Patrick came on the screen.

"At least let's give her a chance," pleaded Joan. "She's never played a part like this before. It might be the one chance she's been waiting for, that will put her right on top."

Beautiful young stars are not in the habit of going to the bat for equally-beautiful young stars, to play in their pictures. But Joan Crawford did more than that. Gail came out and made a successful test. Ordinarily the studio would have sent down and bought her wardrobe at some exclusive shop. Joan asked Adrian, as a favor, to design something especially suitable for Gail. Next Joan talked to the make-up man, the hairdresser and even asked the cameraman to give Gail every consideration in lighting her.

When Gail Patrick went to Joan and tried to thank her, Joan would have none of it.

"If I helped in any way, I'm very glad," said Joan. "There was a time when I would have been so grateful if there had been someone to help me a little. I know what it means when a person wants so badly to make good. What little I could do gave me a great deal of pleasure."

● WHEN JOAN herself isn't drawn to some worthy person who needs guidance and understanding, they manage to seek her out. I've really wondered what it is that inspires people to go to her above everyone else. With hundreds of famous and influential stars in Hollywood, why do these needy ones just go to Joan? What is the bond that exists between her and all humanity? What is it about her that makes her stand out as a solitary figure of tolerance, interest and kindly understanding?

Personally I think it is because Joan is so in tune with all living. There are certain things she feels. They come to her with so little effort, yet are so genuinely sincere, she must apply them where they will do the most good. Having known great hardship, unhappiness and despair in her earlier life, Joan stands forth as a great oasis of refuge today.

Many people have come to me voluntarily and told me of the wonderful things Joan has done for them. Many of them she has never seen, but has helped indirectly. Because it embarrasses to have people thank her, Joan prefers keeping them at a distance. I'm not betraying any confidences when I mention a few of these cases. Naturally I will not print their names. But I almost think they would be happy if I did. They are so grateful to Joan, they would gladly shout her praises from the housetops.

There was the little stenographer who came to Joan, with the oldest problem of all. Married to one man, but separated from him and in love with another who was to be the father of her child, what should she do? Should she tell her husband the truth, or should she keep her secret? Upon Joan's decision the future of a human life hung in the balance. It was a great responsibility and Joan knew it. She thought the matter over carefully and then tactfully brought the three interested parties together. What actually was said will never be known. But today the girl is happily married to the man who is the father of her child.

● A YOUNG inspirational artist, suddenly found himself faced with a great unhappiness. A woman had come into his life, completely dominating him. Paint, brushes and easel were easily forgotten. He was so madly infatuated he could neither eat nor sleep. And just when his very life depended on the woman's love, she walked out on him.

Desperately he planned suicide. Fate somehow brought him a chance introduction to Joan Crawford. She immediately sensed that he was brooding over a great sorrow. Into kindly, understanding ears, he gradually poured his story. Joan talked to him for hours. She begged him to forget his troubles in work and give himself one more chance. Doubtfully, he gave his promise. Today he paints with a new lease on life.

Some time ago Joan started a picture with a leading man, who had just arrived in Hollywood. It was bad judgment on the part of the studio, to give him such a responsible assignment for his first picture. After three days he was taken out of the part. It wasn't Joan's fault that he was inadequate, yet she felt terrible. She sent him a note and expressed her regrets. Then she heard that the actor had lost heart and was trying to get out of his contract.

Immediately Joan sought him out. She tried to reason with him. She suggested that it would be so much better for him to get experience in small parts and then in his first big rôle, score a great hit. The actor took her advice. You know him as well as I do. I know Joan would grieve if I were to mention his name, so I will only say that he is one of the best actors of today.

● JOAN'S DRESSING room and set are a haven of refuge. They are always crowded with girls who have beauty problems, who ask Joan how they should do their hair, how they can lose weight, what colors would look best on them. To all these she lends a willing and patient ear. Somehow she manages to find time for them and yet accomplishes the hundred and one things that comprise her professional and private life.

When the Chatterton-Brent divorce was announced, Joan spent the full day trying to locate the first lady of the screen and sent the message, "Just to let you know I am thinking of you." When the daily headlines announced Russ Colombo's tragic fate, Joan was one of the first to call "Fieldsie," Carole Lombard's secretary, and say, "How is Carole? Please ask her if there is anything I can do."

Having been touched by life and emerging as a tender, compassionate person, a great understanding has been born. With an all-consuming passion for creation, Joan has been able to accomplish miracles in her own life, with enough burning enthusiasm left over to share. In a city like Hollywood—a city of "heartbreak, where the pursuit of artistic expression breeds selfishness, indifference and superficiality, it is a great tribute to a great woman, when she can be called, "Joan, of the understanding heart."

AUGUST, 1935

HARRY CARR'S Shooting Script

Clifton Webb, noted stage star, is the latest addition to Hollywood film ranks. Webb is to co-star with Joan Crawford in "Elegance" following his sensational performance in the stage version of "As Thousands Cheer"

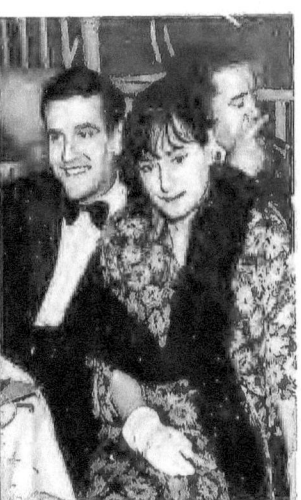

Dorothy Parker, noted author, and her husband, Alan Campbell, snapped at one of the many parties given in their honor by film celebrities

MY OLD friend Frances Marion gave me a dinner party the other night; and I believe it was the most dazzling collection of brains I have ever contacted.

The guests were Jed Harris, the producer of *Front Page*, Marc Connolly, author of *Green Pastures*, Dorothy Parker who is probably the most famous wit in the world and Anita Loos, author of *Gentlemen Prefer Blondes*.

I feel that I should never go to another Hollywood party but should dedicate myself to the memory of this one. I never again expect to hear such dinner table conversation—which ran from ethnological race swirls to imitations of Sam Goldwyn's scenario conferences.

It interested me very much to see how essentially kind they all were; how much sweet reasonableness they possessed and how they were clean of envy and spite.

Dorothy Tones Down

Dorothy Parker has stopped wise cracking and has very little to say. The truth is that she is a very kind and charitable girl—in spite of the fact that she has almost destroyed people with her brilliant tongue. You never hear of the kind and sympathetic things she has done.

Some one told at this dinner of an old star who has been blind for some time but is trying to conceal the fact and it was to Dorothy Parker's eyes that the tears came.

One of Dorothy's remarks will never be lived down by Katharine Hepburn of whom Miss Parker said: "In her acting she runs the gamut of human emotions from A to B."

Frances Moves

Following a terrible automobile accident, her physicians ordered Frances Marion to remain in absolute quiet—which she did by tearing her house to pieces and building it up again.

For an architect Frances had Adrian, the dress designer; and he accom-

Joan Crawford gets a chance to show her new coiffure in "No More Ladies," her latest production with Robert Montgomery and Franchot Tone

plished one of the most charming effects I have ever seen in any Hollywood house; its keynote is quietude. It is like a well-dressed woman; you know she is well dressed but you do not notice her clothes.

Mr. Lederer and Peace

The case of Francis Lederer and the peace movement makes me think of an incident on the old Mack Sennett lot.

Two colored gents were working as extras in a lion scene; they were to lie in bed, apparently asleep, when a tame lion came in and woke them by licking their feet. By mistake some one let out the wrong lion—a vicious brute who came in with an earthshaking roar. When they finally got him back in the cage one of the colored men started to walk off the set; they told him it was just a little mistake; but he rolled his eyes and said balefully, "No sir, Boss. I ain't no actor. I'm a chef and I am going home and start cheffing."

If Mr. Lederer is an actor he had better let world peace alone and start acting. He is getting nowhere fast with his screen career.

B and D

It is no longer important in Hollywood to be beautiful; but it pays to be dumb ... at least not too bright.

I could name a dozen careers that were snapped off by wise cracks. They travel around Hollywood—the wise cracks—like wild fire and they always get back to the producers who don't say anything at the time; but they have good memories.

The most notable instance is that of Mrs. Pat Campbell who came to Hollywood just at the moment when Louise Dresser had started all the studios on a still hunt for personable old ladies. She never got anywhere on account of her tongue.

A swell topic of conversation in Hollywood

HOLLYWOOD SPOTLIGHTS

Indian Uprising

It had been a long, hard day for Ralph Bellamy, Chester Morris, Johnny Mack Brown and their wives at the San Diego Exposition, what with signing autographs, visiting the Hall of Fame and the hundreds of attractions. Somewhat wearily the distinguished group arrived at the Indian village for an impressive ceremony. Ralph Bellamy was to be given an Indian name and made a brother of the tribe by Chief Thunder Cloud. It was a proud moment for Ralph when he became "Chenowah," meaning warrior and poet, after a noted Sioux Chief. After the ceremonies at long length were concluded, Mrs. Bellamy plucked her husband's arm.

"Chief Chenowah," she said plaintively," can Squaw Tired-Of-Walking go home now?"

• • •

A Million For Shirley

Those who are worrying about Shirley Temple's future, and fearing that the inevitable approach of awkward adolescence may cut short all too soon her chance to earn her just rewards, may rest content. Happily enough, Shirley Temple has become a name of great magic in fields commercial, and what with Shirley dolls, dresses, cut-out books, toys, picture books and so on, royalties paid the child are reaching astonishing proportions. She is, in fact, a major industry. Thousands of people gained employment because of her popularity; in one year her revenues from manufacturers has reached $350,000, and next year should place her in the millionaire ratings of Dun and Bradstreet. A doll book paid her $15,000 the first two weeks it went on sale, making her salary of $1,200 a week look like small potatoes.

These tidy sums are thriftly put away by Banker George Temple. Shirley, meanwhile, has her own notions of finance. During the filming of *Curly Top*, John Boles gave her a nickel. Having no pocket, she had to give it to Mother Temple to keep for her. Then she approached John, whom she adores.

"Mother got my nickel," she said. "Isn't it too bad? Now I haven't any nickel." She waited. "I said I haven't got that nickel any more, Mr. Boles."

John took the hint. She got another nickel.

• • •

Familiar Eyes

They were taking tests on the Universal lot. A number of young men and women who were lucky enough to rate screen shots were going through their scenes.

Finally a petite, black-haired girl stepped before the camera and began enacting a brief scene. There was a career at stake and she was just a little nervous. She was supposed to drop her hat on an end table and her purse on a chair. She reversed the procedure, and the purse knocked off an ash tray with a loud bang.

They went through the scene again, but this time her voice cracked with nervousness. They gave her a glass of water, and she promptly romped through the scene in great style.

She was just an extra, taken from the ranks of *Storm Over the Andes*, but there was something instantly recognizable about her. Especially her eyes. Jack LaRue's eyes, unmistakably. There was the key to her identity —she was Emily LaRue, Jack's "Kid" sister. Universal thinks it has a "find."

• • •

Mundin's Mutiny

Herbert Mundin, that clever H'English comic (Barkis is willing!) is playing the cook aboard the Bounty. While the company filming the *Mutiny* was "marooned" on the Catalina isthmus for three weeks, Herbert begged and begged for permission to hire a boat and cross over to Long Beach. After a week of pestering, Director Frank Lloyd finally asked him why he was so insistent. Clark Gable and Charlie Laughton, Lloyd pointed out, were making no such demands, and they, too, were men of affairs.

Mundin finally confessed: "I want to go see a movie!"

• • •

Pie Comedy

Joan Crawford got a yen for some of that pumpkin pie her mother used to bake, and after talking about those yummy pies for several days during the filming of *Glitter*, Brian Aherne asked her why [*Continued on page 63*]

Pow-wowing at the California Pacific International Exposition in San Diego: Mrs. Bellamy, Chester Morris, Mrs. Johnny Mack Brown. Chief Thunder Cloud, Johnny Mack Brown and Ralph Bellamy

A New Log of the "Bounty"

Gable and Director Frank Lloyd consult the script for a take aboard the Bounty

The yearly wage earned by Captain Bligh, even with his petty thieving of ship's stores, wouldn't pay the salary of Charles Laughton for ten days. Laughton went into this rôle with characteristic abandon; so intense is his desire to enact each new character differently that he reduced fifty-five pounds to become Captain Bligh. Those who have seen Charlie at mealtime may appreciate this stupendous sacrifice; to others it would be beyond belief. Laughton is Bligh. He has taken to even hating himself.

To Clark Gable, playing Fletcher Christian, has come the opportunity he has long desired—the chance to show his real powers in a character rôle. In other pictures he has played himself. Now he becomes a man of baffling moods, chafing under cruelties, seething with hatreds born of injustice, until he leads the mutiny and sets Bligh adrift in an open boat.

Clark is ordinarily sunny of disposition. His rôle will offer a strange contrast. An expert shot, he amused himself shooting at sharks that trailed the Bounty every time she put out from the cluster of huts at the isthmus of Catalina.

● After seizing the ship, Fletcher Christian returned to Tahiti and then sailed into the unknown with part of the crew and a group of native girls. Mating with the natives, they formed a colony on Pitcairn Island and when a boat finally found them, many years later, only one white man was left alive.

A movie of the present colony on Pitcairn was shown the actors while at Catalina; the traces of mingled ancestry are plain on the features of these people, and their language is an odd mixture.

Among those who refused to go to Pitcairn was Roger Byam, from whose point of view the story of the Bounty as written by Charles Nordhoff and James Norman Hall is related. The authors, who live at opposite ends of Tahiti to avoid getting on each other's nerves, went to the island to escape from civilization after the World War, much as the mutineers sought refuge at Pitcairn.

The rôle of Roger Byam was one of the biggest plums of the year in Hollywood, and it fell to Franchot Tone by the same sort of accident that put him in Lives of a Bengal Lancer. Another actor withdrew to take a different picture assignment and history repeated itself when the Bounty was cast. Robert Montgomery was broken-hearted when other work interfered and Tone got the job.

The rôle fits him glove tight, and depend on it, Franchot will emerge a star when the Bounty is shown. He, too, did his share of suffering for the sake of Metro, to make the Bounty. A paining tooth was no fun, marooned as he was at the isthmus, but a boat finally was hired and he had the tooth yanked without delaying production.

Metro chose wisely in casting Franchot, for bear in mind that Gable leaves the picture after the mutiny, and so does Captain Bligh, Laughton and Tone must carry the picture from then on.

Tone, left at Tahiti, has a very tender romance and marriage with a native girl who bears him a child. Searchers from England, aboard the Pandora, capture him and start home. The Pandora is wrecked, but Tone finally comes to trial and is condemned to death, for mutiny. Those are thrilling sequences in the film, and Director Lloyd is doing them full justice. It is planned to actually wreck the Pandora, a smaller sailing ship than the Bounty.

The Bounty itself was burned at Pitcairn by Christian, but whether the ship will be destroyed for film purposes has not yet been decided as this is written. I think it would break Jim Havens' heart to see his precious boat done to death.

Every man in the large company has done his share to help make the film a success. There were a number of minor casualties despite every sort of precaution. You can't make an exciting picture of this sort without some risk!

Only three of the eighty-three important character rôles in the picture have been mentioned, but you'll see scores of famous faces in this picture. All are going to win honorable mention from grateful fans when the saga of iron men and wooden ships is brought to the screen in this grand tale of love and hate, mutiny and death, reliving the days when the Bounty was the proudest ship afloat, and its captain was the meanest man alive!

Joan Crawford's Pie Comedy

she didn't drop a hint or two at home to her mother.

Several days later Joan's mother sent a luscious pie over to the set, and everyone was eager for a taste. It certainly was delicious. Joan was mighty proud of that pie, until somebody declared that it wasn't a pumpkin pie, it was made with carrots.

Joan wouldn't believe it until she had cornered her mother and forced her to admit that it was made with carrots. Then it all came out—when Joan was a little girl she refused to eat carrots. So her mother baked them up as pumpkin pies and Joan never learned the truth until now.

SEPTEMBER, 1935

GADGET GOSSIP

● IT IS EMBARRASSING to suggest a drink —and then not have any soda in the house for a high ball. Raquel Torres, in photo above, has a sure remedy for such a situation. She possesses one of those extremely handy Sparklet Syphon bottles which charges its own water in no time! With these bottles comes a box of "cartridges" or refill bulbs so that potential "charge" is available at all times. You just slip a bulb into a little gadget at the top of the bottle, press a lever, and the rest is easy. Raquel keeps it on a shelf just above her bar. It's made of hand blown crystal, sheathed in silvery woven wire, and looks very swanky.

● ● ●

● ADRIENNE AMES has a remarkable new roaster—one of the electric variety known as a Nesco Automatic Electric Roaster, "The Royal Line." Really, it is an electric oven, and in it you can cook whole dinners. Of heavy insulation, it confines heat to the food instead of allowing it to escape into the room. Of course, you can use one of these in any part of the house where there is an electric socket. Four sizes are available.

● ● ●

● THOSE CLUB ALUMINUM griddles which bake hot cakes on one side and broil steaks on the other (no, not at the same time) are simply swell, according to Barbara Stanwyck. They are heavy and shiny and don't need greasing at all. Then, when you turn them over, there is another flat surface, surrounded by a groove which catches the "drippings." Barbara also has sauce pans which she uses, covered, on the top of the stove for baking things such as potatoes and such.

● ● ●

● WORRIED ABOUT moths getting into blankets, draperies and so on? "Think nothing of it," says Joan Crawford, who has solved her own moth worries by using Mortex, a moth proofing spray manufactured by the Murray and Nickell Manufacturing Company, of Chicago. You spray it on with a special gadget. It is stainless and harmless to all fabrics.

OCTOBER, 1935

EYE-WITNESS PHOTOS

by Charlie Rhodes

Gene Raymond threw a birthday party at the Beverly Wilshire. I snapped him facing the camera with Marian Nixon, John Mack Brown and Jeanette MacDonald

I went to the Hollywood Bowl to catch this picture of Jimmy Dunn and Ruth Chatterton during one of the Symphony Under The Stars series

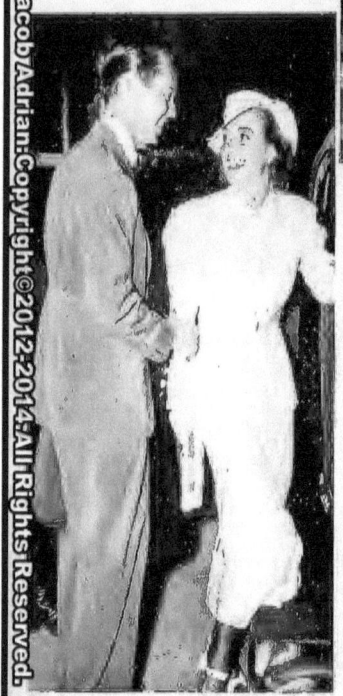

Joan Crawford and Franchot Tone appear often at the night spots. They're glad to pose for pictures, but they won't tell me a single thing about those wedding rumors

They're on the air. It was Campbell Soup time, with Frances Langford, Rosalind Russell, Clark Gable, Louella Parsons and Jean Harlow gathered around the microphone

When I tried to snap Luise Rainer and Max Reinhardt, Jr., at Lamaze night club, the little star gave me a merry chase. When I finally caught up, she whirled around, mussed up her hair deliberately, and said, "All right, shoot!" I did

ARE MOVIE PEOPLE Crazy?

They do the goofiest things in Hollywood! But that's just to be expected in the movies!

by JOHN WINBURN

Two exponents of nonsense: Robert Montgomery and Chester Morris. They're old pals

Plotting something again! Bob Montgomery and Joan Crawford prepare a little gag

But when Robert Montgomery and Chester Morris, of Metro-Goldwyn-Mayer, to all appearances the essence of sane conservatism, known as devoted husbands and exemplary fathers, suddenly are discovered in paint and wigs leading the clown parade at a recent exhibition of the greatest show on earth, it's time to investigate. Are movie people crazy?

I asked Bob Montgomery about it the other day.

"Chester is quite daft," Bob said cheerfully. "Possibly that's why he is my best friend. Corroborating details? I have enough to convict him hands down."

● THE PHONE TINKLED an interruption in his pine-panelled dressing room, in the famed Bachelor Hall at Metro-Goldwyn-Mayer which houses their male stars. Bob lifted the receiver, and spoke these strange words:

"Hal-lo? Mist' Montgomery, he's busy by the stage yet."

Bob hung up with a satisfied grin, remarking: "Why be an actor, if you can't put it to practical account? And now for the evidence against Chester:

"When I decided to give up my polo ponies, which were eating me out of house and home, I gave one to Leslie Howard and another to Chester Morris. I could see that Chester was inclined to [Continued on page 46]

IT'S ALL in the point of view, of course, but to the world beyond the borders of Filmania, our inhabitants must appear at times to be slightly insane.

Where else could a beautiful woman sit down to dine in perfect amity with three ex-husbands? And what would Keokuk, for instance, think of its leading matrons if they proudly published months in advance their anticipations of a blessed event? How would a bevy of New York bankers react if the distinguished Japanese "count" they were entertaining, were disclosed as a house boy put up to the trick by one of the firm?

EYE-WITNESS PHOTOS

by CHARLES RHODES

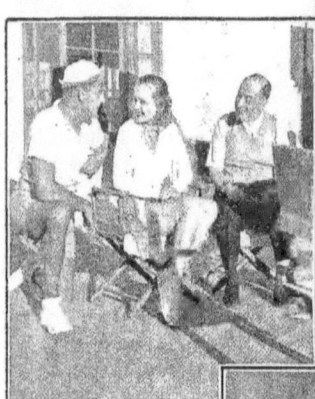

Distinguished visitors broke up work momentarily on the *Great Ziegfeld* set. This picture, from the left, shows Nat Pendleton, Frank Morgan, Gene Tunney, Frances Marion, William Powell and Luise Rainer, all in general conversation

There's nothing like the winter sunshine at Palm Springs, so while visiting the desert oasis I caught this picture of Paul Lukas, Carole Lombard and Eric Blore lolling at the Racquet Club

This picture was snapped at the party given by Countess Di Frasso. Miriam Hopkins, Merle Oberon, Norma Shearer and Dolores Del Rio all posed willingly

When I attended the Will Rogers memorial program at the Shrine Temple, I found the biggest hits were Bill Robinson and Shirley Temple

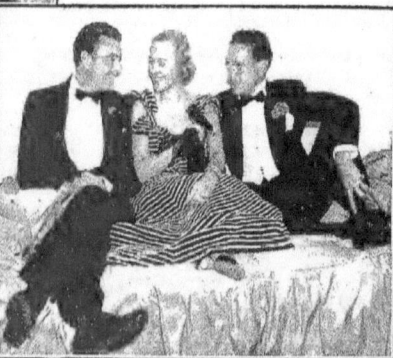

Dancing at the Trocadero were Joan Crawford and her newly acquired husband, Franchot Tone. They grinned cheerfully and told me to fire away

Here's another shot taken at the party given by the countess. George Brent, Grace Moore and Clifton Webb were in a corner of the luxurious home when I snapped this one. Miss Moore had fully recovered from her cold

Dr. J. J. Pressman had gotten over his temperamental mood when he returned from San Francisco with Claudette Colbert

JOAN CRAWFORD
answers her critics

by MARK DOWLING

Mr. and Mrs. Franchot Tone.... Joan Crawford's marriage began a series of hot criticisms aimed in her direction. Now she talks back with revenge!

—Photo by Charles Rhodes

JOAN CRAWFORD's childish! She's gone ritzy! Since her marriage she has forgotten about everyone but Franchot!

These are the arrogant statements leveled at her from critics over the country—words that have gone unanswered for months by the brilliant star. But now Joan talks back—in plain, forceful language! She's standing up for herself after a lot of abusive criticism, and what she told me sounds logical in any language!

Joan speaks frankly, every sentence pounding home a point. When she asks a question, there is reasoning in behind it. For instance:

"Is it fair to criticize *anyone* unless we know why they did a thing—or if they really did it? Can't people learn the difference between stories based on rumor and quoted stories, for which the writers must have actually met and talked with a star?"

We discussed the criticism which has been levelled against Joan—criticism of things both little and big—all the way from petty, unimportant things she is supposed to have done to deep-rooted traits in her character.

One critical letter read in part: "Just as you reached the top, you failed me. You forgot you were a glamorous woman and became a silly child. Instead of reading about what you learned from life, or what you planned to do, I began reading about your picking raisins out of bread and sitting on the floor to entertain the press. Do we have to see our lady of culture and refinement literally wearing rompers?" (See April HOLLYWOOD, p. 16.)

● JOAN MADE NO EFFORT to dodge the issues, to be starrily aloof, to take refuge in silence in the face of the difficult questions.

"Answer?" she cried. "I'd love to answer! Sometimes I sit up nights thinking up ways to answer some of the letters I receive . . .

"It's terrible to feel that you've disappointed someone," she said once. "It used to be like a knife in my heart. *It hurts.*

"Then sometimes—" her eyes flashed, "I grow so furious at them for *believing* the silly stories that I'd like to slap their faces—those people who believe whatever they read about people, without knowing either the circumstances or the truth of the things they criticize them for.

"Pick raisins out of bread? If I choose, I shall continue to pick raisins out of bread! It happens that raisins are good for me, and bread, besides being fattening, is not. And if I am served raisin bread again, I'll do the same thing!

"I *did* sit on the floor at that press reception in New York. Does the writer of this letter realize that there were only twenty-five chairs—and over one hundred guests in the room? I surrendered my chair to an elderly lady of the British press. I remained standing until the French correspondents, who were sitting in a group on the floor, began asking me questions. As I chatted with them, quite naturally, I joined their group. Is there anything so very childish about that?

"I've been criticized for dancing with gardenias between my teeth. Just that. Do these people believe that I am an idiot? I assure them I'm not! It just happens that I'm one of those people who can't wear flowers. They wilt on me. So I carry them in my hand. *But not, I assure you, between my teeth!*"

● JOAN GLANCED AGAIN at a letter, trying to find some basis for a calm and judicious reply to its author. She told me the amusing—and pathetic—story of her reception in New York on her recent trip.

A reporter knocked on the door of her compartment soon after the train left Harmon. He had boarded it there to get an interview. Joan received him at seven-thirty. "I felt sorry for him—he must have risen at five to be there. He asked me about marrying Franchot. I said I'd discuss any other topic, but not that.

"I've been criticized for that, too. I told him we were just two funny people who preferred to keep such things for ourselves alone. That we'd never be married if he and others kept following us!

"We talked, finally, of other things. Then just as he left the train lurched and threw him against the wall. I apologized laughingly for the train's behavior, and said it had been like that for the whole trip. At night I had to stuff myself in the berth with pillows to keep from being thrown out.

"When I reached New York that story had been twisted and I read with astonishment JOAN CRAWFORD SAYS SHE HATES TRAINS BECAUSE SHE HAS TO SLEEP ALONE!"

It was amazing to find a star who is so deeply affected by a single criticism among the thousands of adulatory letters she receives. A friend told us a story about Joan and a certain writer who penned many uncomplimentary things about her —for no discoverable reason. Then he met Joan, and was won by her charm and naturalness.

"I never realized before how sensitive you are," he told her. "I never dreamed how much these things I have written about you might hurt."

Absolute opposites, yet Anita Louise and Dolores Del Rio are good friends who mutually enjoy their contrasting traits

JUNE, 1936

Joan Crawford Answers Her Critics

● THEN THEY BECAME FRIENDS. Joan said, almost with tears in her eyes, "You can't imagine the wonderful feeling to meet him now and know that he isn't thinking those things about me!"

Few stars would be so moved by the opinions of strangers! Talented, successful, happily married, Joan might consider herself above criticism.

"Whenever I hear certain players lamenting that they couldn't move a step in New York for the crowds that followed them, I'd like to—" she smiled, "—kick them where it would do the most good!"

(This answers another criticism—that Joan and Franchot, in New York, had felt that way themselves.)

"We love people interested in us—cheering for us—demanding our autographs. We love fans. We'd die without them!

"Do you think," she demanded, "that I believe for one minute that I advanced from a chorus girl to a star on my own ability? No. I came up because two or three people liked me in a tiny part. They told their friends. That small number of fans grew, encouraging me.

"I love my home—and they provided it. I like my car—and they gave me that! I need my singing lessons—and they are making them possible!"

● THAT'S WHAT I TRY to remember whenever I receive one of those other letters, the ones that criticize me unjustly. And after a few weeks I do reach a stage where I can say to myself that such criticism will come as long as I'm in pictures, and I must expect it. But with each criticism it takes those few weeks to reach that stage. In the meantime, I torture myself!

"There was one woman in particular who wrote me after I made *Rain* and *Letty Lynton*. Yes, she criticized the lip-makeup I wore in those pictures. The phrase *sisters under the skin* is trite, but that's how I felt about the girls I played in those pictures. And I believe that the lip makeup characterized them.

"If that was my idea of playing a part, as an actress, I wonder what my critics would have done? I received no constructive suggestions!"

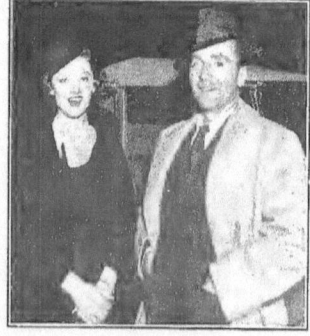

Myrna Loy grins for the cameraman as she emerges from a night spot with her constant boy friend, Arthur Hornblow.

FAN MAIL

by Harmony Haynes

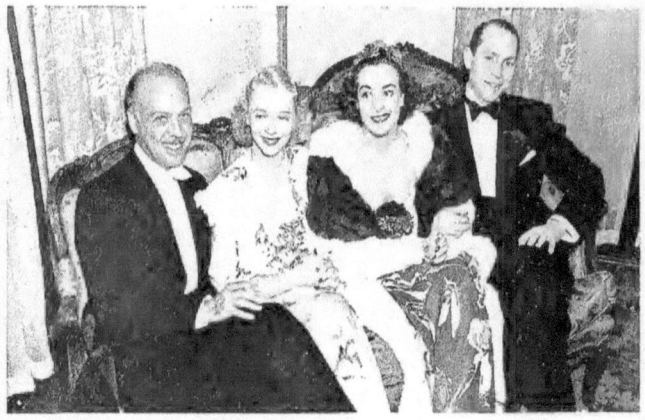

Summer-time is party time in Hollywood! At this gay affair Mitchel Leisen, Virginia Bruce, Joan Crawford and Franchot Tone arrived together

AMONG THE MILLION letters that pour into Hollywood daily, there are many which strike a tender chord in the heart of the star recipient.

For several years, Madge Evans has been writing to a little girl who was crippled. Some months ago she received a letter from the girl saying that she was about to have an operation which might enable her to walk. The child felt that her faith in Miss Evans would prove helpful in this crisis and asked for a new picture that she might take to the hospital with her.

Miss Evans not only sent the picture, but sent cards, letters and little gifts to cheer the sufferer. Then yesterday she wept over her reward—a letter from the girl saying, "I can walk now and it might please you to know that I had your picture in my hand when I took my first step."

● JOHN BOLES WAS deeply touched by a high school girl who had sent him her school pin, saying "It is my dearest possession and I want you to have it."

The pin, of course, did not mean nearly as much to Mr. Boles as it did to the girl, "but the sentiment behind it was so sweet and unselfish that I absolutely feel awed," he said.

He felt that he could not keep such a gift, but he did wear it a whole day, then blessed it and returned it to the sender.

Una Merkel and her mother had been corresponding with a child who had been ill for some time. Eagerly those two looked forward to those childish letters. Then there was a long silence, followed by a letter from the child's mother. Una's little friend had died. Una was so heartbroken, she was unable to face a camera that day.

The moral to all this is that stars do appreciate your appreciation. They read your letters with deep interest and benefit by them. Remember that with thousands of letters pouring into Hollywood, it would be unreasonable to expect stars to do personal favors. Don't ask favors from them and you won't be disappointed in their reactions.

Here Come the Letters

Let Her Have Raisins

Mr. Ken Howard:

May I ask you how you dare criticize Joan Crawford on flimsy bits of gossip? Surely you realize that all the stories that circulate about the stars are not necessarily true?

Even if it is true that Joan sometimes "picks raisins out of bread" and "sits on the floor to entertain the press" one cannot be the smartest, most sophisticated, glamorous woman of the screen every second of the day.

Please allow Joan to do the little every day things occasionally. Do you not relax yourself sometimes and, perhaps, scratch your head?

It was Tolstoy who said, "I love people for what they are, not for what I think they should be."

Most sincerely,
Hilda Orleans,
390 Madison, Ave.,
Albany, N. Y.

Dear Editor:

After reading Mr. Howard's criticism of Joan Crawford, I am convinced that he doesn't understand our Joan at all. The glamorous, sophisticated lady of culture and refinement is the *screen* Joan, and the one who so disillusioned him is the *real* Joan—the one who dares to let her hair down and be herself to the extent of picking raisins out of bread and sitting on the floor in the presence of company.

Do you blame her for shedding all traces of her screen self and being just a plain person as you and I? After all, does she owe her entire life to us? So what if she does kick over the traces once in a while? I prefer her, in a crisp house dress, sitting on the floor, picking raisins out of bread!

Yours truly,
Dorothy Culver,
Parkdale Terrace
Rochester, N. Y.

● ●

Stories for Stone

Dear Editor:

I'm all for Fred Stone having bigger and better parts—and if you don't mind—a few *stories!*

Of course, he's not a *Will Rogers*, but he does have that same homey appeal. In "Alice Adams"

EYEWITNESS PHOTOS

by
CHARLES RHODES

Concert season in Hollywood found many stars in attendance. I snapped this shot of Luise Rainer, who arrived at the affair with William Wyler

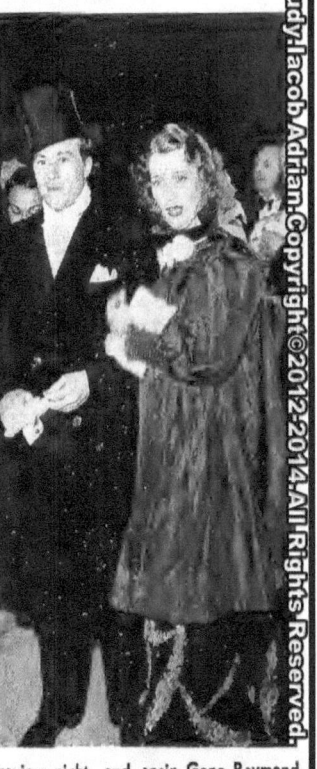

No one ever looked more proud of her boy friend than Irene Hervey when she emerged from the preview of *Showboat* with Allan Jones

Arriving at a gala Hollywood party, Myrna Loy displayed her smart evening gown as her escort, Arthur Hornblow, prepared to doff hat and coat

Preview night, and again Gene Raymond appeared with lovely Jeanette MacDonald. Still, they're only good friends as far as anyone knows

Bob Taylor—who incidentally once squired Irene Hervey, is shown here with Frances Nalle, pretty Texas girl, one of seven Search for Talent winners feted by all Hollywood

Joan Bennett, hostess at the latest Mayfair party, sat with Joan Crawford during the dinner. I never found a more brilliant array of stars than here

Stopping in at the West End Tennis Club, I took this candid shot of James Stewart, Betty Furness and Henry Fonda

WIN CHARLES BOYER'S PORTABLE PHONOGRAPH

Hollywood

5¢ a copy

SEPTEMBER
NSC

5¢

Natural Color
Photo of
**JOAN CRAWFORD
ROBERT TAYLOR**
in
"The Gorgeous Hussy"

JOAN CRAWFORD TALKS ABOUT BOB TAYLOR

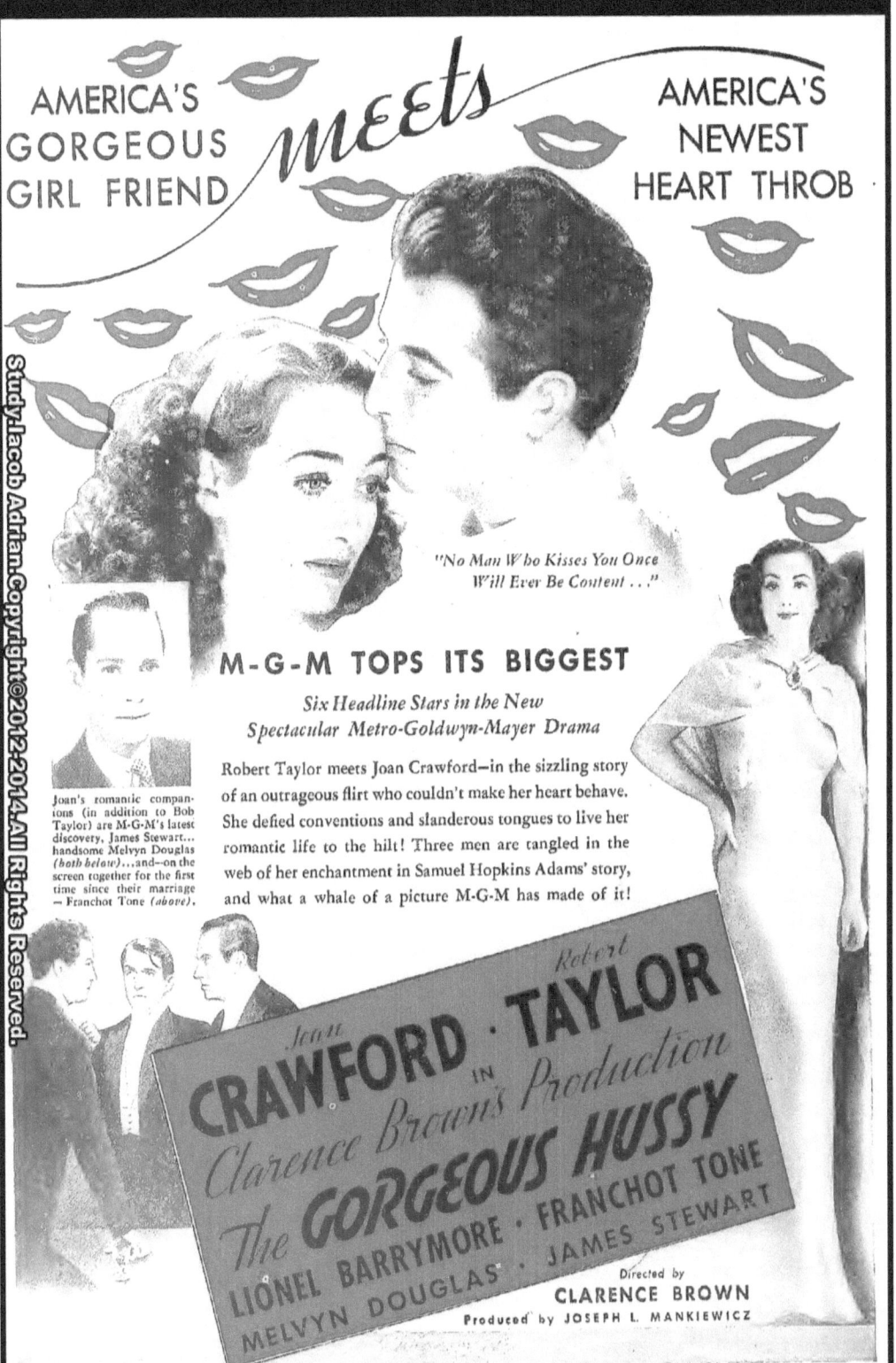

Joan Crawford Talks

"YOU HAVE To know Bob to fully appreciate him," says Joan Crawford. And then she tells of having watched women visitors on the set watching him. They come hoping for a peek at him because he is so handsome, and to see if he is really as handsome off the screen as he is on. One look satisfies them. But after a while they discover there is more to be found out about him.

They see his easy, graceful naturalness, his thoughtfulness of others, they observe his serious workmanship before a camera, they hear his laugh, and they turn to each other and you can see their mouths forming the words, "Say, you know he's all right!"

Joan can appreciate this tinge of surprise in their attitude because she, in a way, has experienced the same thing herself. She, too, has found that there is a lot more to Bob than a beautiful hair-line, a broad pair of shoulders and a distinctive nose.

If you are one of Bob's fans you can appreciate what Joan Crawford means. There have been hundreds of letters wanting to know what Bob Taylor is really like—whether he is a swell, likeable fellow, or whether he is "just good-looking," with only good looks to recommend him. This suspicion is only natural. All beautiful heroes and heroines come in for it during the early part of their career. It's a result of the "beautiful but dumb" phrase which has been repeated for years. Not knowing Bob, one is quite apt to think: "With so many physical attributes, he *can't* have much else!"

We think even Joan Crawford had this attitude about him at first. We know that some time ago when Joan gave a Sunday afternoon soiree for an important musical personality, Irene Hervey, whom Bob was squiring at the time, was invited but Bob was not. Though Joan had met Bob with Irene it just never occurred to her that he would be interested in a musical

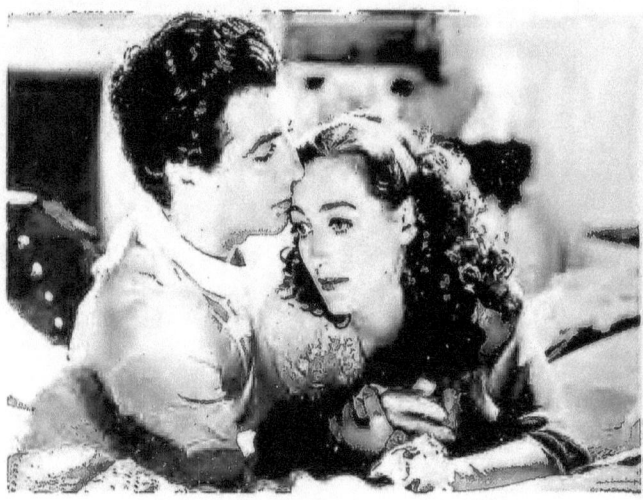

A scene like this from *Gorgeous Hussy* may arouse the envy of most fans, but after all it is just acting! Cast together in this picture, Joan and Bob became fast friends

gathering of that kind. But that was before they started working together in *The Gorgeous Hussy*. That was before Joan learned to know him as she does now. Perhaps in her "discovery" of the Bob Taylor behind the Good Looks Taylor, you'll gain a clearer picture of him too.

Joan Learns About Bob

● "THE FIRST DAY we started to work both of us were extremely nervous," Joan says. "It was my first costume pic-

ture just as it was his. Both of us were trying to adjust ourselves to our costumes and to each other."

Her first surprise came when Bob said that he didn't think he was going to like wearing costumes. "I feel too fussed up, too dressed up, too showy—you know what I mean, as though I were on parade. I don't *like* being on parade. Do I *have* to wear these sideburns?"

Bob was not pretending. We know, because since that time we have watched him at work in *His Brother's Wife*. It's a story of a doctor's struggle in the South Seas. Throughout that picture he wears a pair of slacks and a white shirt, open at the neck, sleeves rolled up. His hair is uncombed, tousled. "This is great," he said. "I don't have to keep fixing myself up!"

But since most actors do like to "fix themselves up" this revelation naturally came as a surprise to Joan and the others on *The Gorgeous Hussy* set. Point number one in Bob's favor: a boy who likes to act but who doesn't like to act like an actor.

Then there was his intense desire to please. Joan and Bob had a difficult scene together the very first day of shooting. As they took their places for a rehearsal. Bob said: "Miss Crawford, I'd appreciate it very much if you would tell me how you'd like me to play this . . . if you have any suggestions."

Startled for a moment, Joan looked at him. Then she smiled, and a memory seemed to flit across her face. "Play it just the way you feel like playing it," she said. "I know you will do it all right."

Afterwards she explained that years ago when she was making *Possessed* she had asked exactly the same question of Clarence Brown—her director then, as he

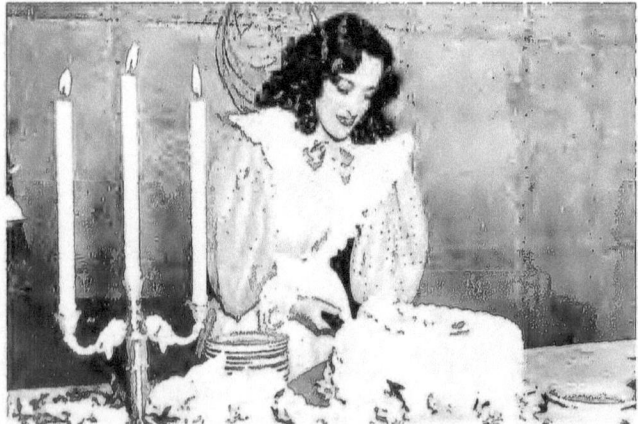

During shooting on M-G-M's picture, *Gorgeous Hussy*, Director Clarence Brown had a birthday. Joan is cutting the cake, and from the way she licks her lips, it must be grand!

About Bob Taylor!

is now in *The Gorgeous Hussy*—and that she had given Bob the same answer Brown had given her. "But I was only beginning when I asked that question," Joan added.

"You think I'm not now! You don't know what a beginner I am!" Bob retorted. "Anyway, thank you for giving me the confidence I needed."

A Sense of Balance

● THE WORLD SAYS he has "arrived." Bob says he still has much to learn ... that he's just beginning. This is what you call keeping a balance in a perilously unbalanced Hollywood.

Most of his efforts to please were less obvious and most amusing. Bob Davis, his friend and stand-in, discovered Bob in his dressing room spraying his throat with a mouth wash. "Got a cold?" Davis asked. "No, a love scene with Miss Crawford," Bob answered quickly. "She doesn't smoke very much and I do."

Anent Bob's smoking, a few days later he mentioned that he thought he'd give it up, because he wanted to gain some weight and he had heard that would help. Joan overheard him and the next morning at eleven there was a steaming milk drink at his elbow direct from Joan's little portable grill. "Your second dose comes at three!" she told him. "Go on smoking. This is what will do the trick! Give your Aunt Joan a chance, and she'll fatten you up. Look what she did for Franchot!"

Yet when we mentioned this to Bob he said, "Why Joan does things like that for everybody. She didn't just single me out. Did you hear what she did for Mr. Barrymore ..." and he was off on an anecdote about Lionel. Point number 3: his natural modesty.

In this respect we might also add that when Bob was talking about all the places he was going to see in New York—Grant's Tomb, the Aquarium, Central Park, the Brooklyn Bridge—someone said, "You won't have time for all that! There'll be so many women waiting to see you." Bob's only answer was "You're kidding!" He thought it *was* kidding too, until he got there and was mobbed by half the women in Manhattan.

Bob Awakens an Interest

● THEN THERE WAS the discovery of Bob's interest in music. As you know Joan always keys the moods of her scenes with music, and her phonograph is a fixed prop on every Joan Crawford set. One afternoon Joan was searching through one of her many albums—she and Franchot together have 3,200 records—for something appropriate for the next scene. She was having difficulty making a choice until Bob suggested a Brahms symphony which immediately hit the musical spot.

Joan looked at him with new interest but said nothing. The next noon when Bob, James Stewart, Melvyn Douglas and Clarence Brown returned early to the set from lunch, and they were playing some of Joan's records, they came across one which featured a soprano voice singing

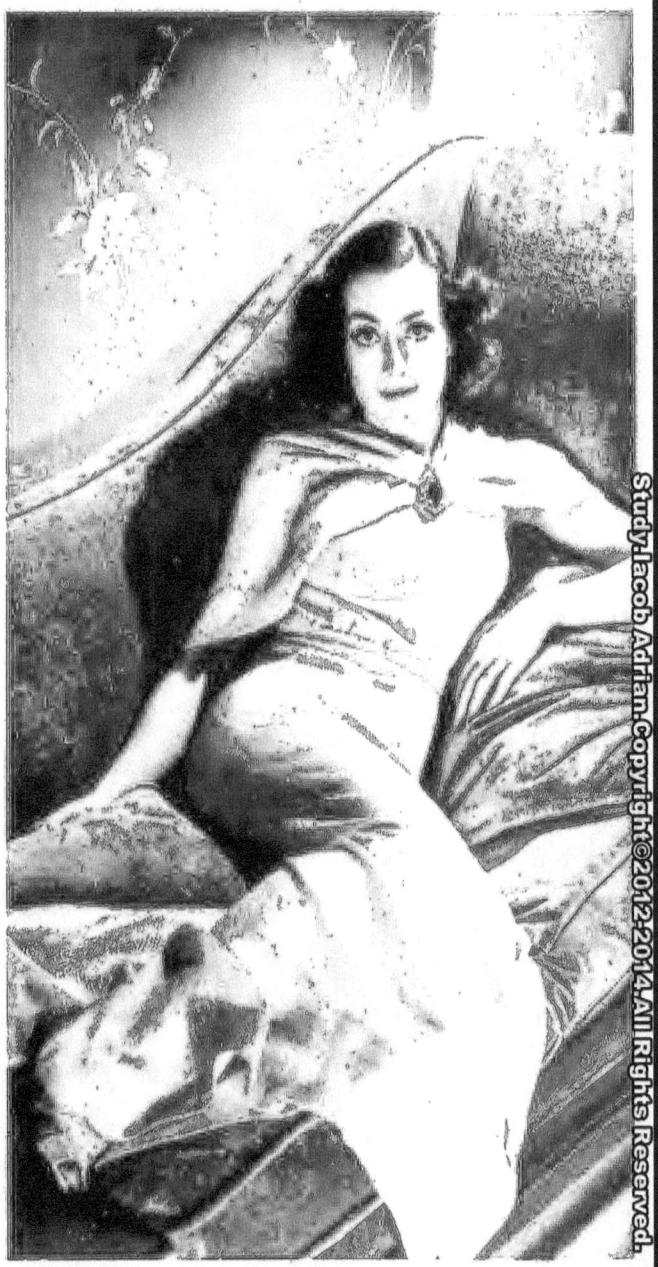

There was a time when Joan Crawford did not dream she and Bob Taylor shared the same interests. Not until she played in a film with him did she learn to know and like the handsome young star

Joan Crawford Talks About Bob

an aria from Bellini's opera *Norma*. No one could place the singer. A dozen suggestions were made. Then Bob, who was listening attentively, suddenly spoke up: "You're all wrong. I recognize that voice. It's Joan Crawford's!" And he went at once to find her to make her admit it. Joan looked at him, the second time, in amazement. "How did you know? You've never heard me sing! That's one of my home recordings . . . it was in that album by mistake. How did you recognize it?"

"I recognized it because it recalled your speaking voice." And he went on to explain that while he had never studied singing, he had worked under one of the finest cellists in the country, and that had naturally developed his appreciation of tone qualities . . . to learn a distinction in instruments is the same as learning distinction in voices.

Bob Sings a Ditty

● INCIDENTALLY BOB SINGS a little ditty in *The Gorgeous Hussy*—"But not as a singer singing," he insists. "Just as a fellow having fun. I wouldn't want anybody to think I thought I had a voice. It's a goofy old sea chanty, and as such it really doesn't require any voice.

"'If all the world were paper,
And all the sea were ink
If all the trees were bread and cheese,
What would we do for drink'

"That and a couple of more verses like it is all there is to it!"

But if Bob doesn't take his singing seriously, he should at least take his dancing seriously, for he *is* a beautiful dancer. He and Joan do a Hornpipe together in the picture, but she discovered what an excellent ball room dancer he was when they took a turn or two around the set one day between scenes. And Joan isn't the only one who will attest to this Taylor prowess. Little Eleanor Whitney, who, like Joan, first won her fame dancing, says that he is one of the best she knows.

Still he never talks about any of these accomplishments. Bob Taylor is one of those people you are constantly finding things about—because you have to do literally that, find them out for yourself. He never volunteers. For example, if it hadn't been for that cooped-up butterfly in Clarence Brown's car, no one would have ever known that Bob was well schooled in entomology—the study of insects, to you!

Joan says that she discovered the butterfly on Clarence Brown's steering wheel, and thought it was so beautiful that she caught it in her hat, to examine it closer. She was just about to call the museum and try to find out what species it was when Bob came along. "Oh, that's a Tatilio Terganus," he said. "Or sometimes it's called Edward's Swallowtail. They're quite rare . . . bring $7.50 a pair." Joan realizes that it's a small point, but indicative. Bob has a keen knowledge on many such interesting subjects.

Supper at Joan's House

● NATURALLY YOU CAN see where all this was leading to . . . direct to a Sunday evening supper at Joan Crawford's house . . . where Bob went one evening with Barbara Stanwyck. Barbara and Joan have been good friends for years. When Joan was married to Doug Fairbanks, Jr., Barbara and Frank Fay lived right across the street, so they're really neighbors of long standing. But it wasn't because Bob is now best beau to Barbara that he was invited to Joan's. It was because Bob was Bob and because Joan wanted his friendship.

That is the greatest recommendation anyone can have in Hollywood for, as you know, all Joan's friends have something distinctive about them. They are all busy, doing-things people. They are all "important" people, not in a business or social sense, but important of themselves, because they are worthwhile.

Joan pays her own tribute in this way: "I find Bob most considerate and wholly unconscious of his growing popularity. Working with him has been delightful and I should love to make another picture with him. My only regret is that he didn't have a bigger rôle in the picture. His part is small but rather than turn it down he said that he welcomed the experience he would gain from it. The only way I feel I can pay him back is by playing leading lady to him. Which I will look forward to doing some day!"

That, from Joan Crawford, is a lot!

Know He's Famous...

As a result his habit of mind is fixed upon their rules of living: innate modesty, good manners, good taste, and moderation. Valued traits, these, which are so thoroughly ingrained as to protect the son fully against gaping pitfalls prepared for all Hollywood stars. Make no prediction of a rush of vanity to the head in this instance.

Proof Of His Calmness

● ACTUAL INSTANCES, HOWEVER, will best demonstrate the odd fact that a star can be unaware of his fame, even with the entire country in a furore.

It was during the filming of *The Gorgeous Hussy*, starring Joan Crawford with Bob playing the lead, that he was invited by HOLLYWOOD Magazine to join a group entertaining seven contest-winning girls. An apology would have been accepted from him for inability to attend, for picture making is gruelling work—yet Bob was first to arrive and graciously did his part. Such courtesies are not common in starland.

Realizing that this was an unusual young man indeed, we quietly investigated the facts in the case.

At his studio an effort was being made to induce Bob to make a personal appearance in New York. For reasons he kept to himself, Bob did not want to go. And this is why, as he informed your HOLLYWOOD reporter:

"I'm afraid the studio will discover I'm not such a good drawing card, after all."

This surprising attitude is difficult to believe, yet it is no exaggeration.

Having never been to New York, Bob was inclined to think that his arrival would create no especial excitement. True, Nelson Eddy came back to M-G-M with echoes of his receptions still ringing in his ears, but Nelson, according to Bob's point of view, is another story. "Even without his magnetic personality, his voice would make him great," Bob points out—with considerable logic. "I am by no means an important actor with a stage following. I have no remarkable talents. I'd rather stay here and go on working my way up."

We pointed out the publicity value of a cross country trip—how reporters and cameramen would bombard him at every stop from Albuquerque to Yonkers.

Bob grinned amiably, and shook his head. "That would be a pretty hard job for any studio to arrange," he insisted.

First Trip From Home

● ONE REASON FOR his naiveté is his utter lack of conceit or professional jealousy. Another is his home training. He was eight when he climbed his cowpony for a fifteen mile ride to his grandmother's place. His father, the town's leading doctor, waved him goodbye. Some miles out of town the lad called his father on a rancher's phone.

"It's pretty far, Dad," said a childish treble. "maybe I'd better come home."

"You go on to grandmother's," said his father. And the boy finished his ride. He learned self reliance the hard way. An only son, Bob was obliged to devise his own entertainment and be self-sufficient. He is that way today—a few friends suffice. There was another advantage to his upbringing; his mother and father gave him adult companionship, and this means usually an adult-minded child you can reason with.

All of this was to help Bob over the jolts in Hollywood. He got into pictures not because he happened to be born with those clean-cut features which exemplify the American girl's dream of the American boy; he got his break playing the difficult rôle of the hard-drinking, cynical

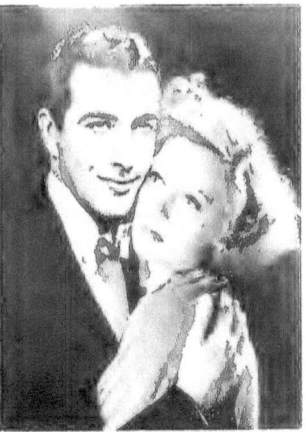

Next in line for Bob Taylor is *Camille*, starring Greta Garbo. This composograph shows how they will look in love scenes

Taylor is a young naval officer in Joan Crawford's forthcoming picture, *The Gorgeous Hussy*, a story of the early 19th century

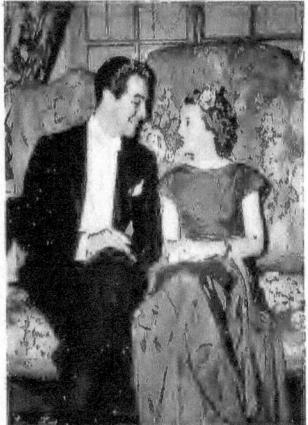

Especially wild were the rumors of a romance between Taylor and Janet Gaynor when they made *Small Town Girl*

Captain Stanhope in *Journey's End*, at the Pomona playhouse. A Metro-Goldwyn-Mayer talent scout saw the performance and he was signed.

Bob was still a greenhorn from Nebraska. He had attended college for two years at Doane, Nebraska, and then his mother decided to bring him to Pomona to finish his college education. He continued in school after signing with Metro, graduating with his degree as Bachelor of Arts.

Time went on and very little happened to further Bob's career. He began to feel as if he were the forgotten man in this huge studio. His earlier success in amateur theatricals began to seem rather insignificant to him.

Back in Nebraska, at the Paduah Hills Playhouse, he had taken the rôle of Armand in *Camille*, and done well by it. Now, he was beginning to believe, he couldn't qualify for a walk-on bit in one of these huge productions going on in the world's largest motion picture studio. Finally he took his courage in his two hands and went to see that omnipotent and mysterious figure, Louis B. Mayer. Bob asked for a release from his contract. In fact, he insisted. He intended to go to New York and try to find stage work.

A Dazzling Wardrobe Appears

● MR. MAYER shook his head. "You have a future with us," he said. "You've got grit. You've shown you can act. Maybe you've had some tough breaks so far, but we'll put you to work. Meanwhile, we'll do some campaigning for you."

Bob wasn't quite sure what that meant, but he soon learned. The studio wheels began to grind. Bob was called in and slicked up by the wardrobe department. Four good suits were added to his private collection, and Bob noticed "Okayed by

HOLLYWOOD PRODUCTIONS

Battle of Wits on the *Cheyney* Front!

WILLIAM POWELL, properly sideburned and with servile pose, walked onto Stage Eleven bowing pleasantly to everybody.

"Good morning, Madam," he greeted Joan Crawford.

"Good day to you, Sir," he bowed to Robert Montgomery.

Montgomery took an extra draw on his pipe, surveyed Powell up and down—his sideburns, his meticulous store-purchased butler's suit.

"Had I known you were going to play *Little Lord Fauntleroy*, I would have worn a bib for my wardrobe!" said Montgomery.

And the Battle of Wits was on, to continue for several weeks during the filming of *The Last of Mrs. Cheyney* and with such other inimitable mimes as Frank Morgan, Nigel Bruce, Benita Hume, Ralph Forbes, Jessie Ralph, Aileen Pringle and Phyllis Claire wielding a barb of banter as occasional competition.

Smart English Comedy

The smart English comedy from the facile pen of Frederick Lonsdale was distinctive in many other ways. It made a butler of Powell, who is so closely identified with detectives and lawyer roles, and divorced him from his many lovely screen wives. It returned Joan Crawford to conservatism, both in characterization and fashion. In it, she appears as smart instead of sensational, distinctive instead of eccentric, graciously sophisticated instead of brittlely flamboyant.

Joan Crawford as Mrs. Cheyney in *The Last of Mrs. Cheyney*, admonishes William Powell, who plays the butler role: "You shouldn't have come here until I gave the word"

Robert Montgomery, playing the detective role in *The Last of Mrs. Cheyney*, reminds Joan Crawford, playing the name role, that he is in love with *Mrs. Cheyney*

"The 1937 Joan Crawford, who makes her new bow in *The Last of Mrs. Cheyney*," Adrian, M-G-M's fashion dictator, predicts, "will become the new person who typifies the things for which women strive. While the earlier type of womanhood she portrayed was obviously dramatic, the new Joan Crawford will become intangibly dramatic."

"She should play more conservative roles, as she does in her new picture," commented a technician on the set. "Her unusual talents should not be confined to freakish interpretations on the screen. They are more adaptable to level-headed portrayals."

While conservatism on the screen is preached for Miss Crawford, there is no conservatism on Stage Eleven.

A one-day visit on the sound stage is sufficient to prove it.

Settings Palatial

The scene is the stately exterior of the Duchess of Ebley's English mansion with its surrounding gardens, hedges, paths, terrace and ornate fishpond. The director has squeezed his corpulent personage into a canvas chair to scan his leather-bound script. The electricians on their high perches and in the rafters are tinkering with the huge lights. Cameraman George Folsey is bossing his assistants around.

Montgomery and Nigel Bruce are lazing near the pool, watching two overalled

"My dear Mrs. Cheyney—you are a godsend!" Benita Hume thus compliments Joan Crawford (center) in a scene from *The Last of Mrs. Cheyney*, with Nigel Bruce and Robert Montgomery on the left, and Frank Morgan and Ralph Forbes on the right. When you read the story you will see that this group of sterling players had rare fun in making this Metro-Goldwyn-Mayer production

Battle of Wits on the Cheyney Front!

workers skimming scum from the water.
"I say, Bobby," quizzes Bruce, "what would you call the duties of those two chaps?"

Montgomery watched the scum-scooping a moment.

"I would say, my dear chappy, that they are an inanimate League of Decency," was Montgomery's parry of wit.

The roseate Englishman wriggled his eyebrows at Montgomery, arose from his chair and sought other fields for conversation. He met Miss Crawford emerging from her dressing room.

"Cheerio, Joan," he greeted her. "I saw your husband, Franchot, last night and he appeared quite white . . ."

Montgomery Retorts

"Oh, yes," came a voice from behind his back. "It's a law for Americans to marry whites."

It was Montgomery, still stalking Bruce.

Montgomery scrutinized Miss Crawford, discovered the snug little black hat on her head, surmounted by three little black pom-poms.

"What a lovely hat," he complimented her. "Looks like a Palm Springs sunset."

The work of preparing the stage, the props, the lights and the camera continued. Time still remained for the Battle of Wits on Stage Eleven.

Powell was walking toward Miss Crawford.

"I'm afraid you're mistaken—this is my room!" Thus Frank Morgan argues with Joan Crawford in a scene from Metro-Goldwyn-Mayer's *The Last of Mrs. Cheyney*.

"You haven't seen your new dressing room, Bill," she reminded him. Let me show it to you."

Powell cautiously peeked in. It was furnished in the loveliest Louis VI style, gaudy plush furnishings, dazzling drapes, maukish paintings, a bowl of flowers and a sewing basket. Powell took another look, then confessed:

"H-m-m, either I must speak with a cockney lisp in this picture—or abdicate."

Frank Morgan was in a corner of the set, confiding quietly to Benita Hume.

"Heaven knows, I've always wanted to be a tragedian and that's why I am a comedian. The difficulty with the tragedian is that he wants to live his baleful roles in private life as well as on the stage or screen. He has been in the habit of snarling all day into the camera and when he arrives home he continues to snarl at his wife and she . . ."

Director Bellows

"Children!" the director bellowed. "This is no kindergarten. We are paid to work, to make the world laugh and cry. Let's go to work!"

The scene revealed all the principals seated on the terrace around the breakfast table, nibbling little sausages. Miss Crawford has just been unmasked as an American adventuress who, posing as a wealthy widow, had attempted to steal the duchess' pearls. Powell, too, has been unmasked by the clever amateur detective work of Montgomery, and he stands at her side.

"Off-stage—quiet!" the director shouted.

Montgomery moved into the scene, moving a chair under Miss Crawford.

"Won't you have a chair?" he asked.

"Thank you," she replied haughtily. She sat down. "As Charles was born a gentleman, mayn't he sit down as well?"

"Of course," Montgomery apologized. "Take a seat, Charles."

Can this be our sunny Joan? More than once during the making of *Mannequin* she turned this hostile glance at Spencer Tracy

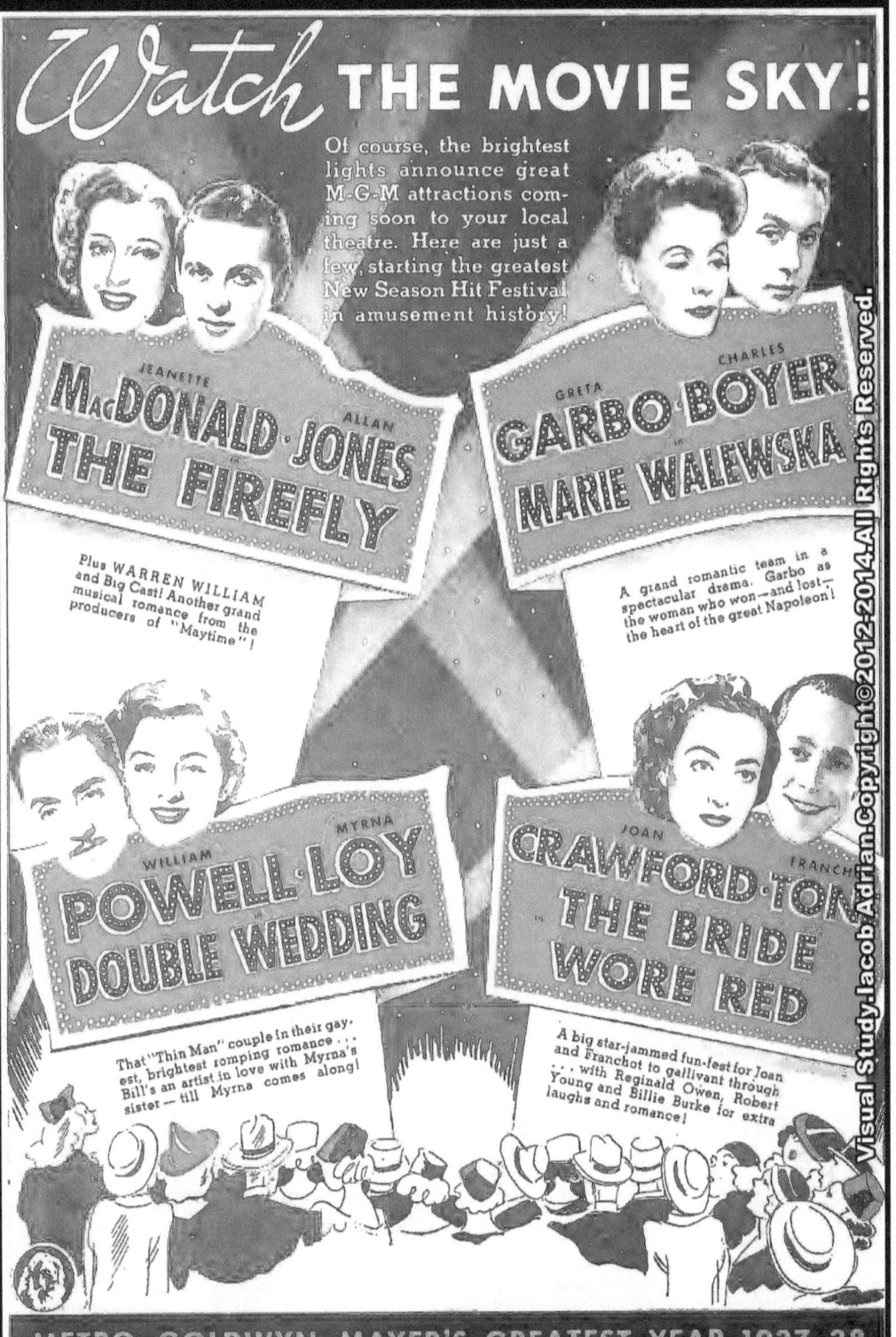

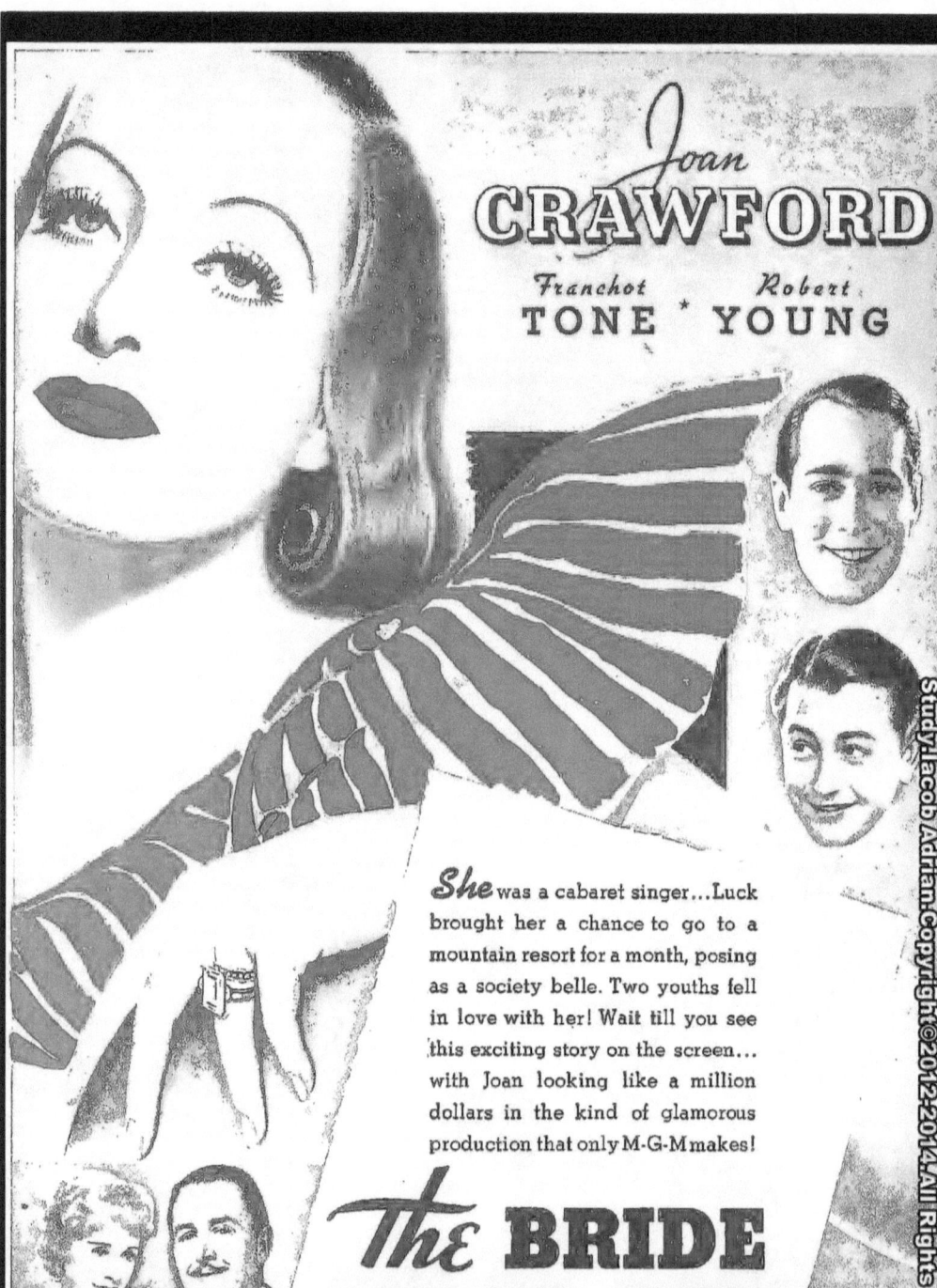

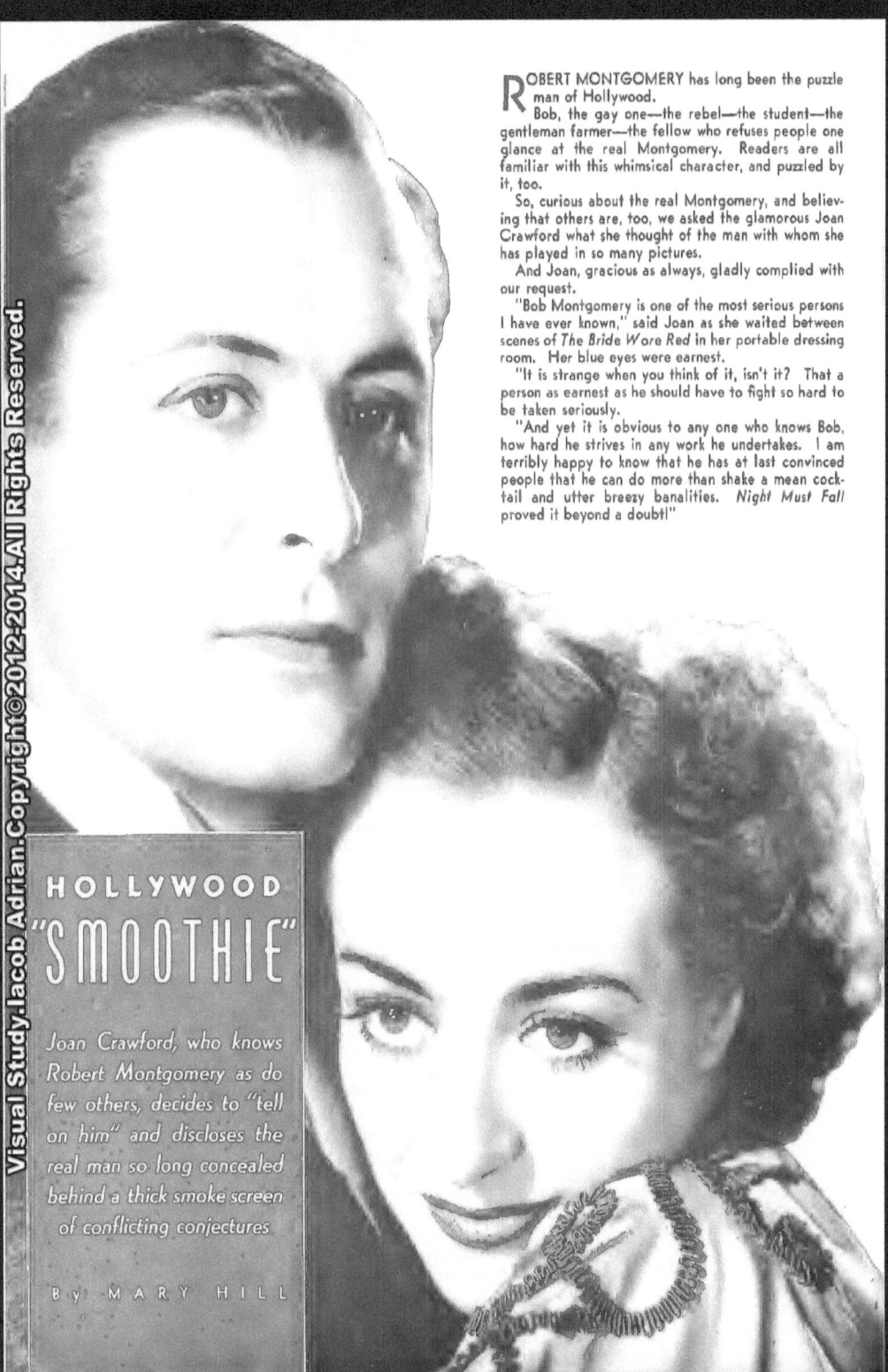

ROBERT MONTGOMERY has long been the puzzle man of Hollywood.

Bob, the gay one—the rebel—the student—the gentleman farmer—the fellow who refuses people one glance at the real Montgomery. Readers are all familiar with this whimsical character, and puzzled by it, too.

So, curious about the real Montgomery, and believing that others are, too, we asked the glamorous Joan Crawford what she thought of the man with whom she has played in so many pictures.

And Joan, gracious as always, gladly complied with our request.

"Bob Montgomery is one of the most serious persons I have ever known," said Joan as she waited between scenes of *The Bride Wore Red* in her portable dressing room. Her blue eyes were earnest.

"It is strange when you think of it, isn't it? That a person as earnest as he should have to fight so hard to be taken seriously.

"And yet it is obvious to any one who knows Bob, how hard he strives in any work he undertakes. I am terribly happy to know that he has at last convinced people that he can do more than shake a mean cocktail and utter breezy banalities. *Night Must Fall* proved it beyond a doubt!"

HOLLYWOOD "SMOOTHIE"

Joan Crawford, who knows Robert Montgomery as do few others, decides to "tell on him" and discloses the real man so long concealed behind a thick smoke screen of conflicting conjectures

BY MARY HILL

SHE SHALL HAVE MUSIC WHEREVER SHE GOES

BY JOHN LEROY JOHNSTON

At the peak of one of the world's most brilliant careers Joan Crawford admits she is counting the days until she can prepare herself for a second career—the ultimate career of her dreams. For Joan Crawford aspires to the opera and to the concert stage, and when Joan Crawford sets her mind to a thing she usually accomplishes it.

Joan Crawford's great passion is music. Few actresses have surpassed her in the ranks of movieland's famous stars; in popularity; in beauty or industry, but Joan is far from satisfied with her attainments. By 1940 she wants to win the plaudits of her friends and critics, not by her motion picture work, but by the sheer merit of her singing voice. To reach such heights Joan Crawford has quietly but consistently carried out a well organized plan to perfect herself for the singing roles she hopes to play a few years hence, and she sincerely looks upon her brilliant movie career as a mere prologue to what is planned for the future.

No star in the history of the screen has evidenced day after day a more honest love for music or has taken greater inspiration from the finer works of musical composition, of interpretation and of individual expression than the star of *The Bride Wore Red*, and *Mannequin*.

In her home the restful music room contains a huge combination radio and orthophonic phonograph which is switched on most of the time the actress is at home. There are special musical selections for early morning when she makes ready for the studio, others for breakfast, others still for evening. Hers is not an artificial or affected love for music but a deeply genuine dependence upon music and a true appreciation of its influence.

At the studio, her portable Colonial dressing room is never more than ten feet from a special phonograph and Eddie Claremont, whose sympathetic understanding of music and of Joan's moods has kept him steadily employed at that phonograph for nearly four years.

In 1933 Eddie Claremont came to Miss Crawford's dressing room to deliver 20 operatic records the star had ordered by phone. His manner and his interest in the records impressed his customer. Today he has 5,000 records catalogued (most of them memorized and within easy reach)

Joan Crawford on the set of *The Bride Wore Red* with Eddie Claremont who delivered some records to her four years ago, and who has been playing music for eight hours a day ever since

and without instructions he proceeds, as Joan says, "to work out a musical score for every day of the picture." He senses Miss Crawford's moods by her morning greeting. Throughout the day he plays recordings which he feels will help build the spirit in her work.

"One day recently I had some excited, staccato scenes to do," says Joan. "Scenes that forced me to act mentally upset, impatient, cranky. Miss Arzner, our director, explained the tempo. I went to my room to read over my lines and rehearse by myself. Suddenly Eddie started playing *Poor Johnny One Note*. He played it and played it until I thought I would go frantic. When I was called to the set I gave him a wilting look but he smiled and played the song twice more before the scene was shot. I was certainly in the mood for that scene! We finished the whole thing in a minute or two! Eddie kept out of the way for a few minutes afterward, but he knew he was really helping me, even though I didn't appear exactly pleased by the song."

Miss Crawford has a standing order for 200 recordings each month and frequently orders 50 and 100 English, French and German records from Europe. She has 2,000 European records. She has every record Bing Crosby has made; the last records made by the late Russ Columbo. Her file on Henry King, Benny Goodman and Eddie Duchin is complete. She likes Gertrude Niesen's throaty recordings and the records of Frances Langford and Ruth Etting. Ray Noble's recordings put her in a dancing mood and when she appears in romantic scenes there are always a dozen Gene Raymond (British) or Wayne King records near the studio phonograph. Henry King's recent *My Day Begins and Ends With You* is a favorite. She admits being thrilled by the singing of Paul Robeson and Lawrence Tibbett, and a negro choir always wins her enthusiastic applause.

Among her most played records are *La Traviata*, *Rigoletto*, *La Tosca*, *Madame Butterfly*, de Bussey's *By the Light of the Moon*, *Tristan and Isolda*, *Overture to Rienze*, Schubert's *Unfinished Symphony*, *Walk to Paradise*, *Afternoon of a Fawn*, Sibelius' *Swan of Tuonella*, and most any instrumental number chosen for recording by Stokowski. Her supreme favorite among songs is *When I've Sung My Songs to You*. Verdi's *Requiem* is possibly her second choice. *None But the Lonely Heart* and *Andante Cantabile*, *Broken Heart* and *Whisper and I Shall Hear* are others which rank high in this music lover's favor.

She aspires to sing many notable religious songs in concert when she is ready and says that few singers have thrilled her as Marion Anderson, the negro contralto, in her program of spiritual numbers.

"Franchot should be ready for opera in two years," says Joan. "He has a splendid voice and is studying all the time. My concert ambitions must wait for the completion of my movie contract but I hope to be ready for an honest trial in three years. No person can give proper attention to two careers at once so I don't attempt it. I take my screen work very seriously and try very hard to bring something new into each new picture, but, when they turn out the lights on my last picture, then I'm off to Europe for broader study and I hope—a new success."

Both Joan and Franchot Tone have been studying voice for some time with Signor Morando, a well known operatic voice coach in Los Angeles. They have daily vocal exercises that are never neglected. Only a few close friends have ever heard Joan Crawford sing because she refuses to sing even before friends until she feels she is ready, but Joan Crawford is still a very young woman and a very talented one.

"I'LL DO IT IF IT **KILLS ME!"**

says Joan Crawford...

a dramatic statement, says you...

a dramatic star, says we...

a dramatic story, says all...

Read it in the January issue of MOTION PICTURE now on sale at your newsstand. Get your copy now because you won't want to miss this or any of the other dramatic stories about your screen favorites in MOTION PICTURE

MOTION PICTURE was the first fan magazine and remains first in revealing the interesting incidents in the lives of Hollywood's glamour people to its fans.

10 CENTS

hollywood radio beam
By GORDON W. FAWCETT

■ Motion picture producers, who just a short time ago were battling the advancement of radio, are now figuring out ways and means of cashing in on its popularity. Metro-Goldwyn-Mayer has just completed a deal with General Foods and for the next 36 weeks radio fans should be able to dial in on a program put on by some of the best picture personalities of the day. Bill Bacher, the genius behind the Hollywood Hotel program, has been engaged to produce the General Foods M-G-M program which makes it doubly sure that it will be a program well worth listening to.

Warner Brothers' Studio is looking for a similar set-up. Most naturally their program would be built around Dick Powell whom they jerked off the Hollywood Hotel hour some eight months ago.

Twentieth Century-Fox is capitalizing on radio in a very big way. All of their players are open for radio programs but if they are to "go on the air" the advertiser must pay plenty for their services—and one-half of the salary goes into the studio coffers. Paramount, United Artists, Universal, in fact all of the studios are becoming very much radio minded.

■ Jack Oakie gave a party for the radio press immediately after the inauguration of his Oakie College last October. Oakie's program this year is to carry continuity from week to week. Stu Erwin will be the star footballer of Oakie College as well as being a very able stooge for Oakie's gags.

■ Hollywood will be originating over 90% of the personality programs on the major networks by the middle of November. Rudy Vallee, Fred Allen and Phil Baker will shift back east, however, as soon as current picture obligations are fulfilled. Eddie Cantor will also etherize his program from New York, but for only a few weeks early next year. As it is now, the following big names are all coming to you direct from Hollywood: Jack Benny, Fred Allen, Burns and Allen, Jack Haley, Ben Bernie, Sid Skolsky, George Fisher (subbing for Walter Winchell), Bing Crosby, Bob Burns, Lany Ross, Chas. Butterworth, Amos 'n' Andy, Jimmy Fidler, Chase & Sanborn Coffee Program, Irene Rich, Tyrone Power, Rudy Vallee Variety Hour, Hollywood Hotel, Ken Murray, Joe Penner, Al Jolson, Lux Radio Theatre, Alice Faye, Jack Oakie, Eddie Cantor and Jeanette MacDonald.

■ The premiere of Woodbury's Hollywood Playhouse Program, starring Tyrone Power was a brilliant one. Power has a guest star each week in front of the mike, and plenty of famous friends in the audience. Darryl Zanuck, Tyrone's boss, was on hand to give the opening program a touch of brilliance. Zanuck had forgotten his promise to appear with Power and when the studio got in touch with him he had just fifteen minutes to get to the studio from his ranch in Encino. That probably explains his showing up in blue dungaree's, boots, and a turtle neck sweater topped off by a plaid sport coat.

■ The sound effect technician of the Lux Theatre is supposed to have the largest library of "effects" in the world. But in a recent Radio Theatre production he had to stop and think. One of the background sounds of the production was a swinging gate, a little bit rusty. First of all he looked for a rusty gate in Hollywood to get an idea of the sound. None was to be found. Then calling on a boyhood memory of what such a gate was like he tried every possible combination of equipment in his "library." None of it sounded like a real gate. So eventually he just went ahead and built a gate, using some old hinges. Oddly enough it sounded just like a rusty gate—that is, the third one he built, did.

■ One topnotch radio comic is threatened with having his long time contract cancelled if he doesn't show up for rehearsals. His sponsors have agreed to give him one and only one more chance ... Bob Burns revealed on a recent broadcast that if he has no oil handy he uses lard to keep his bazooka in tip-top shape ... Sidney Skolsky, the most recent newspaper columnist to turn to radio, suffers terrifically from "mike fright." The studio has a big lounge chair for Sidney to relax in during his broadcast ... Hollywood, known for the unusual, held a party recently with one of its hosts missing. Leading radio and screen celebrities, radio executives and friends gathered in Sardi's Blue room to give Jack Haley a big send-off for his first radio show. Jack Benny, one of the hosts had to stay in Palm Springs under doctor's care with a bad cold ... On a recent Lux program Barbara Stanwyck had to portray by voice alone the same character at the age of 19, 24, 30, 36, and 40 years ... Col. Ezra Simpson, in my opinion will be a big radio name in the near future ...

Shopgirl's Millions...

Through the doors of that workshop ceaselessly flowed girls, girls, girls ... each with a dream and a hope beyond reaching. Here is one shopgirl who lives a drama so amazing, so rich in deluxe living, that it will fascinate and excite you. And Jessie might have been you, or you, or you!

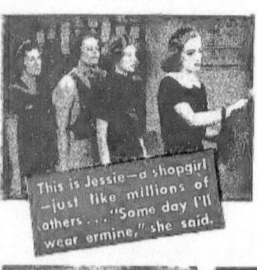

This is Jessie—a shopgirl —just like millions of others... "Some day I'll wear ermine," she said.

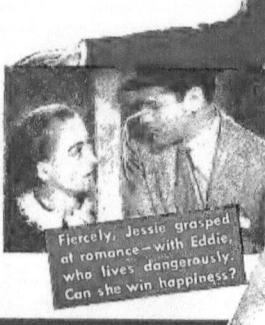

Fiercely, Jessie grasped at romance—with Eddie, who lives dangerously. Can she win happiness?

The wedding party interrupted by the wealthy Mr. Hennessy. Drama enters her innocent life.

Jessie toils to keep their "three-room heaven"... while Eddie gambles— with their love at stake!

"I've only come to you for advice, Mr. Hennessy. Your yacht and penthouse don't interest me!"

JOAN CRAWFORD
SPENCER TRACY
IN
Mannequin

WITH

ALAN CURTIS · RALPH MORGAN

A FRANK BORZAGE Production

A Metro-Goldwyn-Mayer Picture
Screenplay by Lawrence Hazard
Directed by FRANK BORZAGE
Produced by Joseph L. Mankiewicz

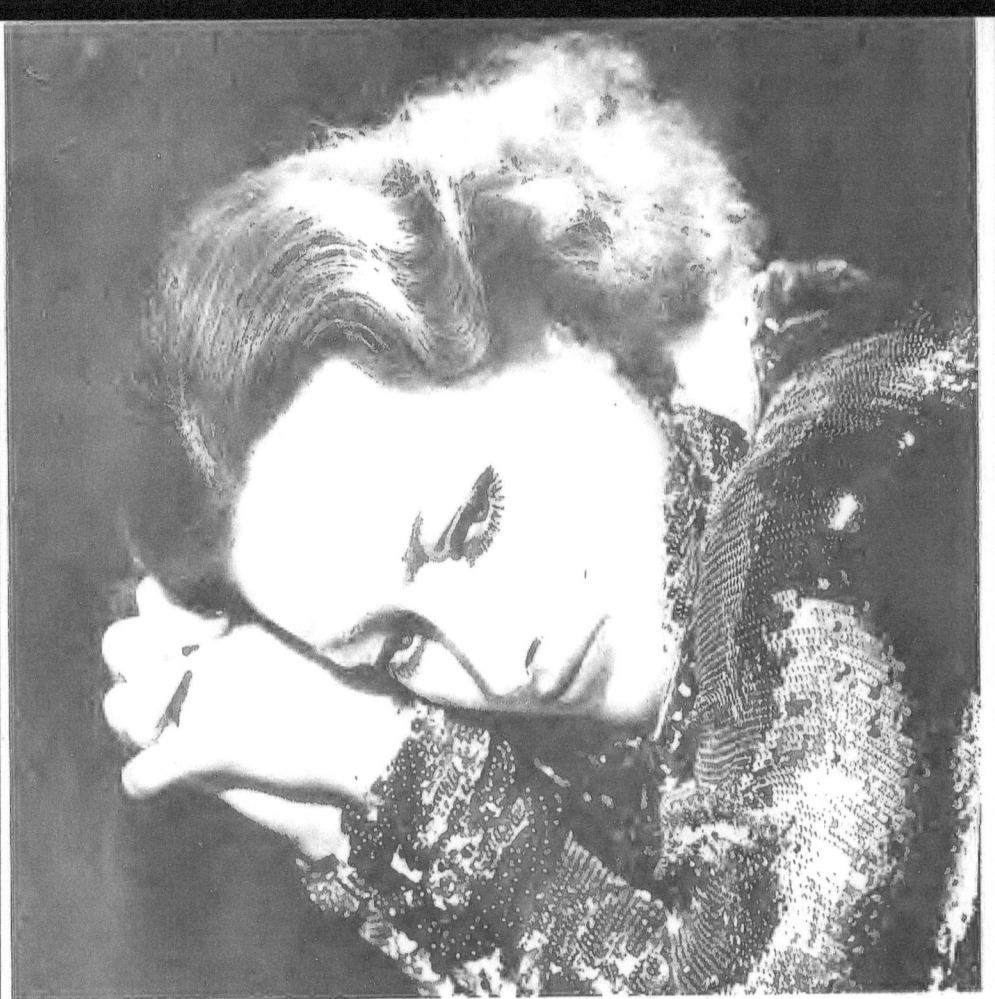

Can this be our sunny Joan? More than once during the making of *Mannequin* she turned this hostile glance at Spencer Tracy

It's Undeclared War!

No formal declaration ever was made, but the exchange of bright barbed quips was fast and furious when the stars let temperament get the better of diplomacy

By TED MAGEE

"You know I love you more than anything in the world, don't you darling?"

Spencer Tracy pressed Joan Crawford close to him and gazed fervently into her eyes. The kiss that followed was one of those things that makes Crawford admirers feel their hearts go flippety-flop from coast to coast—and that's a pretty big flop for the best of them.

"Okay, that's swell," Director Frank Borzage said to everyone on the *Mannequin* set as he reached in his pocket for his pipe and turned away for a smoke. But those standing close to Joan and Spencer suddenly found reason to think things were about as okay as the middle of Shanghai.

Joan was still whispering to Spencer. "Pretty good kissing you think, huh? I'm probably the only one on the set who doesn't think you're another Valentino."

Spencer was ready for that one, for he replied, "Your lipstick looks all right but it doesn't taste so good. Thank God there aren't any retakes."

An unholy light sparkled in the Crawford eyes. Ignoring his remarks she rejoined, "Come along, dear. There's a sur-

prise awaiting you without." The two of them walked off the set arm in arm, but still their eyes had more daggers in them than the whole Chinese army and the Afghans thrown in for good measure. Joan smiled mysteriously and said, "This, darling Spencer, is a tribute to your ego."

They swung around the corner and suddenly in front of them was Spencer's portable dressing room decorated with more colored lights than a Hollywood premiere.

"Very pretty," he said humbly, his eyes filling with non-existent mist, "and it bears the deft touch of a Crawford interior decorating scheme. Is it Christmas or do you merely go crazy over reds and greens?" he questioned.

What Spencer found inside the dressing room was more to the point than anything yet. Joan had had it decorated with huge stars of glistening silver, and twenty or thirty large photos of Tracy in various poses.

"You love yourself so much," she whispered gently, "that I thought this would do you a world of good. Now you can relax and see how very wonderful you really are."

■ One day of this on a Hollywood set is enough to make any movieland gossip writer dull his pencil if not his wits. This was war of the Hollywood kind, and it was being done in the modern manner —without open declaration.

From the very first of the picture, Director Frank Borzage realized that all was not quiet on the *Mannequin* front, on the first day Spencer seemed a trifle cool and aloof. That alone was enough to make people buzz with comment. He was very polite and formal, and the twinkle in his eye hinted of mischief to come. Joan was not slow to take her cue. By the end of the first week, people visited the set with avid ears, anxious to get in on what they considered possibly the best Hollywood feud in many months.

The first open break of relations was made by Spencer himself. During a lull in one of their love scenes, Spencer brought out a large batch of photos. They were of himself and L o u i s e R a i n e r. Haughtily, Joan refused to look. Instead, she sent her maid for photos of Joan with Clark Gable. The next half hour went by with Tracy lauding Rainer to the skies and Joan going overboard about Gable.

The next morning Joan was on the set early and the company was ready to go at nine o'clock. Cameras had been set up, lights tilted to the right angle, and props put in proper place. Joan was in make-up and standing around with Borzage.

Five minutes later Spencer came breezing in, wearing the proper clothes, for the day's shooting schedule. He tossed his hat in a corner and rushed for a mirror to see if he was ready to shoot.

Joan complained to Borzage: "That man Tracy is holding up the company again."

Spencer ignored the crack, but hastened to the set. An hour later Spencer caught Joan before the mirror primping up and commented, "Don't bother combing your hair, dearie. Nobody is going to look at it anyway."

■ One day, after a particularly tense scene in a little peasant shack, Joan remarked, "Mr. Borzage, can't you do something with this man?"

"What's the trouble?" Borzage inquired.

"Well, he's trying to act like a movie star," she said icily, with a strange smile on her face. "I guess he's been reading his publicity stuff again."

Spencer jutted his jaw out invitingly. "That remark," he said, "is an obvious display of temperament. Actresses who are sure of themselves seldom bother to be temperamental. Obviously, now that she sings a little bit, she considers herself a prima donna."

■ In the days that followed *Mannequin* got more publicity than the publicity department had hoped for in its fondest dreams. These two stars daily were putting on a show which was gathering reams of attention. Unconsciously, perhaps, they were conducting their own publicity campaign.

Even Borzage himself laughed openly while they were doing a dance scene which showed Spencer and Joan on the floor of a night club. The scene called for Spencer to dance with her and then suddenly walk away with his face full in the camera. Some technical trouble occurred, and Spencer walked out of the scene showing only his profile.

"We'll have to take it again," Borzage said. "Next time be sure you look at the camera."

Joan didn't miss the opportunity. "He hasn't failed to have his face full in the camera during this entire picture," she said sweetly. "And this obviously is no time for him to be breaking his record as a camera-hogger."

Spence whipped back with a fairly appropriate remark. "You know," he said to everybody present, "it has been an amazing experience to work with a high class thief. I never saw anyone steal as many scenes as she has. Boy, is she coldhearted!"

■ One of the biggest laughs came one day after Spencer had shown up on the set almost fifteen minutes late. He had come in from playing polo and had been so interested in his game that he had forgotten what time it was. Joan had shown no apparent interest in his arrival.

"Hm-m-m," thought Spencer, "the little gal must be weakening. She didn't have a crack to make. Well, I got away with that one."

But he didn't. The next day when he arrived on the set, an office boy presented him with a large and important looking package. When he opened it he found he had been given a sun dial. The donor's name was absent, but Joan's grin was a fair admission of guilt.

"Turn on the lights," Spencer said, "and make 'em real bright in this corner, I want the dope who gave me this to tell me what time it is."

■ Two things usually distinguish the Crawford set. Between the "takes" there is always music from a phonograph, and Joan

And can this be our gentle Spencer. Yes, indeedy, just in the middle of writing an ultimatum to his fellow player

It's Undeclared War!

always has her afternoon tea. Before the picture was over, she got Spencer to indulge a little himself, and then talked him into flipping for the honor of paying for the tea. For one whole week Spencer lost. Frequently, after losing the flip, he would forget to order the tea. Joan did not fail to take advantage of the situation.

"When Crawford buys tea, it's here to be enjoyed," she said. "But when Tracy buys the tea? Well—you've got to fight to get it. And like his soul, it's icy instead of hot."

After one of these daily tea parties, Spencer changed his clothes to formal morning wear as called for in the script. He wore the striped trousers, the long-tailed coat, and the other accouterments. Spencer gazed at himself in the mirror, smoothed out a wrinkle or two, and said to Joan, "Pass the word to your friend 'Moose' Gable. He needn't come back to the studio anymore."

Joan replied irrelevantly—or was it irreverently? "Spence, did you ever look at a flea circus?"

■ The picture was practically completed before the tip-off came. Time and again these two ribbed each other, and frequently both Spence and Joan fled from the set in laughter, both of them anxious to maintain a pretense of anger and scorn. On the final day of shooting, Joan let the world know the truth, however. She filled Spencer's room with flowers, and laughed joyously with him right after he had cracked, "Borzage, do something with this girl. I think she has the worst case of closeupitis I have ever seen."

Then they both explained that rumors of a feud between them had struck them as a joke, in spite, or maybe because of the furor it had caused in Hollywood.

Mannequin is the first picture in which Joan Crawford and Spence Tracy have appeared jointly. Up to this time, if the truth must be known, La Crawford had considered Tracy one of the finest actors in Hollywood. And Spencer himself was immensely pleased when he learned that he was to appear at last in a film with Joan.

Their first formal meeting on the day the picture began production, gave them a cue for the "feud" which was to follow. Joan naturally couldn't gush all over Tracy, and he himself was a bit awed by the situation. They both passed over this difficult period with some first class ribbing, and the *Mannequin* war was on!

"There's an object lesson to all this," Spencer said when the truth finally got out. "You have just had an actual demonstration on how rumor goes haywire and builds feuds where only fun at first existed. In this case Joan and I deliberately fostered the idea for the fun that was in it. But just the same it shows how some people trap themselves into difficulties when they don't mean to."

So let the late, lamented "war" end, with no casualties on either side.

NEXT MONTH
You'll laugh over the adventures which led to one of her most devoted friends calling Joan Crawford "crazy"! Watch for the new issue, on the stands June 10. You can tell it by the striking cover which shows Robert Taylor in a natural-color off-stage shot made during the filming of *Three Comrades*.
DON'T MISS IT!

of Jack than ever when you next see him on the screen, you'll know that his treasure hasn't turned up. Awa ... awa ... awa.

■ When the announcement was made in the newspapers that Kay Francis was betrothed to German Baron Raven Erik Barnekow, stories stated that the German would be the star's fifth mate. But not so ... Kay is indignant about it. The baron will be only the FOURTH, she declares.

■ Edgar Bergen, pal of Charlie McCarthy, tells this one on himself ... and it bears repeating. To avoid bringing pain and embarrassment, however, we'll delete all names but Edgar's.

The ventriloquist had a new and heavy date, a very extra fancy date. So grand, in fact, that he arrived in tails and top hat.

"All ready, honey?" he asked, as he was ushered into the young lady's apartment.

Before that attractive young miss could show her surprise, Bergen broke out in a sudden blush. He had arrived at the wrong house ... and this was the girl with whom he was trying to keep steady company!

(Note ... Edgar refuses to divulge just how he got out of THAT one.)

■ Attention, colleges! Sol Lesser, the producer, is paging five hundred educational institutions for his next Tarzan. He wants a young man combining athletic prowess with a knowledge of the classics. Any candidates?

■ Romance still flourishes, and in goodly measure. Whenever Irene Dunne visits her dentist-husband in New York, for their first dinner they go to a little chop house in Lower Manhattan, scene of

Joan Crawford was snapped with a midget clown at the Circus Party held recently at the Hawaiian Paradise. It is a reassuring thing to notice that even the greatest of stars can have runners in the stockings!

THEY CALLED HER "Crazy" AND SHE DIDN'T CARE

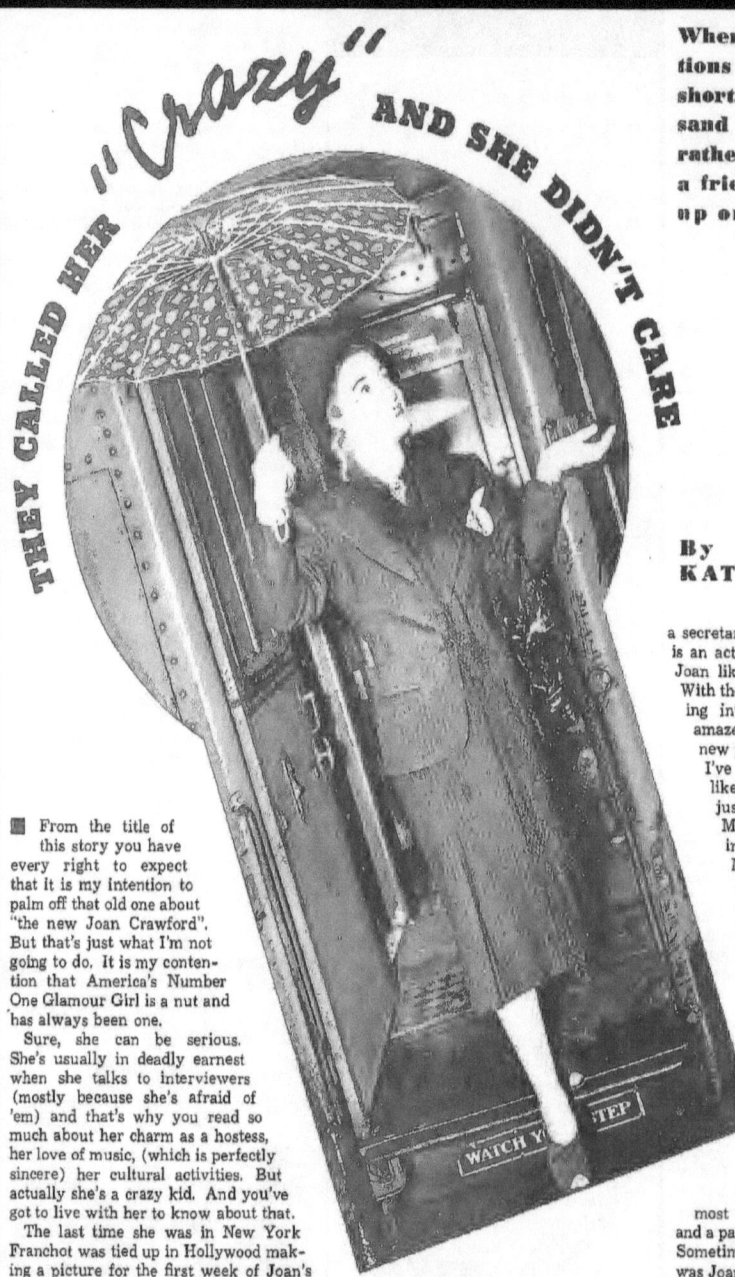

When Joan Crawford vacations in New York time is short and there are a thousand things to do. Here's a rather breathless report by a friend who tried to keep up on her last vacation

By **KATHERINE ALBERT**

■ From the title of this story you have every right to expect that it is my intention to palm off that old one about "the new Joan Crawford". But that's just what I'm not going to do. It is my contention that America's Number One Glamour Girl is a nut and has always been one.

Sure, she can be serious. She's usually in deadly earnest when she talks to interviewers (mostly because she's afraid of 'em) and that's why you read so much about her charm as a hostess, her love of music, (which is perfectly sincere) her cultural activities. But actually she's a crazy kid. And you've got to live with her to know about that.

The last time she was in New York Franchot was tied up in Hollywood making a picture for the first week of Joan's visit so I stayed with her at the Waldorf until his arrival. It isn't exactly what you'd call a chore. But I'm not quite over it yet. And as proof of my admiring conviction that Crawford is goofy, I'd like to tell you some of the things that happened.

First off Joan used her head and got herself a secretary. Last time she was in the big town she answered the telephone herself, saw all the autograph seekers personally, and took care of every letter she received. That left her about two minutes a day to have fun.

I didn't know how a secretary was going to work out. Joan doesn't like everybody by any manner of means. And if a very crisp, brittle, efficient number had appeared Joan would have outcrisped her and there would have been a honey of an atmosphere.

But when Coule arrived I knew everything would be all right. She's a dizzy dame if there ever was one, French and Viennese with a cute accent. (And don't you think it's the last word in chic to have a secretary with a foreign accent?). Coule is an actress and looks like Luise Rainer. Joan liked her immediately.

With the three of us there—Coule screaming into the telephone in bewildered amazement, Joan screaming over every new parcel that arrived and me (well, I've never been called placid) it was like a girl's dormitory if the girls had just poisoned the head mistress. Merchants by the dozen were arriving every three minutes. "Would Miss Crawford condescend to look at this little muff of white mouse fur or a leopard shower curtain or cellophane gloves?" Hattie Carnegie's fitters were in and out all day long. John and Fred were sending up their most incredible hats. Daché boxes were arriving on the hour. Joan was discovering Eric Moller and his amazing hats. Tappé was sending gowns which he hoped would throw Adrian into a swoon. Everyone was yelling and laughing and Joan was padding around in the most enormous-shouldered house coat and a pair of fur mules with bells on them. Sometimes you couldn't tell whether it was Joan or the telephone.

That's how things were when Mrs. Travers arrived. To describe Mrs. Travers and her two children will take a bit of doing. She's the minister's wife from Rhinebeck and when she isn't busy with ladies' aid societies and foreign missions she designs petit-point patterns. Joan has been corresponding with her ever since she saw an article about the patterns. Mrs. Travers had a new stitch Joan wanted to learn. She asked her for tea.

Mrs. Travers is a very nice woman—tall, tanned,

They Called Her Crazy but She Didn't Care

vigorous, country. Her children—one of each sex—aged about thirteen and fifteen, are nice, polite well brought up kids. The Travers are backbone of America, salt of the earth, worthy citizens. They came in with a tide of eight fitters, six hat boxes and a man with five fur coats.

The Elizabeth Arden girls had been having their way with Joan so she just slipped on the padded, rose sprinkled house coat and tinkling mules and, brushing aside eighteen yards of sequins and a hat made to look like a cock's comb, greeted Mrs. Travers.

"And now, dear," said Mrs. Travers, "I want to show you how this stitch goes." And there in that typically actress atmosphere, set and incidental characters right out of "Royal Family", Joan and Mrs. Travers surrounded by a dress called "Daughter of the Regiment" and a hat called "Carnival" put on their glasses while the minister's wife from Rhinebeck taught Joan Crawford a new stitch.

"That's right, dear, put the needle in and skip two—careful of the corner."

And Joan, trying so hard to please, saying as she peered through her horn-rimmed glasses, "I think I have it right, now."

After she had learned the stitch and bid Mrs. Travers and the children good-bye she bought two fur coats and fitted a white evening gown with a decolletage that would make a foreign missionary do penance for a moment.

And the funny thing is that Joan didn't see anything funny about the scene until I pointed it out to her. She was too busy trying on hats.

How many she bought while she was in New York I wouldn't know I never got to the multiplication table in arithmetic. But since Joan has the perfect hat face all the fancy milliners in town pounced on her. Each creation looked more lovely than the next and the creators of the hats just stood around and gasped and she gasped when she tried them on.

She graciously told every milliner that his (or her) hats were divine and she simply adored them and then, one day she had a brain storm.

She had just shut the door on the last beaming designer. That was the day, I think, when she bought ten hats. Then she turned to Coulé and me with a wild look in those big blue eyes. She came toward us stealthily as we backed away and in a low, Boris Karloff voice she said, "If I tell you girls something will you promise me you'll never, never breathe it?"

We expected nothing less than a confession of murder. "No one—no one must ever, ever know this," she went on. "Listen! I hate hats! I hate hats! I hate hats!"

"There, there," we said gently, "everything will be all right. You've just seen too many hats today."

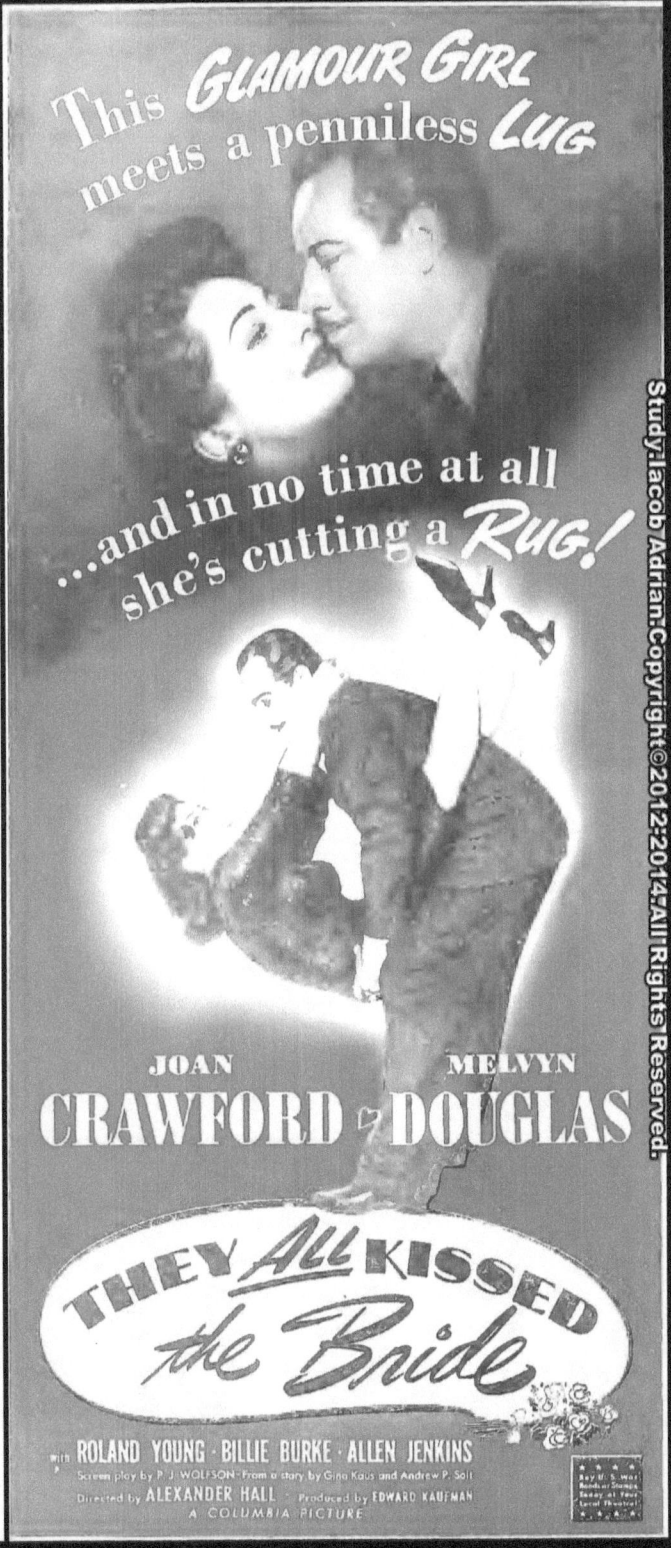

Fun On Ice

At the ice party, following the opening of *The Ice Follies* Joan Crawford proved that she is sure to have fun with her skating role in her new film. Below, with two members of the troupe

Arrival at the rink with Caesar Romero was complicated by the crowd of happy fans at the door

Through the turnstile, all ready for the frigid weather inside

Gallant Romero demonstrates the technic of tight lacing over the instep, looser lacing over the ankle

Center, more cautious members of the film colony preferred to sit behind the barricade and watch brave Joan

No one can be sure whether Crawford is holding Romero up, or he is steadying her. But it looks like fun for both

A highlight of *Ice Follies of 1939* is Joan Crawford's skating act. The ribbons lead to a trick horse, played with great feeling and dash by James Stewart and Lew Ayres together

What with Bob, Carol Ann and the camp manager (who had been called to help) tramping in and out of the trailer a half a dozen times, the floor soon was covered with sand, gravel and a fine scum of mud. It was nerve-wracking to walk on (like sugar on the kitchen floor) and every time she dropped a towel or dish cloth, the thing was a mess. That made Betty mad.

It was half past ten and she hadn't had anything to eat since a hamburger at five o'clock. That made Carol Ann mad.

In bitter despair they ate bread and butter and cold beans for dinner.

Carol Ann's bunk was then made up and she was put to bed.

"Go downstairs now so I can go to sleep, please," she ordered.

"There isn't any downstairs in this house, dear," Bob patiently explained. "This is all of the house, right here. Isn't it cute?"

"No," said Carol Ann. "It stinks."

"Carol Ann! Where did you ever hear language like that?" (This from Betty.)

"From daddy," Carol Ann succinctly said. "That's what he told the man the stove did."

"It did! It does! Everything does!" (This from Bob.)

Blankets finally were strung up to partition off an "upstairs" for the baby, and the elder Youngs settled themselves across the table at the other end of the trailer to discuss the situation in whispers.

"If you ask me, the whole thing is a fizzle!" Bob croaked. "Let's go home. We can make it by two if we start now."

"Where's your sense of humor?" Betty chided. "I thought you told the baby this was fun."

"Uh!" he grunted. "Well, let's go to bed then. All you have to do is lift up this table, slide the seats out, fasten a couple of gadgets and put the seat cushions on for a mattress. That's simple, anyway."

It might have been for a smaller or less harassed man, or in less crowded quarters. For Bob, however, it became a major problem in mechanical engineering. Everything was in place, finally, when Bob asked for the bedding. Betty let out a low, banshee wail.

"It's *under* the bed!" she moaned.

Bereft of reasoning power by this time, Bob viciously pulled the contraption apart, rescued the bedding, and carelessly slapped things together again. Betty arranged the blankets while he changed into pajamas with such modesty as an 18-inch cupboard door made possible. Then in weary resignation he flung himself down.

P-l-l-o-p-p! C-r-a-a-a-s-h! The bed collapsed, jackknifing the erstwhile gay lothario of the screen into a fuming, spluttering human pretzel. If ever the Youngs are divorced, it will be because of what happened next. Under the circumstances most judges would rule homicide entirely justifiable.

"Hey, you guys, pipe down and let a man get a little sleep, will ya?" yelled a trailer neighbor.

"Daddy, I want a drink of water," called Carol Ann.

"I'LL DO IT IF IT KILLS ME!"

says Joan Crawford...
a dramatic statement, says you...
a dramatic star, says we...
a dramatic story, says all...

Read it in the January issue of MOTION PICTURE now on sale at your newsstand. Get your copy now because you won't want to miss this or any of the other dramatic stories about your screen favorites in MOTION PICTURE

MOTION PICTURE was the first fan magazine and remains first in revealing the interesting incidents in the lives of Hollywood's glamour people to its fans.

10 CENTS

"I'll Never Marry Again, and Yet—"

JOAN CRAWFORD CONFESSES

■ Twice Joan Crawford has watched fame begin to slip away from her.

Immediately after her two marriages, the dips in her career have come. Twice, no other star has been comparable to her—in glamour, in the affection in which she was held by the public, in the widespread influence she held over the modes of the younger generation. Now, for the third time, she is again beginning to achieve magnificent proportions.

Joan would be less the brilliant woman she is if she did not see the relationship between her marriages and the temporary suspension of her accomplishments.... Between her successes and her divorces.

She has begun to ask herself: "Is it impossible for a career woman—for me, to be successful in marriage and successful in a career at one and the same time?" Currently she believes that. Therefore, her current vow is: "No more marriage!"

Tan legs, compact body, white shorts, bombastically striped peasant blouse, a new short bob, with little curls fringing her forehead and outlining her head. This was Joan Crawford on the afternoon she talked of her career. Of herself. Of her modified attitudes toward love. Of career women and their pathetic need for love, and how that need again and again betrays them into ill-advised marriages. Of the effect that a film career has on marriage.

She talked of her future. Of what she was planning. For what she was hoping.

In all the years I have known Joan Crawford, I have never seen this side of her before . . . this almost frightening ability to face and force the problems which confronted her.

Today we were dealing in truth. Ruthlessly dissecting the Crawford heart, and the Crawford personality.

"There is no denying," Joan said, "that love has brought me happiness, but it has brought me great unhappiness, too. Not the sort of unhappiness you experience when you are disappointed in work, but something that goes deeper. That permeates to your very bones and makes you feel as empty as a blown-up paper bag. Hollow inside.

"Today, I am confident I'm through with marriage. I'm through with trusting my happiness to another human being. This, I say even in the light of the fact that I have been married to two wonderful men—with charming qualities and great talent as actors. Unfortunately, the happiness of a woman is not determined by the virtues or talents possessed by the man to whom she is married, but on something almost intangible.

"The difficulty today, of course, is that women are two things. They are career women, and yet, fundamentally, they are so vitally feminine that inevitably there is a conflict between the two.

"I am, to put it bluntly, afraid to love, to marry again. At the moment, contrary to gossip, contrary to speculation, there is no emotional interest in my life. I have friends. To them I am grateful, because recently I've been in need of friends.

"Let's see exactly what's happened to me. My career went askew almost simultaneously with my marriages. Curious, isn't it, that after each marriage, I have to pick up the pieces again—to rebuild again. Perhaps I should be grateful for the thing in me which has been so consistently discussed and [Continued on page 52]

Left, Joan Crawford with Douglas Fairbanks, Jr., gay and happy shortly after their marriage. Right, not long before divorce

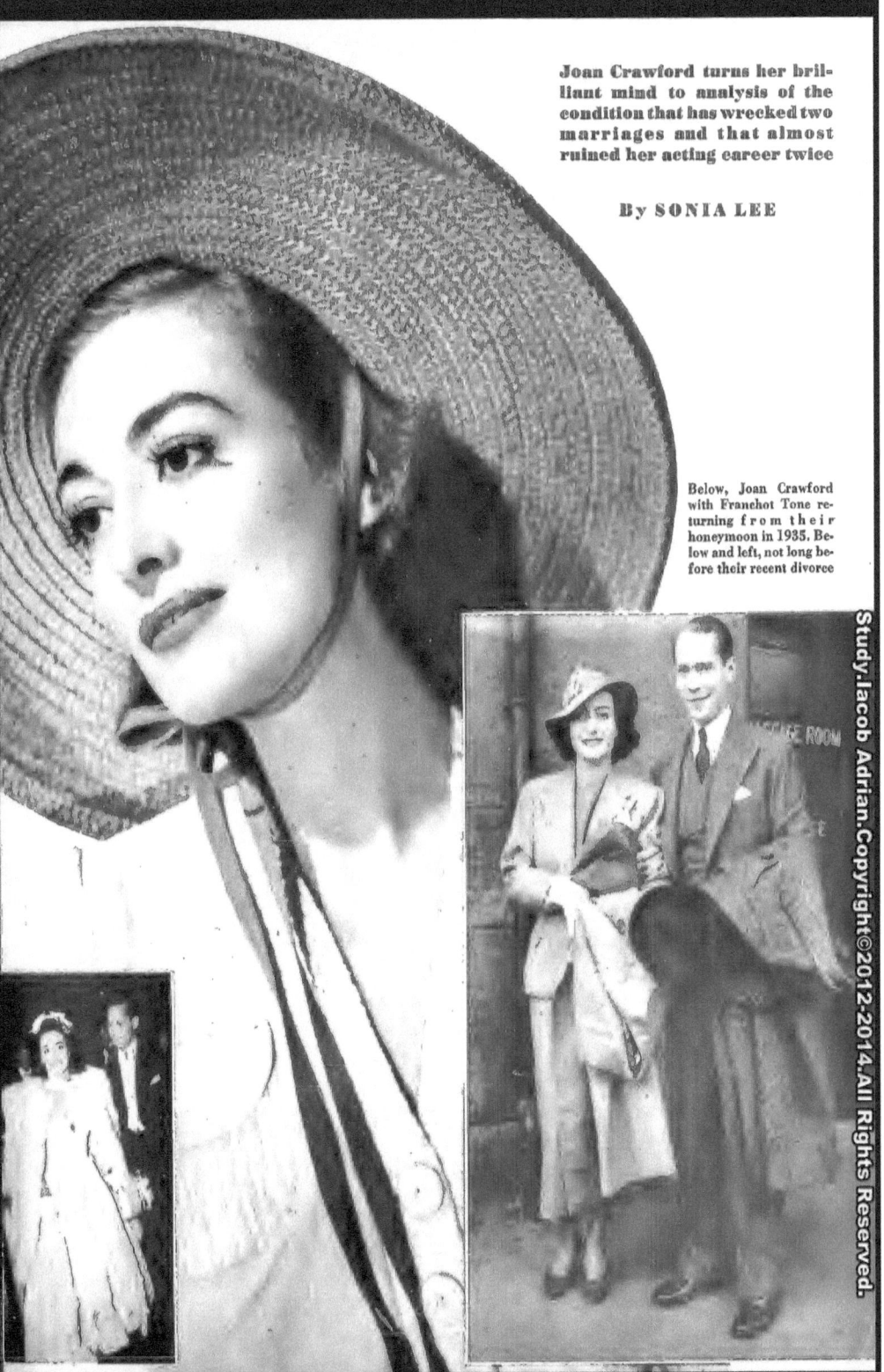

Joan Crawford turns her brilliant mind to analysis of the condition that has wrecked two marriages and that almost ruined her acting career twice

By SONIA LEE

Below, Joan Crawford with Franchot Tone returning from their honeymoon in 1935. Below and left, not long before their recent divorce

"I'll Never Marry Again, and Yet—"

so frequently criticized—my refusal to take defeat, my insistence that there is no defeat unless *you yourself,* make it.

"Recently, one of the nicest things said to me was: 'Well, Joan, you may go down, but you certainly bounce.' After all, no one is out until they've taken the count of ten. That's the law of the ring, and that is the law of Hollywood.

"I say to you I shall never marry again, and yet, knowing myself, knowing Hollywood, I'm hesitant about that word 'never.' Unfortunately, with each disappointment, with each frustration, I find myself as soft, as impressionable, as lacking in bitterness and shell as before that experience.

"Other women build a wall between themselves and the world—between their heart and other hearts, if they are once hurt. But I must be a glutton for punishment. I can't seem to do that.

"And so 'never' can become an elastic word. Who knows? Some one might come around a corner, and there I would stand, and we would look at each other, and we would know almost instantly that we two were suddenly bound together by some mystic, strange, undefinable power. That, I think, is the thing we call 'love.' It may happen to me. How can I tell? I only know that I would fight terribly against another marriage.

"I can say with certainty that never again will I marry an actor. Against such a love, such a marriage, I would fight with every bit of strength of purpose I can command. And that is no reflection on actors as husbands, but rather that circumstances in the profession are against a marriage between an actress and an actor. Marriage between two people in different divisions of the industry has a far better chance of success. The probabilities of disaster are then not too great to venture.

"A woman must turn to a man for that easement from problems which beset her. It's all poppycock—this talk that a woman can stand alone. That her modern independence has released her from her need of man's strength.

"I have yet to see a career woman who, underneath, was not more of a clinging vine than those who make a profession of marriage. Who else needs the devotion and comfort and strength of a man more than a woman who has special battles to win—than a woman who has to fight to gain or hold fame?

"Personally, I hope that civilization will never reach a point where a woman can really stand alone. Basically, the nature of woman is such that no matter what she is, or to whatever heights she climbs, she will always need marriage and its protection and security. By security I do not mean financial security, but a security of spirit. To be able to stand alone would be a violation of herself.

"The career woman—the actress in particular—finds herself in the anomalous position of having created a Frankenstein. She is loved because she is famous—because the very qualities which make her an actress are the qualities which men find enchanting. But these very qualities are a hindrance to happiness in marriage. Yet, let her give her career up—let her cease to be an actress—then she no longer is the person the man loves. And love disappears.

■ "In trying to keep love, by the sacrifice of her career, a woman can count on losing it eventually. I can say that no such thing exists as a successful marriage if a woman has given up her career for marriage.

"Perhaps an actress asks too much of marriage. She asks that romance last—that the high ecstasy of the first year continue as high ecstasy into the second and the third year. She refuses to be cast into a mould of satisfaction rather than of happiness.

"The two, of course, are not interchangeable to the actress. For you see, she always has a pattern of love, according to which she measures her personal life, and her relationship to her husband.

"Other wives pass the first period of high romance. They accept marriage year after year contentedly—with its good and its bad, with its satisfaction and its disappointments, its romance and its placidity.

"But the actress is always playing the scenes of love. She reads the dramatic stories of people in love. She knows the words, the phrases—she knows the nuances of every little emotion between a man and a woman.

"Then she comes home. No matter how much of a realist she is, no matter how much she continues to say: 'This morning I was play-acting. This is real,' there is still in her mind that incongruous comparison.

"So if her own marriage does not favorably measure up to the standard of love as it can be, it does not measure up at all. She *can* take second best. She *can* make the best of marriage. She *can* compromise with the things she wants. She *can!* But why should she?

■ "Many people have tried to explain the cause of divorce in Hollywood. To me, this is the cause: That marriage must continually stand comparison with a type of glamorous marriage which writers conceive and which they put on paper in glowing words. These words an actress speaks and believes!

"Why, then, should an actress dare marry? Even though we say of a marriage, 'this is for always'—in our secret heart, our only hope is that it will last at least two years!

"But we still marry. Why? Because we are women. We want the moon. We reach for the impossible. Hope against hope! Because we want the thing which other women have, and which we, as career women, have sacrificed.

"Who is to deny us the right which all

women have—to possess love, to seek security? To have even isolated moments when we can be feminine, clinging, dependent? We try to deny the truth to ourselves. We blind ourselves to facts. We say: 'This may be it! This may work! This will last forever!' We are afraid—but we hope.

■ "Paradoxical, isn't it? That career woman, who needs marriage so much, finds it so frequently denied her.

"How successful I will be in evading marriage, I don't know. Sometimes a woman is blinded into marriage. By gossip. By the discussions of her supposed plans by others. A drop of water wears away a stone. So, constantly when a woman's name is coupled with that of a man, she becomes inured to it. And comes to believe public definition of her emotions. Frankly I don't know what the future holds for me because I know Hollywood's habit of linking a woman's name with the first man with whom she is seen. I delayed my divorce for months just to give myself a breathing spell.

■ "I hope I shall never again be disenchanted. I hope that I shall never love and then cease to love. I don't think I could stand another disappointment.

"Curiously, there is my career again. I'm playing, in terms of length, a relatively small part in *The Women*. But it is a vitally important role. It's a role which is far different from any I've done before.

"Ah, I have you in my power." says the heroine Martha Raye, to the villainous-mustachioed Jerry Colonn at Victor Hugo

I went to Hunt Stromberg, the producer, and asked for it. After the first day's rushes, those who used to twist the knife in my heart by saying, 'You sure need a good picture,' came around in droves, saying, 'See, I told you this would be the perfect part for you. Aren't you glad I thought of it for you?' No one thought of it except Joan Crawford, who asked for the role. To Mr. Mayer and Hunt Stromberg I am grateful for the confidence they had in my judgment and for assigning the role to me.

"The future is brightening for me again. The song recordings I have made are selling well. For the first time in months, I am happy with a role I am playing. If my life continues according to formula—that is, renewed success in my career after a failure in my personal life—then the future holds happiness for me."

■ To me, Joan Crawford has never been fundamentally and first an actress. She has been a symbol. The standard-bearer for youth, especially for the discouraged youth, who in the light of today's events, say, "What is there for us? What can we do?" And then they read of Joan Crawford—of the girl who came from nothing—of the girl who began with nothing—who became a personality of importance, who, at the point of Fame when others rest on laurels, struck out in the world of music to weave new laurels for herself.

And then they say, "This girl had no opportunity, as I have no opportunity, but she made them for herself. She found them. She constructed them."

Discount the fact that Joan Crawford has given countless thousands hours of happiness in the theatre, discount her leadership in fashion. Rather think of this girl who has given a gift of courage and ambition to youth. For of this, Joan Crawford is an ever-bright symbol!

Can this be our sunny Joan? More than once during the making of *Mannequin* she turned this hostile glance at Spencer Tracy

Sparkling with Gaiety, Romance Stars, Musical Thrills!

ICE FOLLIES
OF 1939
starring JOAN CRAWFORD

with **JAMES STEWART**

LEW AYRES • LEWIS STONE

An M-G-M Picture • Produced by Harry Rapf
Directed by Reinhold Schunzel • Screen
Play by Leonard Praskins, Florence
Ryerson and Edgar Allan Woolf

THE ICE BALLET in Technicolor is magnificent, featuring Skating Stars of the INTERNATIONAL ICE FOLLIES including BESS ERHARDT, ROY and EDDIE SHIPSTAD and OSCAR JOHNSON

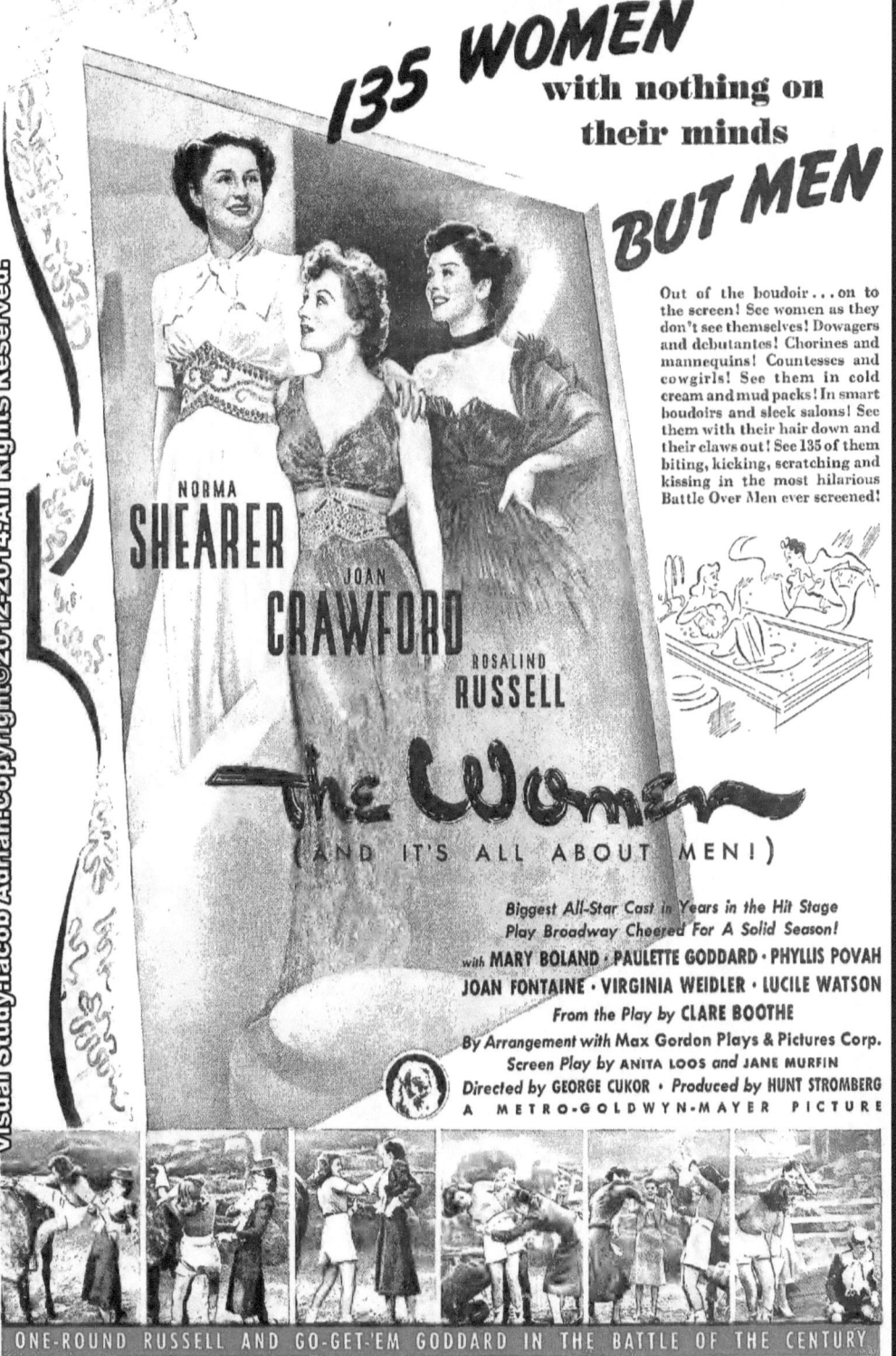

ONLY 5 CENT MOVIE MAGAZINE IN THE WORLD

Hollywood
(Reg. U. S. Pat. Off.)

HOLLYWOOD 5¢

APRIL
NSC

A HOLLYWOOD QUIZ
BY RADIO'S EXPERTS OF
"INFORMATION PLEASE"

DEANNA DURBIN'S
NEW SPRING
CLOTHES

JOAN CRAWFORD

Joan Crawford's "Houseguest"

The little girl who is known, formally, as Miss Crawford's houseguest is an important influence in the life of this glamorous star

By SONIA LEE

Joan Crawford never has had a world of her own, and to a sensitive, electric personality, the inner sanctuary created by great love, by dependence, by warmth and security, is an imperative need.

For many years Joan Crawford has lacked this special, this essential kingdom. Today, she is well on the way to attaining it, and with it the happiness she has been seeking, and the serenity she has never had.

Today, a platinum-haired, six-year-old is so influencing the character, the emotions, even the attitudes of Joan Crawford that she is substantially remaking Joan's life.

The child is her niece and namesake, Joan Crawford LeSueur. From the moment of birth the child has brought peculiar treasures within Joan Crawford's horizons. Joan—the glamorous, the beautiful—has had Fame. But Fame is a cold fire at which to warm your heart.

She has had many friendships—but even friendships are of fragile quality in Hollywood. She has been married—but disenchantment, and heartache and divorce followed. Now, at last, she has a human relationship, which is sound and secure and vital. Let me tell you the story:

The announcement that Joan was to play the title role in *Susan and God* had been made several days before we talked about Joan, Jr.

We had planned a quiet, undisturbed interview, but the New York Grand Central station would have seemed a peaceful retreat in comparison to her dressing room on this rain-drenched afternoon.

"Would Miss Crawford look at costume sketches? Was she ready for her hat tests? Hair tests? Make-up tests? The crew was waiting ... Now, don't hurry Miss Crawford—but will you make it as fast as you can? Just a minute—we must have a fitting on this dress before you go on the set. And what color would you like your dressing room painted? Will mauve be O. K.? And how about purple for the draperies ..."

There were hairdressers, and make-up men and wardrobe girls, and decorators and painters and a famous hat-designer and the even more [*Continued on page 52*]

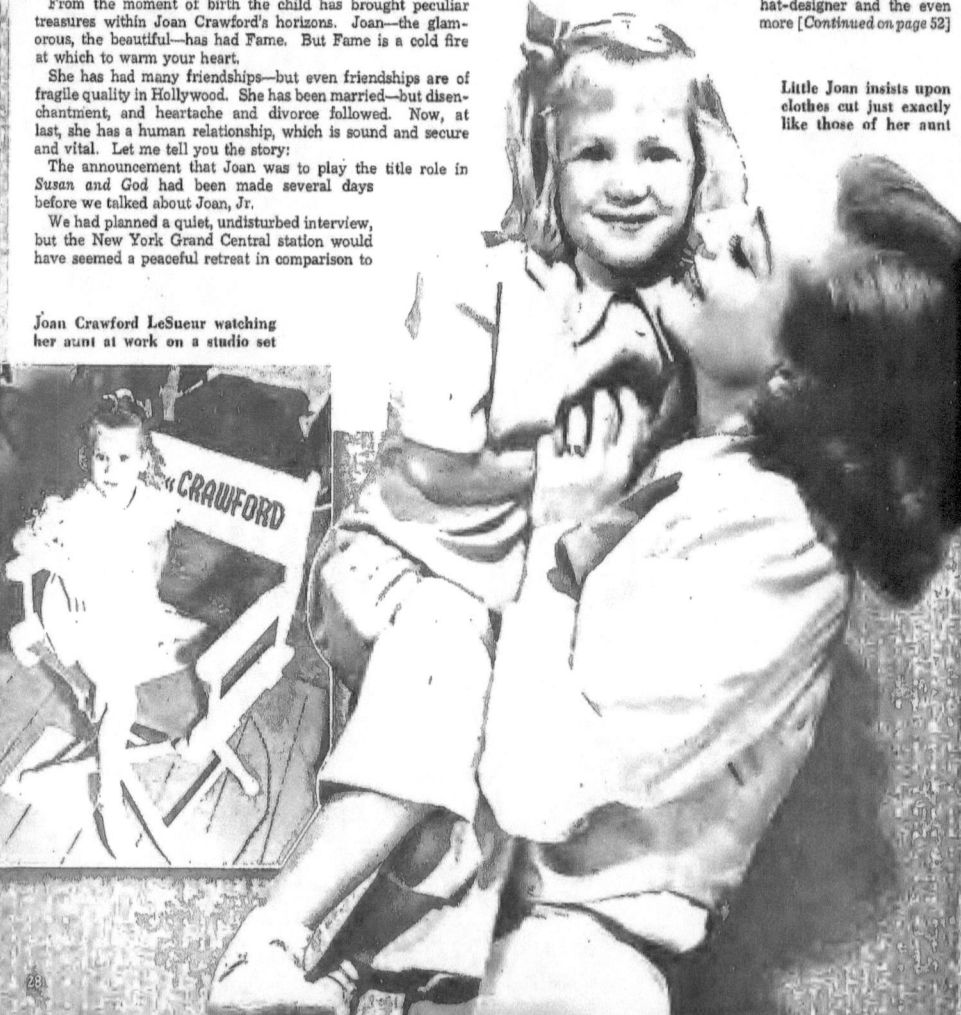

Joan Crawford LeSueur watching her aunt at work on a studio set

Little Joan insists upon clothes cut just exactly like those of her aunt

Joan Crawford's "Houseguest"

famous Adrian. And Guilaroff, the hair-stylist—all there, each snatching a minute, or two minutes of Joan's attention. Then everything was finally done, and tests made, and the following day we sat across a luncheon-table and really talked about the child.

And Joan said: "I told you, shortly after I was separated from Franchot that someday I planned to adopt a child, because I felt that a woman, to find happiness at all, had to be urgently needed. Not in the material sense—but for herself, as a person.

"My plans then were to adopt a very young baby-boy and later to find a little sister for him. But things of this sort take time. I had had to readjust my career and my personal life. And so at the present, my plans are in abeyance.

"But in the meanwhile, my life has suddenly found point and purpose through my brother's child.

"Joanie-Pants (I call her that because she has an aversion to such garments), was an incubator baby. She was so fragile at birth that we had little hope that she would live.

"But she did—and thrived, and after three months in the hospital, she was taken home.

"I was the doting aunt from the beginning. I used to drive the forty odd miles between my house and that of my sister-in-law in the Valley, every day, just to see the sleeping baby for a minute—or to watch the eventful ceremony known as 'bathing the baby'.

"It wasn't long before Joanie became a regular week-end guest at my house. A room was set aside as a nursery. We decorated it in blue and white. Kasha, my sister-in-law, is unselfish. She realized how much the baby meant to me, and how much we loved each other. So, as the years went by, Joanie occupied the nursery more and more frequently.

■ "When Joanie-Pants was just past a year she created her name for me.

"It happened this way: A magazine had a picture of me on the cover. In some way the baby got hold of it. She looked at it intently, then touched it, then kissed it. And suddenly she said softly—'Baby'! I happened to come in just then. She held out her arms to me and shouted—'Baby'! You see, she associated her name and mine. I've been 'Baby' ever since.

"It's curious how much basic wisdom a child can teach us. Adults believe that we are the ones who mould and form the very young. Yet, I venture to suggest that we ourselves change more through association with youngsters than the youngsters do!

"Joanie has taught me many wonderful things. She has taught me how to play with complete relaxation. She is free and easy and uninhibited. She concentrates completely on enjoyment.

"I have never known what it was to forget yesterday and forget tomorrow. To disregard the problems which like probing fingers kept poking into my brain, even when the day was done—when I was entitled to dismiss them for a little while.

"Now, I can settle down with Joanie to a game of tag, or a swim, or to a class in geography for the dolls, without once thinking about lines or scenes, or what some columnist has written in criticism.

■ "I can see myself so frequently in Joanie. She is impatient. She will demand—'But why can't I have it? I want it NOW'!

"I, too, have always wanted things NOW. I've broken my heart a score of times over inescapable delays.

"Joanie has taught me the value of time. Nothing of importance can happen overnight. There is a definite and precise cycle through which events and lives must pass. That has been my hardest lesson to learn.

"Now I know that everything passes—given time. Six months ago I thought nothing would ever change. That I would continue perplexed and unhappy. But the wheel spun on. And here I am—happier than I have been in years.

"I suppose one reason is that now, at last, all the conflict in my private life, all my confusion about what will happen to Joan Crawford, as a human being, is dissolved.

"I know, for instance, that my decision never to marry again will not change. That is a difficult conclusion for a woman to reach when human relationships are as important as they are to me.

"I have changed imperceptibly, but definitely in the past six months. I don't take things so hard. A friend who became no longer a friend, made me feel as if I had failed in some vital quality.

"Perhaps I expected too much of people in the past. Perhaps I suffered from a perfectionist complex. All I know, is that I made myself wretched over disloyalty and unfairness and broken faith. Now, I take them in my stride.

■ "I see Joanie take things so philosophically. A bruised knee, a broken doll is a matter of moment—for the MOMENT. And then she forgets it. I am trying to acquire that imperturbable serenity of hers. I consider matters as they occur, evaluate their importance, do the best I can with them, and then dismiss them from my mind.

"Do you remember how rattled I used to get in emergencies? I don't any more. It was through Joanie that I learned self-control.

"I was driving her to dancing-school one day; she was hanging over the seat. I cautioned her that she might get hurt if I had to stop suddenly. Just then she leaned over to kiss me, her hat blew off, and she screamed 'stop!' I didn't know what happened, but I stepped on newly-adjusted brakes automatically. Joanie was thrown hard against the windshield and catapulted into the back of the car.

"Children are scarred by such experiences. I knew that I had to minimize the seriousness of the accident, if she were to forget it quickly.

"I took her in my arms, knew that she was frightened and hurt—and I began to talk to her!

"'Joanie, you were so funny when you made your somersault. I've never seen anything so funny in all my life. And your face had the most surprised look. I wish I had a picture of you like that. You looked exactly like Donald Duck.'

"I kept her face pressed against my shoulder so that she wouldn't see my tears and my face. But I kept my voice gay—I chuckled as I talked to her.

"When her face remained crinkled up, ready for tears, I whispered our magic formula—'Whoa, Bill'. That means between us that we're grown up and we don't cry.

"She began to laugh—and when we came home we went into hysterics of laughter—Joanie, because she thought the accident was amusing, and I, from relief.

"That night I said to myself—'If you can keep your head in every emergency as you have in this one, you'll save yourself a lot of grief.' I've remembered that accident to good advantage in instances where it was imperative that I think fast and think clearly.

■ "Joanie has serious plans for herself. She has amazing dramatic ability. She picks up a dance routine merely by watching it once. She says: 'I want to be A ACTRESS, like Baby'.

"Naturally that pleases and flatters me. I am delighted by her demands to have peasant-dresses precisely like mine, by her efforts to copy my speech and my walk and my general attitudes.

"Needless to say, I am more careful about what I say and do, than I have ever been in my life. After all, my first duty to her is to set a good example.

"I do not intend to use my influence in helping her to success either on the stage or on the screen. I WILL help her—do everything in my power—to PREPARE herself for it. But I won't lift a finger to get her there. My sister-in-law and I agree on this, as in other things.

"She'll have to do things under her own steam, on the strength of her own talents, and courage and spunk. Achieving things the hard way is the only way to get lasting satisfaction out of success.

"She has a fine mind—at three, we took her out of school because she was far too advanced for her age. She has only recently returned to school. And incidentally, she attends a public school.

"Her mother and I are trying to teach her to be self-reliant and self-sufficient. She makes her own bed in the morning and dresses herself. Occasionally, she comes in for help with a difficult button or a shoe-lace, but with a little encouragement she finds that she can do it herself.

"We don't want her to be dependent on the routine of living. But we do want her to know constantly that help and approval and love are constantly at her command.

"Children give us those wonderful things—the least we can do is to return their trust and faith with the best we have."

counterparts in fact. For Betty Field is the perfect example of the small town girl who wanted to be an actress and by sheer persistency pushed her way from a balcony seat to the center of the stage.

Broadway has been applauding Betty Field's talents for considerably longer than Hollywood, which just this year added her profile to its special ballyhoo book of fresh faces. So it was appropriate that it was to the dressing room of a Times Square theatre, and not a Beverly Hills bungalow, that I turned my footsteps in search of a background story on this lively new screen personality.

Her celluloid portraits of the irrepressible Barbara Pearson in *What a Life*, the loquacious Lola of *Seventeen* and the provocative Mae in *Of Mice And Men*, had prepared me for a somewhat flighty little miss whose conversation would be cushioned with soft endearments, the kind of a girl who calls everyone "Darling" to save the bother of remembering their names, and quotes freely from barroom Boswells like Winchell.

Instead Betty Field proved to be a modest, serious young lady whose all consuming ambition to climb to the top of the theatrical ladder has left her no time to acquire any artificialities on any of the rungs. She has the direct manner of a bright, successful young career woman in a *Ladies' Home Journal* serial. When she is thirty she'll do all the proper things about diet and exercise.

As she sat at her dressing table and wiped away the make-up of that afternoon's matinee, there emerged from under the layers of footlight filigree a pretty, personable, self-assured young lady with a good complexion of her own, friendly grey eyes and soft, light brown almost blond hair that photographs much darker than it really is. Her most arresting feature is her wide, humorous mouth. Her figure is worthy of a Petty poster. When she stands on a weighing machine the little white ticket that plops out at her reads 110 pounds and, to complete the records, let it be added that she is five feet five inches tall.

Between pats of cold cream, Betty dabbed at her memory, too, and revealed a biography brilliant for the very simplicity of its singleness of purpose. In a year when so many other cinematic discoveries were Cinderellas "found" over a chocolate nut sundae in an ice cream parlor, or lured away from a typewriter by a talent scout, it is reassuring to realize that an arduous apprenticeship in the theatre itself is still one of the open roads to film fame.

Betty was born in Boston, February 8, 1918, daughter of George and Katherine Kearney Field. On her father's side, her ancestry runs far back into New England history to the Priscilla Brewster who advised John Alden to speak for himself, a positive trait Betty was to borrow at the outset of her own career. Another distinguished photo in her family album is that of Cyrus Field, the man who laid the transatlantic cable. Her inheritance from her mother is Irish, and it was from her mother, too, that Betty absorbed her love for things theatric.

"In a way, I have been acting ever since I can remember," declared Betty. "When I was eight or nine, I used to stop people on the street and pretend I was somebody else. I would watch to see if they believed me, because if they did, I knew the pretending was good. My hair was cut in a boyish bob so one day I dressed up in boy's clothes, walked the way I had seen boys walk, and told people I was a boy. But I could see they didn't believe me and I was awfully disappointed and puzzled." It was, perhaps, the only time in her life Betty Field was to fail to give a convincing performance.

After a childhood in Newton, Massachusetts, Betty moved to Morristown, New

Joan Crawford, in ermine for a chilly summer evening, wears the brightest smile in months. Reason? The baby girl she adopted on her last trip to New York and named Cristina Crawford

Jersey, about the time she was ready to enter high school and it was during her senior year there that Betty, following several triumphant ventures in school plays, decided to chart the course of her life by the lights from the footlight troughs of the professional stage.

That decision made, Betty moved promptly to carry it out. Her first step was to see as many plays as possible and the Saturday matinees of the Rowland G. Edwards stock company in Newark became her hunting ground.

"I loved everything about the theatre," Betty continued, "and after every show would go home and recite as many of the lines as I could remember. It seemed to me that the theatre was the only place in the world that was really exciting and to be a part of it, no matter how small, the most desirable career imaginable.

"Often, after the matinees, I used to stand outside the stage door and watch the company come out. They seemed like magical people leaving a fairyland. Florence Reed was one of the visiting stars and Bert Lytell another. They were wonderful creatures to me, not quite human. I used to ask them for their autographs and then, if they'd stop and talk for a minute, inquire if there wasn't a chance for me in the company.

"Finally, one day, someone told me that Mr. Edwards' secretary lived in the hotel next to the theatre and that if I wrote her a letter it might lead to an opening. So I wrote, not one letter, but two or three."

That she was something more than just a stagestruck schoolgirl must have shone through the lines of her letters, the earnestness of her ambition, and her tenacity, must have touched the imagination of that Newark repertory company manager for one day there came a telephone call to the Field house from the theatre.

"What a moment that was!" Betty recalled. "They said they could use me as an extra in the next week's play. It was *Shanghai Gesture*, with Florence Reed. All I did was sit behind some lattice work, made up as a Chinese sing-song girl but I could not have been more thrilled if I had been ensconced on a throne playing *Mary, Queen of Scots*.

"After that, they let me work in other plays as an extra and the last week I was with them, I had quite a lot to do. I was a maid who ran into a room and discovered that someone was lying there murdered, and screamed!"

■ In view of the fact that her first movie role was that of the vocally vigorous high school cheer leader in *What a Life*, it is pertinent to note that Betty literally yelled her way right out of her own high school career.

That one week of making a dramatic entrance and screaming, in the stock company mystery shocker, convinced Betty that she was wasting precious time thumbing books on biology or chemistry. Where she belonged was in New York reciting to producers the story of her record in Newark, pressing for a test on Broadway.

Her campaign of propaganda for parental permission to quit high school would have sold a Vermont Republican on a third term for a Democratic President. So Betty, full of confidence, and with a handful of clippings showing her name in the Newark casts, crossed the Hudson in her march on Manhattan's citadels of the stage.

It was Spring. She was sixteen. And New York was just waiting for her to knock, she was sure. She knocked for a month with no response.

"There's one thing I can say, I certainly had nerve," Betty picked up the tale again. "I would breeze blithely into a producer's

An Open Letter to Ed Sullivan from Joan Crawford

Following Are Excerpts From Ed Sullivan's Newspaper Column of Oct. 6th

"Goodness knows that I don't often rap people, or performers, and Joan Crawford, for instance, struck me as being one whom I've tried genuinely to like.... For certainly an inherent friendship is a point I insisted on in what became there is which regards then is Joan's exclaims that the no proof of the country has been unfair to her, and many, really, anyone who has some sort of cooperation.

I don't know, really, anyone with so little talent as Joan Crawford.

A better rowing section is that which acclaims Crawford.... Raft has the public country rooting for him, because here is a man who, like Joan Crawford, is more than a movie name, but who also gave... Like New York to movie fame, but the sidewalks of New York forget his old friends, unlike her; he never forgot his old friends.... I confess that I've lost patience with Joan Crawford.... No longer movie stars put the blast on her for her insincerity, or for her defense when other movie stars put the affectations."

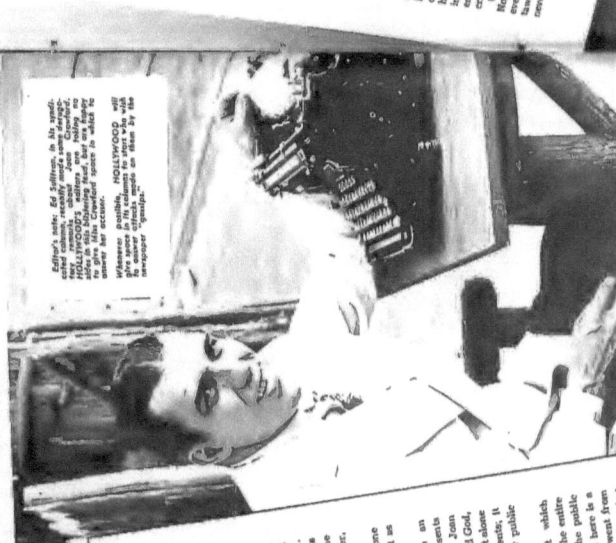

Editor's note: Ed Sullivan, in his syndicated column, recently upbraided Joan Crawford for comments about Joan Crawford, who is also known by other names, but we are happy to give Miss Crawford space in which to answer her accuser.

Whenever possible, HOLLYWOOD will give space in its columns to stars who wish its answer attacks made on them by the newspaper "greats."

Above: Ed Sullivan, columnist, and his trusty typewriter accompany each other wherever they go.

Right: From her hotel suite in New York, Joan Crawford is seen addressing her letter to the HOLLYWOOD offices.

Dear Ed Sullivan:

Goodness knows I do often rap people and I'm honest enough to admit it, although I'm not proud of myself for doing so. Naturally, when I read your blast in the papers, my first emotion was to wish you boiled in oil. Then I thought: "No, it's over and done with. Let it pass. To give Joan Crawford space is which to answer."

But this view I concluded in time was wrong. It implied submissiveness. Hence this letter, meant not so much to slap back at you as to take a definite stand on this business of "cooperation," to indicate, perhaps, that cooperation is to you and to me and to set you right on a point or two.

You say that for two years you have tried to like me, Ed, now? By saying me? I haven't known you since I felt? No indeed, Ed, and Joan since I talked from a visiting firemen when I asked it as silly and if we thought it could be settled out if we thought it could be civilized and I wanted that I talked to you people. Besides, I thought it high time we got together and you and I got to dine with you and your escort and me to dine people.

These were the only attractive I've ever were for the life of me I cannot seen and and like me.

I have never reclaimed that the press have been columnists, unfair to me, but I say too columnist, however, that a columnist has no adequate or unfair to criticism; that does not include legitimate criticism or art by properly qualified critics.)

Certainly I have complained about the comments about me for my craft and trade, to attacked. I consider it cheap, have been to marvel at the paradox of otherwise respectable newspapers that are paying men, usually newly community constables, who, at the same time, permit journalists to stink up their papers, Chad Street and Broadway through a loudspeaker.

"While she has been in the East, Miss Crawford was asked by two newspapers to cooperate with them in stunts which would have placed her in a favorable light," you say, "and out of sheer publicity, Ed, publicity, of course which pre-sented, not for the purpose of placing me in a favorable light with newspapers or the public."

Goodness knows, certainly I do, that a motion picture actress without a public would be a phantom, a fantasy, perhaps, and a cipher forever. *(Continued on page 60)*

An Open Letter from

Editor's note: Ed Sullivan, in his syndicated column, recently made some derogatory remarks about Joan Crawford. HOLLYWOOD'S editors are taking no sides in this blistering feud, but are happy to give Miss Crawford space in which to answer her accuser.

Whenever possible, HOLLYWOOD will give space in its columns to stars who wish to answer attacks made on them by the newspaper "gossips."

Following Are Excerpts From Ed Sullivan's Newspaper Column of Oct. 6th

"Goodness knows that I don't often rap people, or performers, but it's about time to crack down on wide-eyed Joan Crawford... For some years, I've tried sincerely to like her, but she certainly strains friendship to a point where something has to give, and it GAVE... This squawk then is justified because there is no performer who so often exclaims that the press of the country has been unfair to her, and non-cooperative.

I don't know, really, anyone who has gone so far in this business with so little talent as La Crawford.

Broadway, which remembers her as an N. T. G. girl and a Shubert chorus girl, resents that attitude with good reason... If Joan wonders why her latest flicker, *Susan and God*, was such a terrific box-office flop, it is not alone that the part was unsuited to her talents; it was also because the contact with her public has been broken.

A better rooting section is that which acclaims George Raft... Raft has the entire country rooting for him, because the public has more than a sneaking idea that here is a nice guy... Like Crawford, Raft went from the sidewalks of New York to movie fame, but unlike her, he never forgot his old friends.

I confess that I've lost patience with Joan Crawford... No longer will this pillar rush to her defense when other movie stars put the blast on her for her insincerity, or for her affectations."

Above: Ed Sullivan, columnist, and his trusty typewriter accompany each other wherever they go

Right: From her hotel suite in New York, Joan Crawford is seen addressing her letter to the HOLLYWOOD offices

to Ed Sullivan
Joan Crawford

Dear Ed Sullivan:

Goodness knows I do often rap people and I'm honest enough to admit it, although I'm not proud of myself for doing so. Naturally, when I read your blast in the paper, my first emotion was to wish you boiled in oil. Then I thought: "No, it's over and done with. Let it pass. Forget it."

But this view I concluded in time was wrong. It implied submissiveness. Hence this letter, meant not so much to slap back at you as to take a definite stand on this business of "cooperation," to inquire, perhaps, what it means and to set you right on a point or two.

You say that for some years you have tried to like me. Ed, how? By seeing me? By talking to me—as friends? No indeed. I haven't seen you since I separated from Franchot. And before that I talked to you exactly twice, once when in New York as a visiting fireman—when I asked to see you. You had printed something perfectly silly and I thought it could be straightened out if we talked it over like civilized people. Besides, I thought it high time we met. I remember that you were kind enough to invite Franchot and me to dine with you and your very attractive wife.

Those were the only times I've ever seen you. And for the life of me I cannot remember any great effort you made to know and like me.

I have never "exclaimed that the press of the country has been unfair" to me. I have said, however, that a columnist—any columnist—is unfair to attack anyone who has no means of reply. (This does not include legitimate criticism of commercial entertainment or art by properly qualified critics.)

Certainly I have complained about that. Not for myself alone but for my craft and everyone so attacked. I consider it cheap, tawdry, and gangster journalism. I have never ceased to marvel at the paradox of otherwise respectable newspapers that are serving their community constructively and who, at the same time, permit journalistic lice to stink up their pages. If you so desire, I will tell you that at 42nd Street and Broadway through a loudspeaker.

"While she has been in the East, Miss Crawford was asked by two newspapers to cooperate with them in stunts which would have placed her in a favorable light," you say.

Ed, publicized acts of mine are not premeditated, nor for the purpose of placing me in a favorable light with newspapers or the public.

Goodness knows, certainly I do, that a motion picture actress without a public would be a thing of beauty, perhaps, and a cipher forever. [Continued on page 60]

An Open Letter to Ed Sullivan

That much is true. But how in the name of heaven does she acquire that public? Because she fell out of a tree into the arms of a movie scout? Or because Darryl Zanuck happened to see a picture of her in a cigarette advertisement? Or because she did some occasional hoofing for the Shuberts?

What this last might explain is merely how she gets into pictures—not how she acquires a public. This public she acquires, if she does, by hard work. But the press, you shriek! Yes, indeed, the papers helped. And the magazines, too. And she is properly grateful. And how does she show it? By doing everything from lolling around in pajamas to jumping through a hoop, for benefit of photographer.

For years she does all that. Comes an occasion when she does not leap through the hoop. Then annihilation! But—supposing we turn to your column:

"On both occasions she delegated the task of breaking the bad news, her refusal, to M-G-M publicity men. In other words, Joan didn't have the nerve or the courtesy to call the newspapermen or their offices to say no," you lash out.

Since the invitation to appear at the *Daily News* Harvest Moon Ball came from M-G-M publicity men it is perfectly natural that the refusal went to them. I even explained that I was in the country with my infant child who was ill with a cold. And whether you like it or not, Ed, I would not have left her for any favorable publicity.

The other affront to a paper, if I must go into weary detail, was perpetrated with even greater innocence on my part. Too late for any possible cancellation of plans, I received a vague and belated request to cooperate in a fashion show to be staged by the *Chicago Tribune*, for which paper I have nothing but respect. The show would have been under way and over by the time I managed to straighten out my affairs and fly down to Chicago.

Your comment on the box-office results of *Susan and God* places you in the position of having information not available to me. However, if you are interested in accuracy you can probably get the correct information from M-G-M—and according to Mr. Mayer last week *Susan* was doing all right.

Here's another little gem of yours:

"I don't know really anyone who has gone so far in this business with so little talent as La Crawford."

Aw, Ed, how could you? As long as I was getting away with murder why turn stool pigeon and snitch on me? When one is blessed with such magnificent talents as you are, Ed, you must try to be more patient with the less-fortunate, non-talented Crawfords.

Your petulant "I confess that I've lost patience with Joan Crawford" is Age II stuff. Please, Mr. Dictator, don't banish me because I have lost favor with you.

"No longer will this pillar rush to her defense when other movie stars put the blast on her for her insincerity or her affectations," you write.

Any time you "rush to my defense" it has been because of your own free will. I have never asked you to do so. The times I have seen you and had occasion to talk to you it has been as a friend to whom I desired to give my side of a story in detail. To hell with whether you retracted anything or not. It was you as a person that I wanted to be fair.

My batting average with respect to requests from your paper, the *Daily News*, has been pretty good. Last April I accepted an invitation to and attended a cocktail party given by the *News* during the publishers' convention. I considered it an honor and a friendly act to be invited. By the same token I considered the invitation to the Harvest Moon Ball as an honor and a friendly act. It was simply impossible for me to attend.

And as for not answering the telephone (as Tyrone Power and Annabella presumably do) what with a "secretary" guarding me from callers, please be informed that the only time I don't happen to pick up a telephone is when my maid—*I don't even have a secretary*—beats me to it.

From here on your column trails off into a welter of abuse, bearing little or no connection with the subject at hand. You take time off to compare me with George Raft, "a nice guy," who makes the night clubs and does the right thing. I, too, regard George Raft as "a nice guy," just as free to attend night clubs and opening nights at the bistros as I feel free to pass them up, possibly because I don't seem to enjoy these affairs quite so much as Mr. Raft does. Then, too, I don't happen to be financially interested in night clubs as is Mr. Raft.

What I have been trying to say is that what columning needs, apparently, is not only the "divine dispassion" supposedly the very soul of a good reporter, not only the sense of fair play, not only a disposition to remain always selfless and to make a religion of facts, but, above all, a recollection that an actress, even one who makes bad pictures, is an actress, first, and a trained seal secondly.

So that possibly she may be forgiven when she stumbles.

Okay, Ed?

Sincerely,

Joan Crawford

NEXT MONTH!

HOLLYWOOD MAGAZINE takes you on the set of COME LIVE WITH ME, the new M-G-M comedy, co-starring Hedy Lamarr and Jimmy Stewart. You can't afford to miss this exciting production story. Look for it in the February HOLLYWOOD MAGAZINE, on sale the tenth of January.

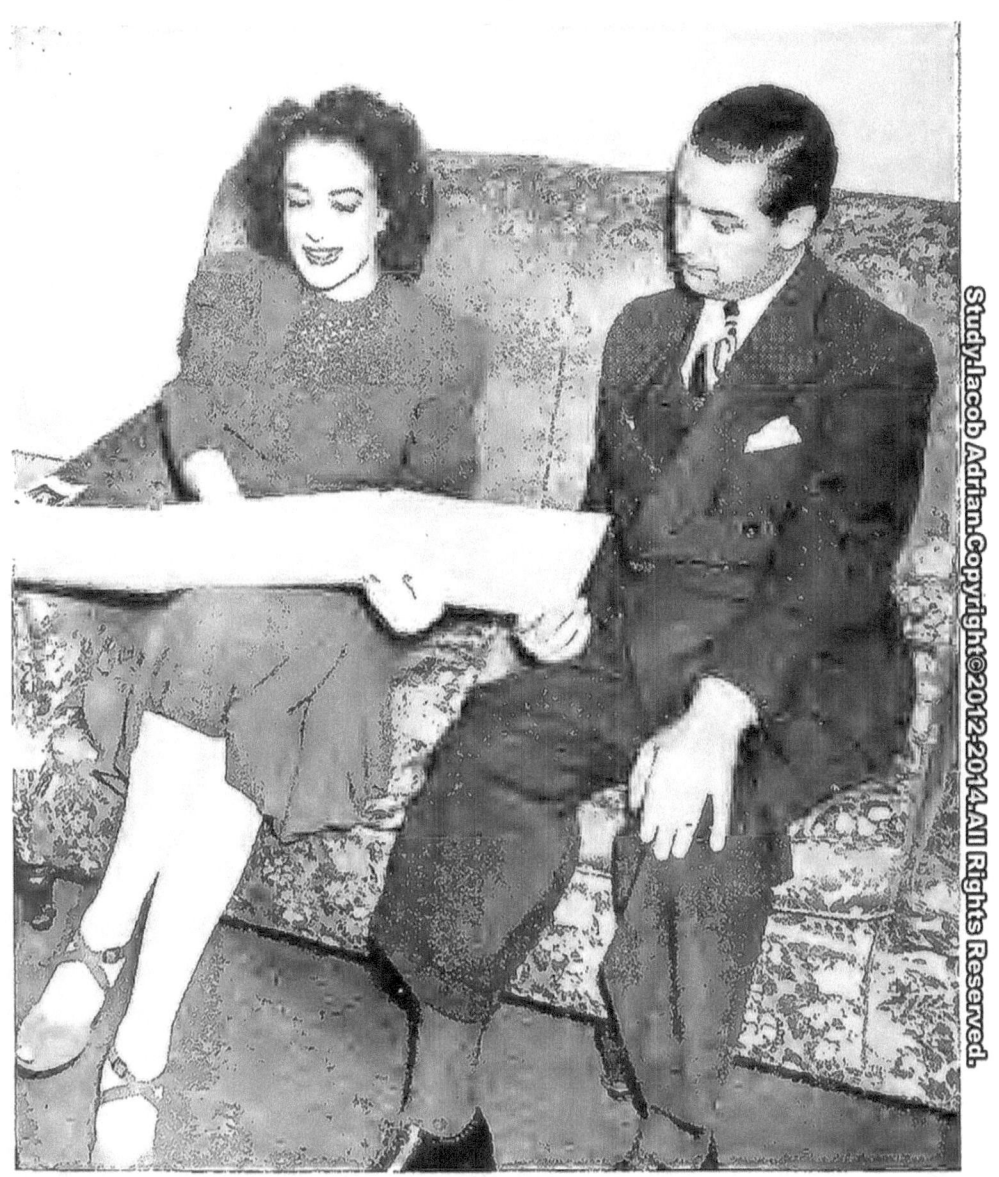

W. H. (Buzz) Fawcett, president of Fawcett Publications, and Joan Crawford enjoy a tete-a-tete. Joan is showing Mr. Fawcett a photo of her newly-adopted daughter, Christina. Miss Crawford's next picture will be Metro's *A Woman's Face*, in which she portrays the role of a badly scarred woman

Joan Crawford's Most

BRUTALLY SCARRED

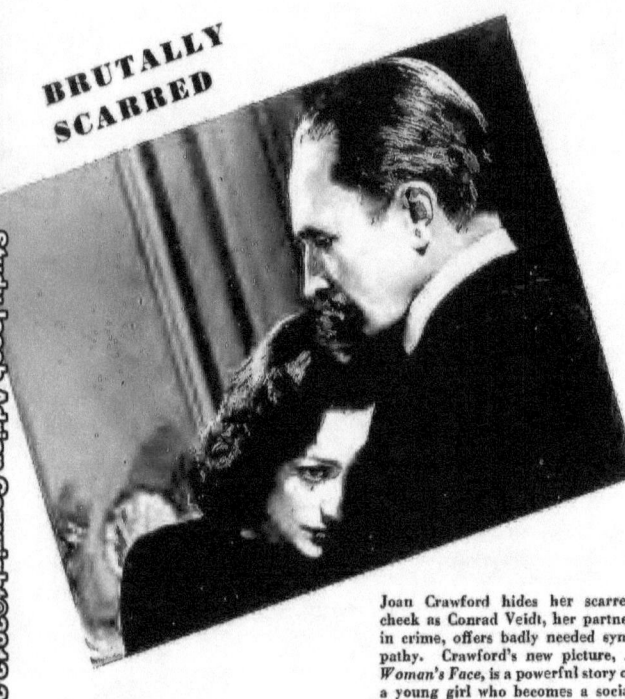

Joan Crawford hides her scarred cheek as Conrad Veidt, her partner in crime, offers badly needed sympathy. Crawford's new picture, *A Woman's Face*, is a powerful story of a young girl who becomes a social outcast because of an ugly scar

■ Joan Crawford is accustomed to having people stare at her—but never in horror. It's a new experience for her to have them suddenly stop in their tracks and shudder as she approaches. And she loves it.

It's the scar that gets the starers, Joan's own wonderful scar, that she won after heated battles with studio executives, who didn't think movie queens should ever be anything but beautiful. During the filming of her new picture, Metro employees would rush to Stage 14 just to take a quick look, and Joan would stride over with the good, right side of her face in full view. Then, mischievously, she would turn her head and smile pleasantly as her visitors gasped in fright. For the whole left side, stretching from eye to mouth, was just a mass of seared tissue. Joan had gone out of her way to prove that she could be the first contender for the gruesome sweepstakes. The biggest compliment you could pay her was to say, "Why, Joan, you look terrifying!"

The scar isn't used merely for one of those lightning close-ups, either. Joan wears it throughout one-third of the picture, and hopes to scare the daylights out of the spectators when the film is released. The story is taken from the three-year-old Swedish movie of the same name, in which Ingrid Bergman played the featured role.

The film opens in a courtroom where Joan is on trial for murder. As the witnesses appear on the stand to give evidence, the plot gradually unfolds in a series of flashbacks.

Joan is *Anna Holm*, a cultured Swedish girl who was so severely burned as a child that the resultant ugly scar on her face made her a social outcast. None of her classmates would play with her when she was little; as she grew older, she found that everyone shied away from her in horror. To revenge herself on the society which had treated her so cruelly, she joined a gang of blackmailers.

The blackmailing gang runs a restaurant as a blind, to hide its nefarious activities. The crew consists of Reginald Owen, who is the mastermind, Donald Meek, who acts as a waiter, Connie Gilchrist, a decoy masseuse, and Joan. Into the restaurant comes *Torsten Barring* (Conrad Veidt), the wastrel son of a

With her face swathed in bandages, Joan sits with tightly clasped hands, awaiting the removal of the fateful bandages. Director George Cukor is shown giving Joan and Melvyn Douglas, who portrays role of the doctor, last-minute instructions

prominent Swedish family. He is irritated because the restaurant will no longer extend him any credit. He asks to see the owner. "Where is he?" he demands. "Have him come here!"

Joan enters with her hand covering the left side of her face. "It's not a he," she says. Veidt wants to know if she has something in her eye, and removes the hand from her cheek. Joan stands perfectly still, without flinching, and is astonished when Veidt doesn't recoil at sight of her. He is the first person she's ever met who wasn't repelled by her disfiguration. Fascinated, she accepts his invitation to call at his apartment.

Veidt, who is one of the most gracious and best-liked actors in Hollywood, was rueful about the villainous part he's playing in this picture. Since his American debut in 1926 with John Barrymore in *The Beloved Rogue*, Hollywood has always cast him as a scoundrel.

"I've never done anything wicked in my life," he said on the set one day, "and I'm always doing wicked things on the screen."

When he returned to America last year, he thought he might be given a change of role, but the first part for which he was cast was the Nazi general in *Escape*. His villains, however, are no run-of-the-mill bogies, for he plays them with great suavity and charm, so that audiences are inclined to sympathize rather than condemn. "I try to find somewhere the human weakness that makes a monster out of a man," he explained. "In the case of *Torsten Barring*, I arrived at the conclusion that he wasn't quite normal—definitely a pathological case."

Joan and Veidt develop a curious attachment for one another. When she visits

DELICATE

Daring Role!

By IRVING DRUTMAN

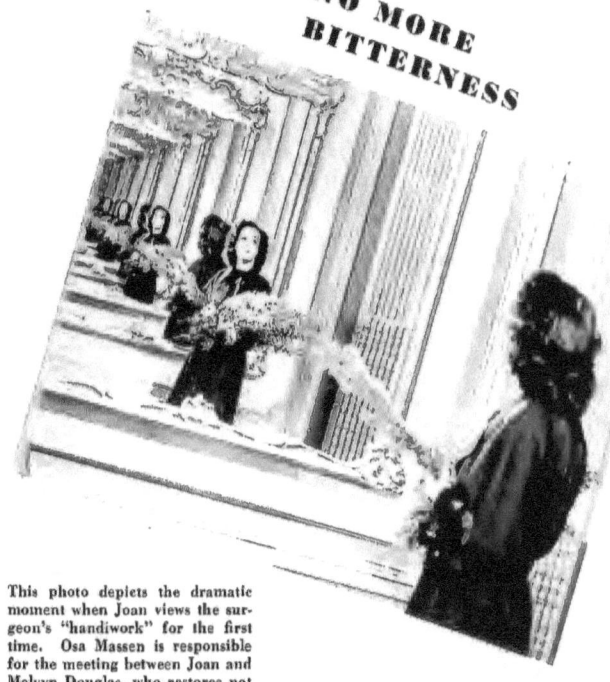

NO MORE BITTERNESS

him in his apartment, the audience gets the first intimation that he is planning to have her join him in a criminal coup. Pouring out some sherry, he raises his glass in a meaningful toast. "Skoal, Satan!" he says.

We next see Joan in the midst of one of her blackmailing operations. The gang has stolen some incriminating love letters from Osa Massen, the wife of a prominent plastic surgeon, and Joan goes to her house by appointment to return the letters in exchange for jewels. As Osa hands over her precious baubles she hypocritically cries, "These were given me by my husband, whom I love better than anything in this world." Joan says sharply, "That's not what you wrote in these letters to your lover."

Osa, who has only seen Joan in the half-light, senses that something is wrong with her face, and turns the reading lamp full upon her, revealing the dreadful scar. "Oh," she says, taunting her, "so that's what love means to you!" Joan is taken off her guard and loses all self-control. "No," she cries, "this is what love means to me," as she slaps Osa repeatedly across the face, "and this, and this!"

The slapping scene, one of the most difficult to shoot, provided a great deal of amusement for the cast. Since Joan does everything thoroughly, the actual slapping was full of vigor. Crawford was apologetic to Massen, saying, "I'd much rather be on the receiving end of this." Massen, however, said she was used to being slapped "because I was brought up with three older brothers." When the first rehearsal was over, she claimed she hadn't been hurt at all; that the slaps felt just like her weekly facial at the beauty

This photo depicts the dramatic moment when Joan views the surgeon's "handiwork" for the first time. Osa Massen is responsible for the meeting between Joan and Melvyn Douglas, who restores not only Joan's original beauty, but her faith in mankind as well

OPERATION

parlor. Joan looked at her hand, which seemed to be smeared with blood. The crew was worried, and offered to call a doctor, but the "blood" turned out to be Osa's lipstick which had come off on Joan.

The change in Joan's scarred character comes about when Melvyn Douglas, playing Osa's plastic surgeon husband, comes suddenly into the room and discovers Joan clutching his wife's jewels. He is at first tempted to call the police, until his attention is drawn to her face. "That's too wonderful a scar to send to jail," he says, and offers to operate on her.

The operation is successful, and Joan emerges from the hospital a beautiful woman. But though the scar has been removed from her face, it is still in her soul. She and Conrad Veidt hatch a plot to get rid of his six-year-old nephew, so that Veidt can inherit all his grandfather's money. The plan is for Joan to become governess to the child and at the first opportunity push him over a cliff.

Joan is eager to be Veidt's accomplice, but when she has been with the family for a short time, a change gradually comes over her. People in this new world treat her differently. The grandfather is very kind to her, and she grows greatly at-

tached to the child. During the week of the winter peasant carnival, Veidt arrives for a visit and sees that she will never go through with their murderous plan. He becomes demoniacal and snatches the child away in a sleigh, with Joan and Melvyn Douglas following close behind in one of those mad movie chases. The scene then switches back to the courtroom, with Joan on trial for murder. There is a surprise ending, which Metro is keeping a closely guarded secret, no one not working on the production being in on the denouement.

Secrecy was the rule throughout the filming of most of the picture. The set was closed to all visitors while Joan had the scar on her face. No stills were taken of Joan with the scar. The trailer announcing the picture will have no shots of the scar.

When all the scenes of Joan before the operation had been taken, it was discovered that the scar was too large and might distract audience attention away from the action. So that part of the film had to be shot all over again with the scar slightly reduced in size. The only trouble Joan had with the scar was that it itched terribly. The day before she was to take it off for good, she stuck out her tongue at Osa Massen, schoolgirl fashion, and said, "Ahhh, tomorrow, I'm gonna be pretty too!" ■

Hollywood's Proudest Mother

By MARGARET CHUTE

Editor's Note: The writer of this article is an English journalist who is now in America through the kindness of Joan Crawford. Everyone who comes from England in war days must have a guarantor in America. When Miss Crawford heard that Miss Chute, whom she has known for years, was trying to get a permit to come to the United States to continue her work as a writer, she volunteered to be her guarantor.

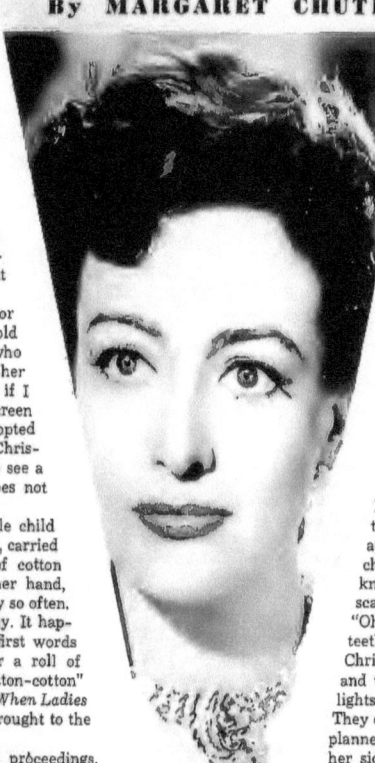

■ On a table in Joan Crawford's portable dressing room stands one of the loveliest pictures ever captured by a camera. It shows Joan lying down, with a golden haired child held up in her arms. The tiny laughing face rests against Joan's cheeks in a kiss. There is devotion in every line of Joan's face; there is adoration in the laughing eyes of the child. Such a radiant baby. Such a contented mother.

Joan herself would never talk for publication about the two-year-old child she adopted, the tiny creature who has brought so much happiness into her life. But I feel she will forgive me if I tell some of her friends beyond the screen a few things about Christina, her adopted daughter. From watching her with Christina, I feel I have been privileged to see a Joan Crawford whom the world does not know.

Christina Crawford is a sweet little child of definite character. Her favorite toy, carried everywhere with her, is a lump of cotton batting. She clutches it firmly in her hand, beaming at it with vast affection every so often. It became her pet toy in a funny way. It happens that "cotton" was one of the first words she pronounced plainly. Show her a roll of cotton, and she would exclaim "cotton-cotton" with emphasis. During the filming of *When Ladies Meet*, Joan allowed Christina to be brought to the set at 5:30 each day.

Until 6:00 Christina watched the proceedings, perfectly at home in a studio. Then Joan and Christina drove home for the precious romp that ends each day. In advance, Joan explained to Christina that she must keep very quiet while on the set; no running around, no sudden shouts. Fully understanding, Christina arrived accompanied by her capable, kindly, Scotch nurse. Blue eyes shining, white-gold curls framing a sweetly eager little face, the child watched in thrilled silence. Suddenly someone walked by carrying an enormous roll of cotton. And that broke up Christina's obedience and good manners.

At the full pitch of her clear young voice she shouted—"Cotton! Cotton!" The scene went into the ash-can, of course. Nothing was said, and work continued. At 6 o'clock the director of the picture came across to little Miss Crawford, and solemnly presented her with a big roll of her adored cotton. She drove home hugging it, and from that moment nobody can separate her from the toy she treasures most.

When Christina arrived in Hollywood early this year, she was wearing a Lily Daché hat! Strictly, it was a bonnet—but it had the famous Lily Daché label

Joan Crawford has steadfastly refused to talk for publication about her young adopted daughter. HOLLYWOOD takes particular pride in presenting this exclusive, heart-warming story by a writer who knows both Joan and little Christina well

inside its brim. No, Joan did not buy this bonnet for her daughter. She has firm ideas about non-essential expenditure over Christina's clothes. It was Lily Daché herself who insisted that Christina must have one of her special head-coverings for her first trip to California.

So an entrancing creation arrived at Joan's hotel, addressed to Miss Christina Crawford. Off to the train—Joan never travels any other way—went a happy child, with a wee bonnet of a heavenly shade of yellow sitting on her cloud of white-gold hair. A tiny ostrich feather, also yellow, rested along the brim.

Joan is very sensible about the child's clothes. She buys perfectly plain frocks, in blue, pink, or daffodil yellow, insisting that it is unwise to buy masses of expensive things. She feels that later on Christina will appreciate luxurious "fluffies" much better if she has not already had a chance to grow weary of them.

Loving the child so deeply, Joan shows tremendous self-control in refusing to become sentimental over her. With all the love in the world in her eyes, she still manages to sound matter-of-fact when talking of or to Christina.

They romp together like a couple of young tigers. Christina coos with bliss when Joan slings her against her hip, spins her around the room, finally rolling over on the bed amid shrieks of joy. One day Joan appeared on the set with a red mark on her chin. "What's that?" her director wanted to know. "Have you been devising a new kind of scar for us?"

"Oh, no! Christina is using my chin to cut her teeth on!" Joan replied proudly.

Christina loves to make odd little singing sounds, and takes some shaky dancing steps—which delights Joan, who began her own career as a dancer. They dance gaily in the big nursery Miss Crawford planned for her daughter; Joan showing the tot by her side some simple steps which Christina tries, so solemnly, to copy.

To encourage the child's love for music, Joan has hunted everywhere for records of nursery rhymes. While the victrola plays "Little Miss Muffett" and "Three Blind Mice" Joan sings the words softly; and soon Christina is singing along with her!

Another Christina-inspired hobby is a movie camera. Joan has learned how to operate it, and her movies have a truly professional touch. Like other devoted mothers, she has reel after reel of moving pictures showing every phase of her daughter's life to date. First staggering steps ... first bath in a real bathtub ... playing with a dog ... playing with the now famous cotton batting ... laughing, trying to dance ... mouth wide open in that first frantic effort to cry "Mum-m-m!"

Partly for Christina's sake, and partly because of her own big warm heart, Joan recently added another wing to her nursery and brought home a small baby brother for Christina. He has been named Christopher, and in appearance and temperament he closely resembles Christina.

"They might be true brother and sister," Joan says happily. ■

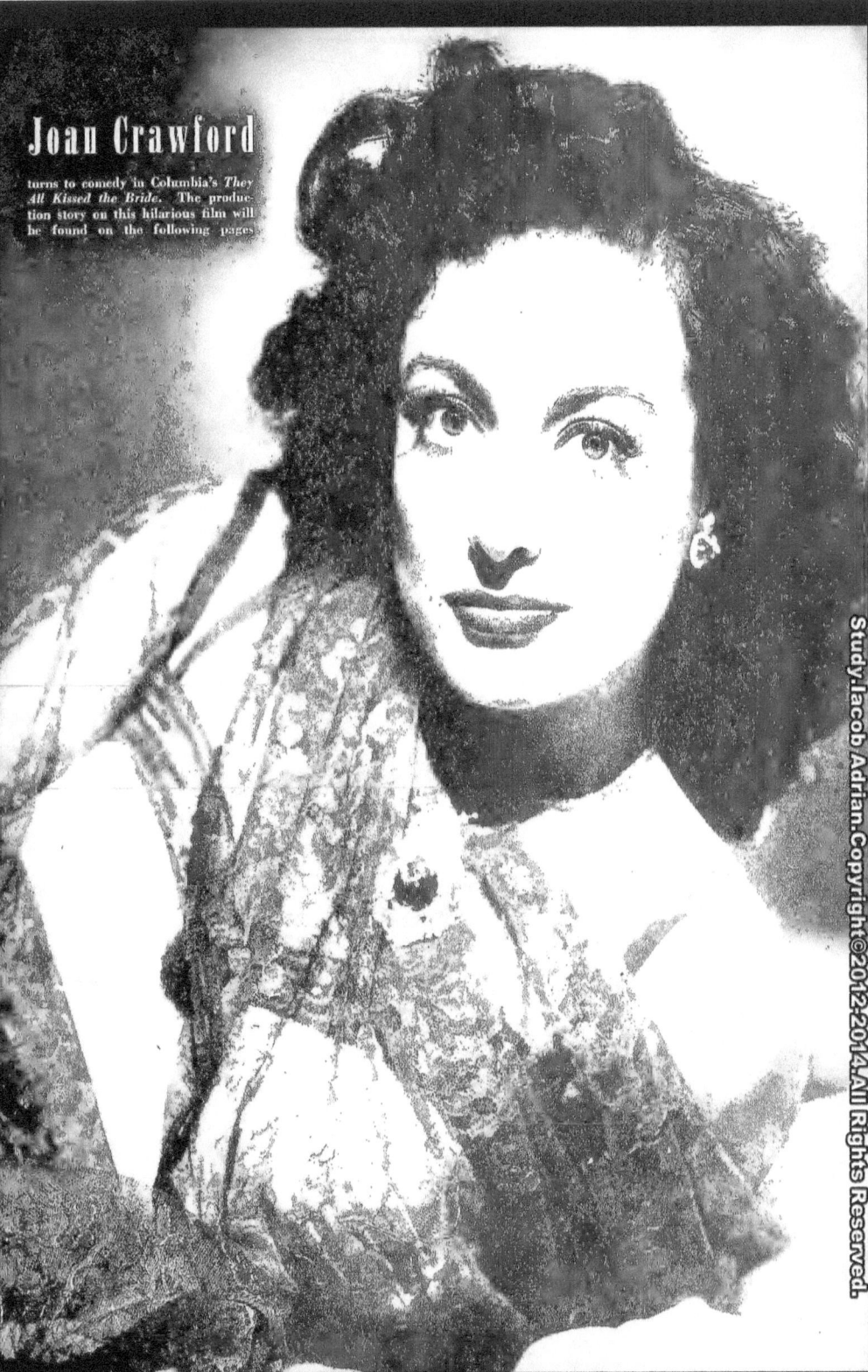

Joan Crawford

turns to comedy in Columbia's *They All Kissed the Bride*. The production story on this hilarious film will be found on the following pages

Crawford Cuts a Rug

By CHARLOTTE KAYE

Joan Crawford does a hilarious jitterbug routine with Allen Jenkins in her new picture, *They All Kissed the Bride*

Joan took jive lessons from Dewain Truitt, Seaman First Class, well-known jitterbug champ of the Pacific Fleet

Top left: Joan cuts birthday cake presented to her by cast and crew. Helen Parrish helps with proceedings, while Mel Douglas stands by. Right: An informal moment between scenes—Joan plays hair dresser to Roland Young. Left: Joan and Mel Douglas, in one of 78 love scenes!

"The public wants light laughter and hot romance, and, believe me, we are giving it to them in this picture! With the war uppermost in everyone's mind, I think the movie-going public is begging for escape from reality when it goes to the theater these days. There are no less than 78 love scenes, and they are the kind which created the Great Lovers in the old days. Nor are my kisses any sisterly pecks or gentle lip-brushings. When I kiss the various men, I mean business," said Joan Crawford enthusiastically.

My money says the loyal Crawford fans will be doing nip-ups of joy when they see *They All Kissed the Bride*, for it marks Joan's return to frolicsome comedy with plenty of torrid love scenes which originally skyrocketed her to stardom. If they have been unhappy with her recent ventures such as *When Ladies Meet*, they have had nothing on Joan. She has shied away from such stories for a long time but always found herself stymied when she tried to effect a change. Movie stars have bosses, too, and the boss' word is law.

Offhand, Joan's boast would indicate the censors were in for a busy time, but Director Alexander Hall believes he has that little problem all solved. Rather than see his favorite necking scenes land on the cutting room floor, Hall invited the censors to watch all doubtful scenes being filmed and got thumbs up or thumbs down on the spot! A smart gent, that one, as well as a past master at sophisticated comedy.

All hellzapoppin' as the story of *They All Kissed the Bride* opens. Joan as Margaret Drew, the tyrannical head of a vast trucking business which she inherited from her piratical millionaire father, is giving her board of directors merry what-

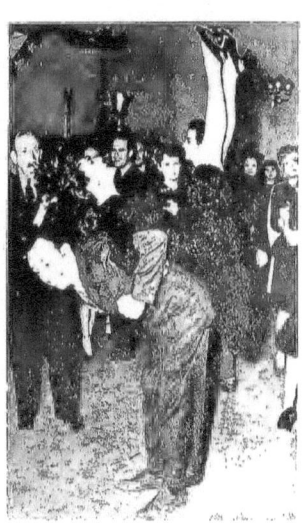

Joan is snooty boss of a truck company, Allen an employee. Together they get in the groove and win a silver cup

Unexpected climax to the jitterbug sequence comes when Allen swings his partner right to the floor. This role was intended for the late Carole Lombard, and in tribute to her memory, Joan donated her salary of $125,000 to charity

for. A writer, *Michael Holmes* (Melvyn Douglas), is preparing an uncomplimentary biography of her dead father and an expose of her own dictatorial management of the business. She demands *Holmes* be found so she can deal with him in person. All in all, it is a stormy session and keyed to a fast tempo.

As Director Hall prepared to shoot this opening sequence, a certain tension and nervousness was evident on the set. Joan was a visiting star of the first magnitude, working for the first time on the Columbia lot under Hall's direction. She was a stranger to most of the crew and the actors, hence everyone was slightly on edge. In addition to all this, Joan was stepping into the role that was originally intended for the late Carole Lombard, whom everyone loved, and whose grim and untimely death everyone still mourned. Too, it was the scene which would set the pace for the entire picture and doubly important from that standpoint.

Finally the cameras started to turn. As the action demanded, Joan raged up and down the office, wheeling her big desk chair in a series of shoves and turns. The close of the scene called for her to thump herself down heavily in the chair.

Joan sat—clear to the floor! In her enthusiasm she had shoved the chair entirely out of range. The ensuing roar of laughter, led by Joan herself, broke the last remnant of tension. From then on, cast, crew and Crawford were buddies!

The story, of course, develops into a nonsensical dogfight between Joan and Douglas with all manner of complications, including the tearful wedding of the younger *Drew* daughter (Helen Parrish), the fluttering of *Mrs. Drew* (Billie Burke), a suit for false arrest, two farcical bedroom scenes, a jitterbug dance contest which Joan wins with a truckdriver partner (Allen Jenkins), a mad scene in a subway and a madder one in a taxi, and eventually, the happy ending. It doesn't make much sense but it's grand fun and a laugh a minute. Plus those 78 kisses, extra warm.

For a brief time one day it appeared one of Joan's burning ambitions—to get her pet dachshund, Pupschen, into a movie —would be realized. For 5 years Joan vainly has been trying to persuade directors to give Pupschen a chance to enter the lists against Asta, Daisy and other celebrated cinema canines. Always the answer was a polite "No" until Hall, in a generous mood, said "Okay."

Came the big day. Pupschen was supposed to run across the room and jump into Joan's lap as he does in real life a dozen times an hour. All went well in rehearsals and finally the cameras started to turn. Proudly Joan waited for Pupschen to shine.

Alas for ambition! The pup merely sat on his hind legs and continued to howl until his humbled mistress carried him to the dressing room in disgrace! But at least it won Pupschen one distinction—the shortest screen career on record. Or so Joan consoled herself.

Comparable to the tales of Pupschen's prowess were the enthusiastic reports Helen Parrish made each day anent the vegetable garden in her back yard. Inch by inch came the reports of the green beans' growth, the fine quality of the squash, and the ripening color of the tomatoes. Willy nilly, the cast had to listen to the details. Then suddenly Helen grew silent on the subject. After three days the suspense was too much for Hall.

"Tell me, pretty maiden, how does your garden grow?" he asked Helen.

"Oh, it's wonderful!" Helen replied. "We had it for dinner three nights ago!"

Highlighting all Crawford pictures invariably are the fashions, for Joan admittedly has a flair for wearing clothes, and more than any other Hollywood star sets styles and trends. *They All Kissed the Bride* should prove no exception to the rule, for Joan has 21 changes, all designed by Irene, ranging from business suits to formal evening gowns with a super jitterbug dance frock for good measure.

The strongest style influence undoubtedly will be set by the three suits which Joan wears in the sequences showing her as a business woman. Heretofore the Crawford suits h a v e emphasized severe tailoring, particularly in lapels and neck and shoulder lines. In wartime, however, both Irene and Joan agree women's clothes should be more feminine than ever, hence the new suits are softened in line and cut, and feminized with soft necklines and trims of bows and ties. Typical is one of navy blue wool with a slightly flared skirt which is trimmed with tiny flared tucks spreading down from the waistline. The jacket has a cut-away vest effect, fits snugly at the waist, with only a short flare below the waistline. With it she wears a crepe blouse in a soft shade of dusty pink and two frilly carnations, made of the blouse material, are tucked at the neckline. The hat for the outfit is a navy blue pillbox with a cluster of pink crepe carnations and a touch of navy blue veiling beneath the chin.

They All Kissed the Bride will reveal another fashion touch which is apt to send husbands and brothers on the trail of padlocks for their bureau drawers.

With all her suits, Joan wears suspenders!

The Hollywood rumor factory worked overtime when Joan Crawford wed the comparatively unknown actor, Phillip Terry. Despite his famous wife's influence in the movie industry, Terry will carve out a career through his own efforts. Joan's in Metro's *Reunion in France*; Phil's in *Bataan Patrol*

By KAY PROCTOR

"I Didn't Marry Joan Crawford for Fame"—Phil Terry

▪ Phillip Terry is a young man with notions and the spunk to back them up. One of those notions right now is that he is *not* going to ride to Hollywood success on the coat-tails of his wife, Joan Crawford. Twice before—once at M-G-M and again at Paramount—he had the courage to walk out on lucrative contracts when he did not like the set-up, so there is no reason to believe he will back down on his current stand. Particularly when Joan agrees with him 100 per cent!

No sooner had Phil and Joan been married (a marriage which caught all the Know-It-Alls napping!) than gossiping tongues began to wag in the usual Hollywood fashion.

"*Joan Crawford and new spouse to co-star on Broadway,*" one columnist printed. "*Crawford asks studio to co-star mate with her in new picture,*" wrote another.

Back of those items, and a score like them, was the unwritten implication that Terry's film career was due to take a sudden rise because of his wife's influence and power.

As would any man, Phil began to burn. "It's not true," he said in indignation. "We have no such plans or intentions." No one bothered to print that.

It is true Joan has a great faith in Phil and his future. Any woman—secretary, welder's wife or plain Mrs. Brown down the street—feels that way about her man. It's part of love and marriage.

"Naturally I am proud and grateful for Joan's faith in me," Phil said, "but I would never ask or permit her to go out of her way to assert that faith to her studio. It would be unfair to her, put her on the spot. It would put her in a bad light with the executives who know and trust her judgment. She got where she is by her own efforts, and I intend to do the same.

"It would endanger my career, actually, because it would be jamming me down the public's throat, and the public is quick to resent (and rightly so) any such tactics. Studios have found that out in the past when they have tried to force 'finds', 'discoveries' and 'importations' into public favor before the public was ready to accept them.

"Finally, it would be unfair to the studio. It should be allowed to make its decisions without pressure. If you buy something under pressure, you may tolerate it but you never have any enthusiasm or real interest in your purchase. It's like buying a new hat: if you make your own choice, you like it; if a high pressure salesman talks you into it, the chances are you will decide it stinks by the time you get it home!

"Call it a hunch, intuition or what you will, but I *know* some day I will make my mark in Hollywood. Meantime I am content to wait for that day, and to work to be ready for it. There is precious little satisfaction in success handed you on a platter; to enjoy it you must earn it by your own efforts."

Phil started working toward his goal back in 1930 when he first decided on a picture career. He felt a sound theatrical training was an essential background to film success, and because the American stage at the time was in the doldrums (those were the depression years) he went to England for that training.

"I also had noticed that Hollywood had developed a great affection for English actors," he observed succinctly.

He studied at the Royal Academy of Dramatic Arts and upon graduation, joined a repertory company and toured the provinces. An unexpected illness of his father caused Phil to return to California in 1935 and he set about the business of getting a job in the movies. A dreary, disheartening task it proved, too; for a solid year he could not get his nose inside an agent's office, much less a studio. Everywhere he heard the same refrain until it began to sound like a dirge:

"Not a chance, and for heaven's sake, get rid of that English accent!"

It must have given Phil considerable enjoyment some time later when a certain agent rushed up to him after the preview of *Parson of Panamint* in which he played the title role.

"You were great, my boy!" the agent gushed. "Wonderful! Come around and see me tomorrow. Together, we can do great things!"

"You don't remember me, do you?" Phil answered.

"I Didn't Marry Joan Crawford for Fame"

"I went to see you once and got a very chilly reception. In fact, you turned me down cold!"

For two years he batted vainly against the studio walls, meantime appearing in numerous radio plays. Finally, in 1937, Columbia tested him for a role in a story Tommy Mitchell had written. By mistake the test was sent to M-G-M and Phil wound up under contract to that studio. (It was then he first saw Joan and worked in one of her pictures although she was unaware of his existence.) Because he was a capable performer, he soon found himself working as the foil for every new personality the studio tested. Big roles were promised, but invariably they went to other players. He was supposed to play one of the leads in *Northwest Passage*, for instance; Bob Young got it. Ditto the Stewart role in *The Young in Heart*.

Being a young man of spunk, Phil took just so much and no more. He quit. In the following year he made eight pictures on a free-lance basis and then signed with Paramount. After *Parson*, Paramount announced him as one of their brightest new stars—and then shoved him into stinker roles in unimportant pictures. Again the courage of his convictions asserted itself, and he again quit.

"The law of averages and percentages can't fail," he says today. "My break is coming. Look what has happened already! I'm married to the most wonderful girl in the world!"

As might have been expected, the gossips have been busy about that marriage too. For some strange reason, particularly since the gossip always lacks personal venom or malice, Hollywood seems to resent a happy marriage and promptly starts trying to undermine it.

"Such gossip can't hurt a marriage where two people really are in love," Phil said.

It is not impossible that Phil and Joan will do a picture together sometime. Both naturally would like to, because the home recordings they have made prove that they make an excellent team. If it happens, however, it will be because it is the right thing at the right time.

If and when Phil gets a contract, you can bet he will have earned it on his own. Anyone who wants to question it better be ready to put up or shut up. ■

Joan Crawford startled Hollywood when she announced her marriage to Philip Terry, rising young actor. Since her divorce from Franchot Tone, her name has been coupled romantically with some half a dozen men, but Terry won her heart after a brief, whirlwind courtship. Joan's in Metro-Goldwyn-Mayer's *Reunion*

Anthony and Cleopatra, as Romeo and Juliet. Naturally, Benny took a lot of kidding. "It's okay with me," he said, finally, "just as long as they don't pose us as Fred Allen and Portland Hoffa."

■ On location at Knab, Utah, with the *Desperadoes* company. Glenn Ford Claire Trevor and Evelyn Keyes were inveigled by a local theater manager into making a personal appearance with a screening of *The Adventures of Martin Eden*. "You'll pack the theater," he enthused. They did. P. S. The theater seats 150.

■ The wife of a film producer surprised him the other day with a portrait of herself done by a local artist. "Isn't it wonderful?" she gushed. The producer took one look and then said. "But darling —this painter—he's a nobody. I've always thought some day we could afford to have your portrait done by one of the Old Masters."

■ Swell line in the script of *Girl Trouble*. Don Ameche gets a black eye and assorted bruises in a dance hall fight and Joan Bennett tells him. "You look like what I would like to do to Hitler."

■ Ameche, incidentally, would like to try his hand at directing. "Who knows," he says, "when the public will get tired of seeing my mug on the screen. When they do, I can hide behind the camera."

Queen Victoria comes to life again in the person of 21-year-old Diana Barrymore! In Universal's *Between Us Girls*, Diana portrays a variety of characters from a 12-year-old tomboy to the 80-year-old monarch

Bibliographic sources :

Hollywood (1934-1943)
Publisher: Hollywood Magazine, inc. ; Fawcett Publications, inc.

This documentary study use,
combined in various proportions,
elements from the following categories,
forms and subsets :
- fair use
- documentary
- documentary photography
- feature
- journalism
- arts journalism
- visual journalism
- photojournalism
- celebrity photography
in order to :
- employ material as the object of cultural critique ,
- quote to illustrate an argument or point ,
- use material in historical sequence,
providing independent opinion,
using photos, press articles, advertisements,
opinions of fans etc. ...

Copyright©2012-2014 Iacob Adrian.All Rights Reserved.

www.ingramcontent.com/pod-product-compliance
Lightning Source LLC
Chambersburg PA
CBHW030912180526
45163CB00004B/1804